COMPENDIUM OF
ACRYLIC PAINTING
TECHNIQUES

COMPENDIUM OF ACRYLIC PAINTING TECHNIQUES

300 TIPS, TECHNIQUES AND TRADE SECRETS

Gill Barron

Search Press

A QUARTO BOOK

Published in 2014 by Search Press Ltd
Wellwood
North Farm Road
Tunbridge Wells
Kent TN2 3DR

Reprinted 2014, 2015 (twice), 2016 (twice), 2017, 2018, 2019

ISBN: 978-1-78221-045-0

Conceived, designed and produced by
Quarto Publishing plc
The Old Brewery
6 Blundell Street
London N7 9BH

QUAR: ACPA

Project Editor: Emma Poulter
Art Editor: Anna Plucinska
Copy Editors: Sally MacEachern and Hazel Harrison
Proofreader: Claire Waite Brown
Picture Researcher: Sarah Bell
Indexer: Dorothy Frame
Art Director: Caroline Guest
Creative Director: Moira Clinch
Publisher: Paul Carslake

Colour separation in Hong Kong by Modern Age Repro House Ltd
Printed in China by C&C Offset Printing Co., Ltd.

Contents

Introduction

Acrylic paints are an incredibly versatile medium that can be used for a huge range of painting techniques to create an array of effects. An indispensable compendium of essential know-how, inspirational project ideas, troubleshooting tips and useful careers advice, this book will help you get the most out of this wonderful painting medium.

Whether you are an ambitious amateur eager to improve your art and move it in a professional direction, or a complete beginner, you'll find here all you need to know to take your work forwards. Packed with detailed inside information and practical ideas on painting with acrylics, colour theory, composition and more, you'll also find a range of useful tips for getting the most out of your time in the studio, avoiding pitfalls, saving money and expanding your artistic career.

Detailed explanations and step-by-step demonstrations let you try a number of styles and techniques with this most user-friendly medium, and also show the techniques applied in context.

With 300 practical tips and techniques to spark your creativity, as well as information on how to make the most of your finished art, this book is the best companion you could have on your journey into making art with acrylics.

About this book

The information in this book is organized into three chapters:

Chapter 1: Setting up (pages 8–69):
Here you'll learn about the basics: the properties that make acrylics unique, how to choose your palette, brushes and painting tools, supports, mediums and much, much more – in fact, you'll find all the information you need when getting to know acrylics.

Acrylic tips and techniques:
300 numbered tips and techniques are organized in an easy-to-use way that will enable painters of every ability to develop their own approach to acrylics, and achieve excellent results.

Chapter 2: Designing the painting (pages 70–117):
Learn about the importance of composition, the various methods of transferring your subject to your support, and colour theory. This chapter also provides a wealth of subject ideas and useful tips to help aid you in your approach to acrylic painting.

Try-it panels:
These panels contain great ideas for experimenting with methods and materials, and will inspire you to develop your own preferred ways of working.

Fix-it panels:
These regular companion features contain useful advice on how to avoid or rectify common mistakes.

Step-by-step sequences:
A number of techniques are demonstrated in easy-to-follow step-by-step sequences, with full-colour photography.

Golden rules and tips:
Key information and golden rules are flagged in coloured panels.

Chapter 3: Techniques (pages 118–171):
A host of techniques is explored here. Find out how acrylic paints can be used in a watercolour, gouache or oil painting style, as a medium in their own right, or in a collage and mixed media context. Monoprinting and mural painting are both explored, and the section finishes with information on completing your painting framing it, and making the most of your finished art.

Artist at work:
This icon symbolizes where an artist is at work. A range of artists' approaches are interspersed throughout the book and demonstrate a variety of the techniques in context. Look over the artist's shoulder and take inspiration from the step-by-step sequences and their individual ways of working.

The subject:
A photograph of the artist's chosen subject is provided.

The palette:
The artist's colour palette is also given.

Setting Up

As a painter, being properly equipped from the outset is the best way to help yourself to success. In this section, not only will you find all the basic know-how you need, but you will also discover many fresh angles on less obvious aspects of the art that are sure to inspire and spur you on to fresh endeavours.

1 Why use acrylics?

Considering the drawbacks of oil paints, it is extraordinary what the old masters achieved. How they would have loved acrylics! Take heed of the points listed below and explore the advantages of acrylics. As your work progresses, you'll find more reasons to be glad you chose this most user-friendly of all the mediums.

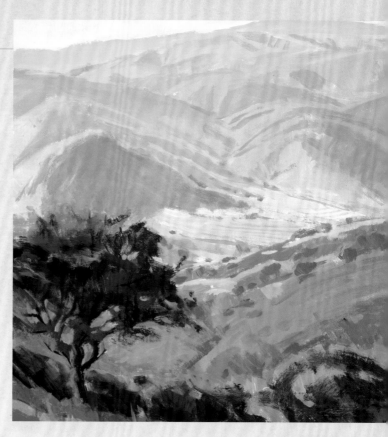

1 Acrylics can be used both thick and thin, and you can even work diluted paint over solid applications, something you cannot do with oils. In *Redshank* (below), Fiona Clucas has used fairly solid paint in the foreground, and watery colour for the background, which has the effect of pushing it back in space.

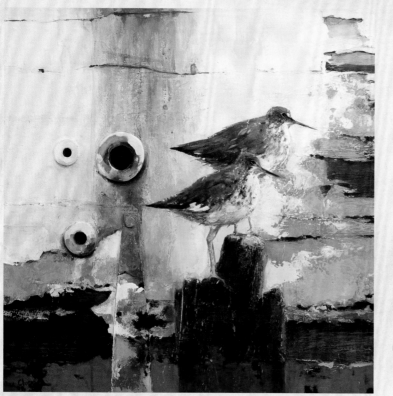

2 The quick-drying properties of acrylic make it ideal for achieving crisp edges where needed. In *Farewell to Spring (above)*, Marcia Burtt has given sharp definition to the shadows and light-struck areas of the hills. In the foreground the edges have been softened by using the paint thickly and working wet-into-wet. Retarding medium can be used to keep the paint malleable for longer periods.

3 Using just one set of tubes you can recreate every traditional style and technique – oils, watercolours, gouache – and invent new ones in the exciting realms of mixed media.

4 Acrylics are very stable, with strong adhesion – they won't crackle or craze, fall off the canvas, or need restoration at a later date. It's great to know your work will have such a lifespan.

5 Acrylic pigments are extremely lightfast, so you can use vivid colours with no fear of them fading. Worked with medium-thick paint, the judiciously heightened colour in Karen Mathison Schmidt's *Sleeping Dog* (right) will have as much impact in future as it does today.

6 Unlike gouache or watercolours, acrylics are flexible enough to use on canvas. With large work, the canvas can be taken off the stretcher and rolled up for transportation without fear of the paint cracking. Reuse a single set of stretchers with fresh canvas to produce many paintings that fit easily into your luggage!

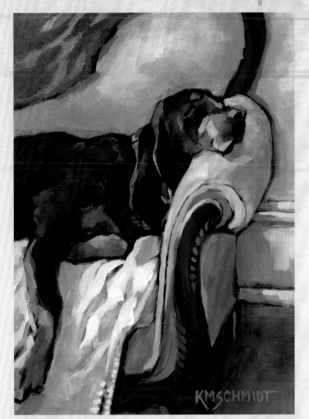

7 The tough, flexible paint film is entirely waterproof and can be scrubbed clean. It's safe to hang unglazed acrylic paintings anywhere, even steamy kitchens and bathrooms.

8 Being entirely water-based, there are no smelly solvents to create fumes, give you a headache, or pose a fire hazard.

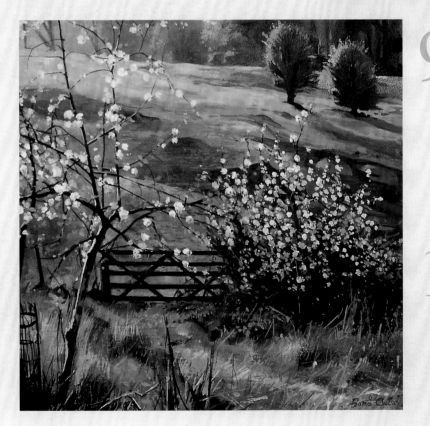

9 Due to years of research, and in response to popular demand, the range of acrylic pigments is increasing. Today, there is an unbeatable array of new pigments, including many excellent ready-mixed greens. In Fiona Clucas's painting of *Fields in Spring* (left), done very much in oil-painterly mode, the greens are amazingly varied, both in hue and tone.

10 Besides the many types and consistencies of paint available, an ever-growing range of specialist mixing mediums means that the possible applications of acrylics are truly boundless. If you can imagine it, you can paint it – fearlessly.

Getting to know acrylics

In the 50 years since acrylic paints first appeared, many variations have evolved to suit every painterly need and to help solve the problems of yesteryear. Like any medium, it takes time to explore all the possibilities. As a start, here you'll find some essential technical tips to help you select among the many choices and ideas to expand the versatility and enjoyment of your artwork.

Playing with colour and patterns, such as this jelly-bean formation, is a great way to explore the nature of acrylics.

Understanding viscosity

Viscosity describes the thickness of paint. Milk is low viscosity, peanut butter high. Different types of acrylics have different viscosities; you may need to experiment to find which suits you and your technique best. Labels vary according to manufacturer; look for a viscosity rating on the tube, or ask your art-shop guru for advice.

Medium Viscosity / Soft Body
Viscosité Moyenne • Cuerpo Suave
Mittlere Viskosität • Media Viscosità

Relative Hue Ton Relatif	RP	R	YR
Munsell Hue Ton Munsell 6.28R	Value Valeur 4.48	Chroma Saturation 13.82	

Opaque ■ Lightfastness: I-Excellent Vehicle: Acrylic Polymer Emulsion Pigment: Cadmium Red (PR 108)
Opaque ■ Tenue lumière : I-Excellente Liant : Emulsion polymère acrylique Pigment : Rouge de cadmium (PR 108)
Opaco ■ Solidez a la luz: I-Excelente Vehículo: Emulsión de polímeros acrílicos Pigmento: Rojo de Cadmio (PR 108)
■ ★★★ - Pigment(s) : PR 108

Thin viscosity
Also known as flow formula and soft body, this formulation is ideal for wet techniques.

Medium viscosity
An all-purpose formulation that can be thinned with water or bulked up with gel mediums.

High viscosity
Ideal for thicker applications, but smooth blending of colour is more difficult with this formulation.

Working with pure paint

Many painters prefer working with acrylic paint just as it comes from the tube, thinning only when necessary with a little water. This method is technically sound (as long as you don't use too much water – always use more paint than water) and reduces studio clutter and mess. The secret is to choose the consistency of paint that best suits your style and techniques.

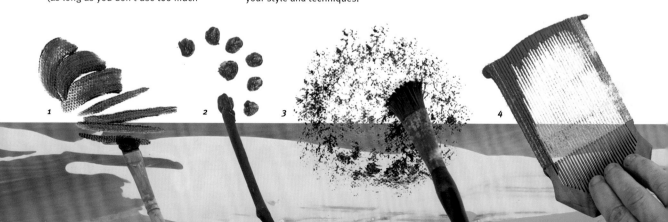

4

Mixability

All acrylic paints and mediums can be safely mixed. The acrylic resin binder, which is the adhesive basis of the paint, happily accepts all sorts of pigments and additives, as long as they're water-based. Fats and oils are totally incompatible and chemically unstable in mixtures, although they can be safely layered over acrylics – never under. This is known as the 'fat over lean' rule and should be followed at all times. See pages 52–57 for more on mediums.

Gloss and matte (G&M) medium
Use to add transparency and slow drying times – this medium is interchangeable with retarder (see page 57).

Impasto gel medium
Adding bulk and sculptability to all viscosities, impasto gel medium is extremely versatile.

Flow improver
A wonderful additive, mix flow improver with your paint to help dilute evenly and soak into the paper better.

Water
Given that acrylics are water-based, water itself is often the only medium you need. Use to thin and dilute.

5

Soft body

Soft-body paints are lower viscosity, creamy paints and are the more liquid flow formulas, which are very easy to use, blend with other colours and rinse from your brush. Owing to their relative thinness, transparent pigments make good glazes without additives. If you like a smooth, level paint film without ridges and bumps, or you work with many layers, use soft body. Always buy the best quality you can – versions of flow-formula paints sold as 'student quality' contain less pigment, so opaque colours are likely to need recoating.

6

Heavy body

Altogether more tactile, high-viscosity paint needs more handling than low viscosity. It will often need to be mixed or even applied with a painting knife and tends to leave a textured surface. The paint stays exactly where you put it, retaining brushmarks and crisp edges. This, together with its adhesive powers, makes high-viscosity paint ideal for impasto work, mixed media, collage and printing. It also takes a little longer to dry than soft body, giving more open working time. Ultrahigh-viscosity versions are available for those who really like to knead and grapple with their medium.

Tools for different viscosities:
1 *Fitch brush for soft body*
2 *Twig (quill cut) for either body*
3 *Scrubber for soft body*
4 *Comb for heavy body*
5 *Twig with leaves for either body*
6 *Toothbrush for soft body*
7 *Painting knife for heavy body*

5

6

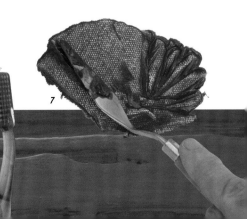

7

Finding the perfect palette

One of the secrets of successful painting with acrylics is to use the right type of palette. As acrylics dry rapidly in contact with air, this vital platform between tube and canvas must protect the paint and provide a good surface for laying out and mixing colours. These pages look at various solutions to the problem of keeping paints workable and explore the options for making a stay-wet palette customized to your needs.

7 The ready-made stay-wet

The stay-wet palette is the ideal kind for acrylic paints. It works by osmosis—as the paints on the surface of the palette begin to dry, moisture is drawn up through a semi-permeable layer, from a water-holding layer beneath. Ready-made versions of these palettes are available from art shops, with packets of tailor-made replaceable inserts. Although very convenient, they are expensive for long-term use, so you may want to try making your own instead (see page 16). There is a trough at one end intended for leaving brushes to soak in water. This is a bad idea—not only is it messy but it can cause your brushes to rot quickly. So, use the trough for mixing only, and always rinse brushes properly as you go along.

8 Conventional palettes

The oil painter's wooden palette, with its swoopy shape and thumb hole, is useless for acrylics, which stick to the wood and dry out into 'chewing gum' blobs in no time. Acrylic will not adhere to a non-porous surface, and so panes of glass and ceramic plates are ideal, easy to clean, and will not stain. Plastic palettes work well too. These palettes are, however, exposed to the air and so to counteract this, and keep paints workable, spray the palette frequently with a fine mist of water. You can add some retarder (see page 57) to the water, too. Glass or ceramic also gives a firm surface for working with a knife, and for impasto. Always transfer the mixed paint to a damp environment immediately to prevent skinning over.

If working in a more watercolour way with watery washes, a plastic palette with 'wells' prevents the colours from polluting each other and keeps the acrylics moist.

9 The mixing palette

If you use mediums regularly, you'll need a hard, non-porous surface on which to mix, or rather mash, them into your colours. This should always be done in advance, not on the canvas. A sheet of thick glass is ideal but be sure to tape the edges to avoid cutting yourself. Use a knife, be thorough, and scoop the mixture onto the palette or into an airtight storage container.

A large glass palette gives more scope for vigorous mixing.

10

Don't worry about waste

Never hesitate to throw out a mixture or membrane that's turned muddy. Do it right away. Paint gets wasted – it happens, so don't fret! Instead, think about the value your artistry is adding to the raw materials, and always use paint that's fresh and juicy.

11

Supporting the palette

There is as yet no airtight palette available that has solved the 'thumb hole problem', so holding on to the palette while you work can be tricky. A simple hands-free solution is to place the palette on a tall bar-type stool alongside the easel so you can see and reach the paint easily without bending.

Making use of a tall stool is a practical way to keep your palette within easy reach.

12

The mildew menace

Taking the lid off the palette to find your beautiful colours speckled with black mould is a horrid experience; unfortunately the damp, airless conditions are ideal for mildew growth. Fear not! There is an answer. Add just a few drops of distilled white vinegar to the water bottle when wetting your damp layer (see pages 16–17) and your problem will be solved!

13 **The golden rule**

Always, always, replace the lid! However short the break you plan to take, get in the habit; it'll save you much time and frustration in the long run.

14

Four ways to store paint

You may need to mix a large quantity of a colour, or keep some in reserve for touching up. Paint in jam jars goes bad or lids get stuck on, and cling film is messy to use, so try these methods:
1. Scrape into a container such as a jar lid and seal in a zip-closure bag.
2. Cover the open container with wet cloth and tin foil.
3. Turn the container (jam-jar lids are excellent for this) upside down onto a glazed surface, such as a plate.
4. Store the palette in the refrigerator. Paint will keep for ages in cold conditions.

For airtight, stay-moist storage for crucial colour mixes, just turn your lid face down.

15

Trouble with tube caps

A palette allows you to lay out sufficient quantities of paint for working, without endless fiddling with tube caps. These quickly become clogged from frequent opening, besides being easily dropped and lost. To clean out the threads of clogged caps, soak briefly in hot water. A toothpick will remove the dried paint easily. It's essential to always replace caps; without them, the whole tube rapidly solidifies and must then be thrown away. Ouch!

Even from the most battered old tubes, paint can be rescued with hot water and a toothpick.

16

Make your own stay-wet palette

For the studio, you'll need a decent-sized palette. A variety of shapes and sizes of airtight plastic boxes are available; choose one that's as shallow as possible to limit air space. The ideal is a circular one with moulded compartments. You'll need a water-retaining material for the damp layer and a suitable material to make the membrane layer (see page 17 for more information).

1 Press a soft piece of cardboard onto a compartment to get the shape, and mark out with a pencil.

2 Cut the cardboard into a template.

3 Use the template to draw the shape onto a stack of folded sheets of sponge cloth, blotting paper, or similar (the damp layer), and cut out.

4 Repeat with a stack of tracing paper or baking parchment (the membrane).

5 Place one or two sheets of the sponge or the paper in each compartment and sprinkle all over with water; do not flood, otherwise the paint will dissolve.

6 Next, add the membrane layer and press into contact with the sponge.

7 Lay out your paints in a logical order (see page 22). Your palette is now ready.

8 Remember to replace the lid – always!

A reservoir for lots of white is useful.

A palette with built-in divisions helps prevent your colours from getting muddy.

17 The damp layer

You can use a variety of water-holding materials for the damp layer:
• Blotting paper
• Synthetic chamois leather
• Kitchen sponge cloth
• Gardener's capillary matting
• Paper towels (you will
need to use several layers)

Paper towels – absorbent, cheap, disposable.

18 The membrane layer

Use tracing paper or baking parchment.
• Tracing paper lasts longer than baking parchment. Choose it if you work with knives or stiff or spiky brushes that would soon tear baking parchment, the cheaper alternative.
 • Baking parchment lets more moisture through and needs changing more often, but it is cheaper and thus more disposable. Changing the palette often is an advantage – a fresh palette ultimately gives cleaner, brighter results.

Synthetic chamois leather – less prone to mould and longer lasting.

Baking parchment has many other uses in the studio. Buy big rolls.

TRY IT ▶ With glass

Working on a tinted ground? Paint a sheet of paper the same colour, and place it under a sheet of glass. Do all your initial mixing on this, and you'll be able to judge tones very accurately at the earliest stage.

19 Time-saving tip

Make a cardboard template of the shape of your palette, and use this to cut out lots of damp layer and membrane layer inserts at one time. Now you can have a fresh palette whenever you like.

20 A travelling palette

A more portable version of the studio stay-wet palette can be easily made using a fishing tackle storage box, or one designed for storing buttons or other small items. Make sponge and membrane inserts (see *Time-saving tip*, above). It's important that the compartments be moulded as part of the box rather than as drop-in sections, since those would allow the colours to leak and mingle.

Out to paint

There's no need to carry all those heavy tubes with you, just squeeze as much paint as you'll need into a handy airtight box with divisions, like this one, and away you go.

FIX IT ▶
Rescue your mixes

Help! The doorbell rang, the dog ran away, you left the lid off the palette and now the paint is useless! But don't throw the membrane away. Instead, use it immediately as a colour swatch to mix new batches of paint, before you forget how you made those vital shades.

Choosing your colour palette

The colours you choose when you buy your first set of paints have a big influence on your progress. The right combination of colours will work together harmoniously to give you pleasure and fluency in your work. Follow the suggestions below to find the set of colours that will work best for you. To understand how colours interact, turn to *Colour theory* on pages 106–111.

> **EXPLAINER**
>
> The word 'palette' has two meanings in painting: first, the range of colours you choose to use, and second, the flat object on which you arrange them. So we lay out the palette on the palette!

21 Earth pigments

These are made from natural materials— finely ground coloured earths, minerals, semiprecious stones, plants and even beetles and crustaceans. These ancient pigments connect you directly to the old masters who used them. If you paint the natural world, it's enjoyable to use colours that are part of it. A proportion of earth colours in your palette helps keep your work grounded and 'real'.

Terre verte

Gold ochre

Yellow ochre

22 Mixing palettes

To a modern eye, a palette composed only of earth colours might seem dull, but one composed entirely of synthetics will tend toward gaudiness. Too many strong, vivid colours cancel each other out. It's a good recipe to offset the brightest accents of the pure chemical colours with the more sober richness of the earths.

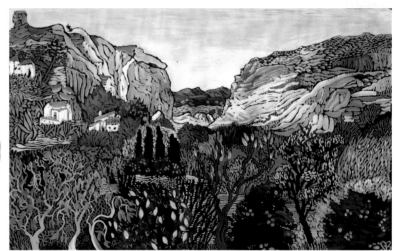

The palette chosen by the artist for this painting is predominantly earthy, accurately reflecting the colours of the rocks and soil.

23 Synthetic colours

These colours have a brilliance and lightfastness that earth colours can seldom match. If you paint the man-made world, these colours created by chemistry fit in perfectly. Nowadays all pigments have been significantly improved to ensure their permanence, so you can choose between them freely; all are intermixable.

Phthalo green

Deep violet

Magenta

24 Opaque and transparent

Some pigments are opaque and some transparent. If you're working in a watercolour technique, or need colours for fine glazing, select transparent ones; for greater coverage, choose opaque. Check the manufacturer's catalogue listing and write down the pigment code. Some pigments come in both varieties. Opaque colours can be thinned by adding glaze medium, though some clouding will remain. Transparent colours can be made more opaque by adding white or an opaque version of a similar hue. It's best to choose your paints according to the technique you're using. Check the Opaque/Transparent (O/T) column in the manufacturer's catalogue!

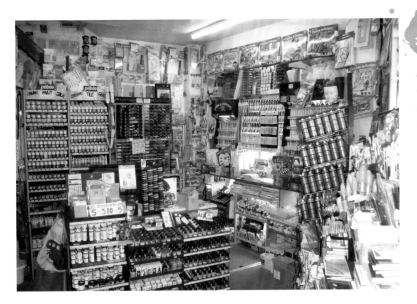

25

A treasure trove

The art shop is an Aladdin's cave, an exciting place in which to spend time – and money. Your local shop is a great resource not only for inspiring materials but also for expertise, advice, contacts and news. If you find the variety on offer bewildering, pick up some catalogues to study at home. Making a list will give you confidence to choose what's right for you.

26

Price and pigment

Another factor affecting price is the concentration of pigment: cheaper quality will contain more 'filler', so the tinting strength of the colour will be reduced. 'Hue' colours are often a good compromise (see *Economy tip*, below). All modern acrylic paint ranges from reputable manufacturers have good lightfastness – they won't fade or yellow – so your painting won't deteriorate over time. Always buy the best you can afford – basic or student ranges are really quite good – and upgrade later. Cheap, unbranded acrylics are more filler than pigment and a waste of time and money.

27

Understanding series numbers

The cost of colours relates to the pigments involved. The common pigments are series 1, while the rarest and most intense are series 4. Most of these are colours you would just use for special effects, so a small tube of, say, cobalt turquoise (4) will last for years, whereas a large yellow ochre (1) will cover a lot of canvas in many guises and be used up much more quickly.

28

Economy tip

Stretch your budget by buying paints labelled as 'hue'. These are virtually identical to the original colour but made with a synthetic or cheaper pigment. Lemon yellow and lemon yellow hue, for instance, are the same colour, but mixtures made with the hue are a little less intense. Upgrade the colours when you can afford to.

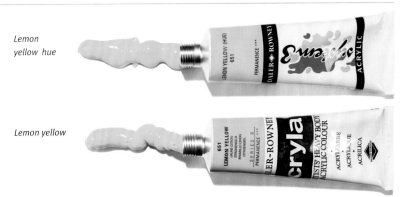

Lemon yellow hue

Lemon yellow

29

A good set of colours to get you started

Names may vary among manufacturers, but all of these are standard colours, available from any good art shop. Pigment codes remain the same, even when the names of colours change, so by referring to the given code (shown below in parentheses), you will be able to obtain the exact colour.

By combining the colour primaries listed below, you can mix virtually any hue. The colour square (right) shows the array of hues obtainable by mixing the various primaries; mixtures with white are on the diagonal.

1. Titanium white (PW6)

Three yellows:
2. Lemon yellow (PY3 or 35)
3. Cadmium yellow medium (NY24)
4. Yellow ochre (PY43)

Three reds:
5. Vermilion (PY108)
6. Red oxide/Mars red (PR101)
7. Alizarin crimson (PR 83)

Three blues:
8. Cerulean blue (PB35)
9. Cobalt blue (PB73)
10. Ultramarine blue (PB 29)

You'll also need Payne's grey (PB15) in lieu of black. This colour darkens without dirtying. Buy a soft-body or flow-formula version for easy mixing.

Colour mixes
By mixing primaries on the vertical column, with primaries on the horizontal row, you can make an almost infinite number of colours.

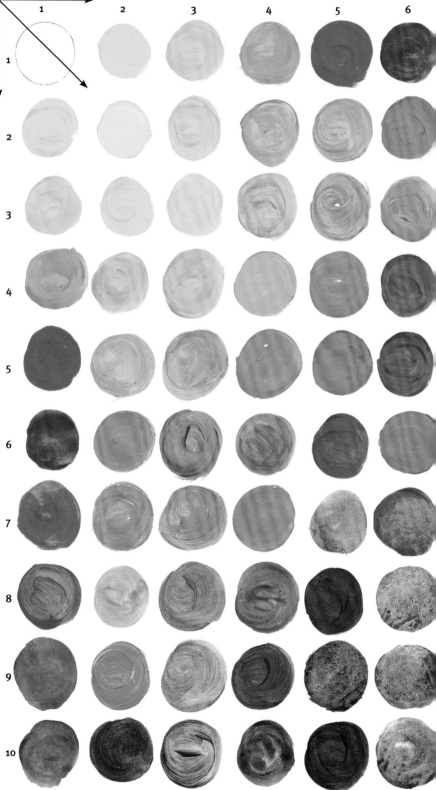

30

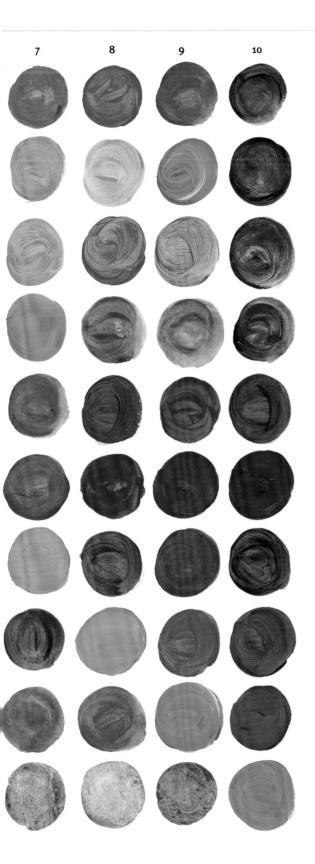

| 7 | 8 | 9 | 10 |

Secondary colours

In theory, you can mix every colour you want from the primaries, especially if you have several of each hue. In practice, it's tricky to have to recreate every mixture every time with perfect accuracy. It's much easier if you have some of the secondary colours ready-mixed, to give you a constant starting point. Also, these pigments give a vibrancy that no mixture can match. So treat yourself to a few tubes of these exciting, helpful colours. Having these secondary colours in your collection will help with speedy mixing of many clean, vibrant hues.

Starting with sap green as a base, a huge range of greens can be easily mixed.

Greens
• Sap green (PG12) is the perfect, sharp mid-tone green.
• Opaque chromium oxide green (PG17) is a duller green that creates subtler tones useful for oil-style landscapes.
• Hooker's green (PG8) is a clear dark green, easily lightened with lemon.
 With white, and/or various blues and yellows, these greens will give you an enormous range of clean, green tones.

Sap green

Orange
• Cadmium orange (PO20) is fiercer than any orange you can mix.

Cadmium orange

Purple
• Dioxazine purple (PV23) is transparent and very dark. It needs some white to reveal the colour. Alternatively glaze it over a white ground. This secondary is good for shadows. Mix it with cobalt blue for warm violet tones.

Dioxazine purple

31

Laying out your palette

It's easier to squeeze out a useful amount of each colour at the beginning of a painting session, to avoid the fussy business of constantly removing and replacing tube caps (see *Finding the perfect palette*, pages 14–15 for advice on types of palette). Most painters will position colours from light to dark, with white in the centre, as shown on the palette here. It helps if you develop a consistent pattern, so that when you're in the grip of inspiration you can find every colour almost without looking.

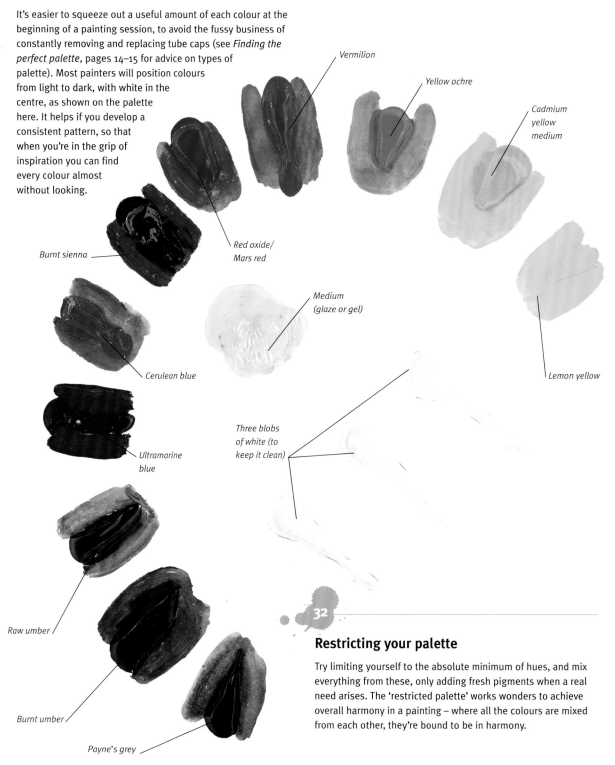

Vermilion

Yellow ochre

Cadmium yellow medium

Red oxide/ Mars red

Burnt sienna

Medium (glaze or gel)

Cerulean blue

Lemon yellow

Ultramarine blue

Three blobs of white (to keep it clean)

Raw umber

32

Restricting your palette

Try limiting yourself to the absolute minimum of hues, and mix everything from these, only adding fresh pigments when a real need arises. The 'restricted palette' works wonders to achieve overall harmony in a painting – where all the colours are mixed from each other, they're bound to be in harmony.

Burnt umber

Payne's grey

33

Earth colours

Every painter should explore earth colours: they will extend your range in many positive ways. Below you'll find a list of useful colours. These are common pigments, so code numbers are not necessary. The colour wheel opposite, shows these colours in their purest form (outer ring), then diluted with a little water (inner ring) and then diluted further (centre segments):
• Yellow ochre gives realistic, earthy greens when mixed with blue, and a lovely range of warm creams.

• Gold ochre is a transparent, warmer version, very useful for sunlit scenes and skin tones.
• Burnt sienna is a warm reddish brown, of transparent quality, and a wonderful mixer.
• Raw umber is seemingly nondescript, but one of the most useful pigments (see page 25).
• Burnt umber is a strong, dark brown that makes a useful base colour.
Other earth colours include indigo, sepia, and red oxide/Mars red.

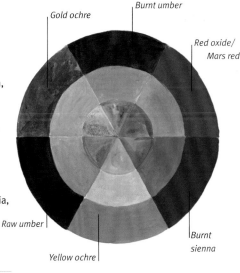

Gold ochre
Burnt umber
Red oxide/ Mars red
Raw umber
Yellow ochre
Burnt sienna

34

A very modern palette

Printing technology uses a four-colour process: cyan, magenta, yellow and black (CMYK). You can experiment with mixing all your colours from these – all are labelled as primaries – and white, of course. These hues add great versatility to any palette and will improve your understanding of how colour works.

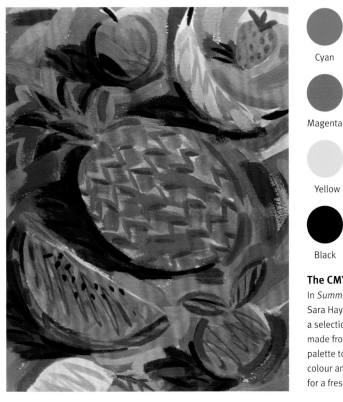

Cyan

Magenta

Yellow

Black

The CMYK mix
In *Summer Fruits*, Sara Hayward uses a selection of mixes made from a CMYK palette to explore colour and pattern, for a fresh result.

35

Colours to avoid

Some of the newer, chemical pigments are just too artificial. Many experienced painters avoid the phthalocyanine colours, which can give the work a peculiar 'fake' look, as can viridian. They also despise 'flesh colour' (or 'light portrait pink'). As if skin tones could just be squeezed from a tube! (See page 24 for more on mixing realistic flesh tones.) Similarly, anything with 'black' in the name will make mixtures look dirty. Ultramarine is a great blue, but makes dreadful khaki greens. Find out what doesn't work for you, and throw it away.

36

Realistic skin tones

As mentioned previously (see *Colours to avoid*, page 23), skin tones cannot be squeezed from a tube, instead they should be mixed. A good general palette for making skin tones should include:
• White
• Small amounts of burnt sienna and yellow ochre
• Burnt umber and Payne's grey to darken
• A very small amount of alizarin crimson or cadmium red for rosy tones
• Even less viridian and violet. The fashion for rainbow-faced portraits has passed.
There are an infinite number of possible skin tones. Some good mixes to get you started are shown right.

Pale skin

Burnt sienna *White*

Varying amounts of raw umber added to the basic pale skin mix above will produce a range of darker tones.

Add cadmium red to the basic pale skin mix for rosier complexions. Experiment with these mixes for lip tones, too.

Adding varying amounts of white to the above mix will enable you to create a huge range of even paler tones, great for adding highlights.

Mid-toned skin

Burnt umber *White*

For rich, warm mid-toned skin, add raw sienna to the basic burnt umber and white mix above.

For even warmer, rosier variations on the mid-tone skin mix, add a hint of pink, by mixing in some cadmium red.

Dark skin

Raw umber *White*

For a good dark skin base, mix raw umber with white. As above, mixing cadmium red to this base will provide you with a range of warmer tones.

For paler variations, and a number of highlighting tones, add varying amounts of white to the basic dark skin mix.

Dark skin

Dark skin often has more obvious highlights than light skin. The highlights on the nose and chin here would be much the same tone as the mid-tone on a pale skin.

37

Raw umber – the magic non-colour

	Base colour	plus raw umber	plus white	plus more white
Raw umber				
Ultramarine blue				
Sap green				
Yellow ochre				
Deep violet				
Red oxide/Mars red				

There are so many delicate, in-between tones in nature. What we call brown or grey for convenience covers a huge range of nameless shades. These can be mixed as tertiaries – any mix of the three primaries in different combinations – but as an effective shortcut for reliable easy-to-replicate results, just add some raw umber or white to the major hue.

Here you can see some of the possibilities. Adding white to your colour alters the hue, making it a paler pastel. By adding only a small amount of raw umber to any hue, you can 'knock it back' or reduce its intensity or saturation, making it optically paler without having to add white.

Raw umber plus white added to any pigment will produce soft silvery tones. Try these for undersides of clouds where they reflect the land beneath.

38

Golden rule of mixing colours

Always add dark to light. Start with a good quantity of your paler colour (say white or yellow) and add very small amounts of the darker hue, which will have greater tinting power. Increase gradually until you reach the desired shade. To mix orange, for instance, takes very little red – but if you started with red, you would need a bucketful of yellow to dilute it.

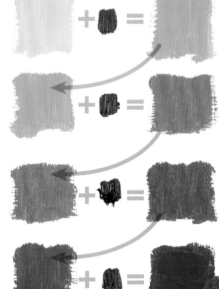

Lots of pale base colour *plus a touch of dark* *changes the tone gradually*

39

Be adventurous

Using a pre-packaged, ready-made set of colours can really spoil the fun of getting to know your paints as individuals. If you have such a set, add some extra primaries and watch your versatility rocket. And throw away the black!

Cerulean is a cool, airy blue, good for mixing paler tones.

Use permanent rose to add rosy pink tones to your mix.

Lemon yellow adds freshness and zing to any mixture.

40

Black is a colour, too

A rich, lively, chromatic (that is, colourful) black can be mixed from any dark blue – ultramarine or Prussian – with burnt umber or sienna and a little red, such as alizarin crimson. In various proportions, this mix will give you a range of colours you can use without deadening adjacent colours or appearing to make 'holes' in the painting.

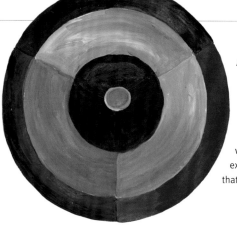

A range of greys

By varying the proportions of the basic brown, blue and red combinations, plus white, many rich and subtle 'greys' can be mixed, as shown in this colour wheel. Spend some time experimenting, and you'll soon see that the possibilities are endless.

Chromatic blacks

Here are some mixes for a range of colourful or chromatic blacks:

Utramarine blue + burnt umber + alizarin crimson, followed by the resulting 'black'. The mix is then made paler by adding white.

Dioxazine purple + burnt sienna to create chromatic black number two. This is made paler by adding white to the mix.

Hooker's green + cadmium red for another variation. Again the resulting mix is made paler by adding white.

41

Five pointers for using white

White puts light into all the others. Follow these pointers and explore its facets:
1. White in a mixture reduces the saturation – the vibrancy – of the hue. Too much white overall, too many very light tones, leads to blandness.
2. Save pure white for only the very highest highlights. It's like the top note on the piano – there's nowhere higher to go.
3. Adding white makes the colour opaque. If you want to lighten the colour while keeping its transparency, underpaint the area in white and glaze the pure colour on top. Watercolour techniques, where all colours are transparent, use the white of the paper for this purpose.
4. 'White' things are seldom white. They all contain some reflected colour, very pale tones of the surrounding objects.
5. You can't use white to lighten red. Pink is a different colour! Use lemon yellow instead, starting with the yellow and adding red gradually.

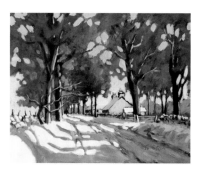

The snow here has a slight pinkish tinge, since it reflects some colour from the setting sun, and the shadows are a warm purple.

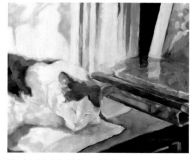

The highlights of the cat's fur are nowhere near pure white, and the mid-toned shadows are blue-green.

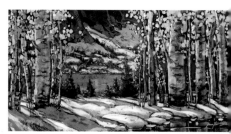

In this snowy landscape, the sun is very low, and the colours muted, but because of the contrast with the shadows, the snow still reads as white.

42

Developing a personal palette

Eventually you'll find you have favourite hues – tubes you reach for often, while others remain unused. Put those unused ones away, and develop your affinity with your own personal palette. This is how an individual style emerges, so go with the colours you like and explore as far as you dare.

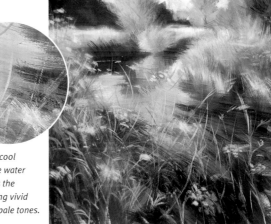

The calm, cool blue of the water intensifies the surrounding vivid hues and pale tones.

▲ The colours, although drawn from the local landscape, are heightened in accordance with the artist's own preferred palette, which is distinctive and easily recognizable.

The luminosity of the moonlit water is conveyed by placing many small brushstrokes of skilfully variegated colours together.

◄ Here, an idiosyncratic palette builds mood and atmosphere, playing with subtle variations within a small range of colours, expressing a unique painterly personality.

► Although the colours are largely naturalistic, expressing the artist's interest in painting the world 'as it is', the obvious simplification and the bold treatment and careful balance of tones and shapes give an insight into the person behind the picture.

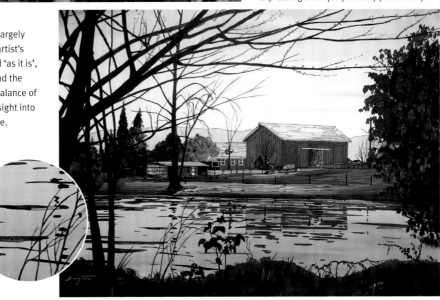

High contrast and simple shapes create vivid patterning in the mirror like water.

Brushes for acrylics

Painting isn't just art, it's also a manual activity – a craft – and brushes are the tools. In theory you can use almost anything – feathers, rags, toothbrushes, fingers, even sticks of celery – to transfer paint onto canvas.

But if you never learn to handle a real paintbrush properly, you'll miss out on the most satisfying painterly experience there is. The right brush, properly used, will do most of the work for you.

Stroke the brush.

43 Brush types

White nylon filbert brush

White nylon priming brush

Hog's hair flat brush

Brushes can be made from all sorts of hair. By far the best for acrylics are the new synthetics – look for white nylon. It keeps its spring well, carries plenty of paint, washes out easily and doesn't rot. Brushes made from natural sable and squirrel hair are good for delicate work with thin paint, such as watercolour washes. Hog bristle is coarse and more inaccurate but perfect for applying thick, sticky paint and impasto work, where boldness is the aim.

44 How to load a brush with paint

Stroke the brush through the paint, turning it as you go. Never jab or stab into the paint – you'll splay the hairs and permanently ruin the tip.

Don't scrub into the paint.

45 Brush shapes

These are the basic shapes of brushes, and they are all useful. You can never have too many brushes. Flat, filbert and chisel brushes can make thick or thin marks: use the edges as well as the face. Riggers are intended for painting thin lines (for instance ships' rigging) and should be loaded with enough paint to complete the line. Chisel-ended brushes (also called 'sign-writer's pencils') have amazing versatility and paint-carrying capacity – these will develop your brushmanship like no others. The one-stroke brush was also originally developed for signwriting and has the same 'italic nib' properties.

Range of brushes:
1 Soft wash brush
2 Small soft brush
3 White nylon point
4 One-stroke brush
5 White nylon flat
6 Chisel brush
7 Sable point
8 Rigger
9 Fan
10 Scrubber
11 Toothbrush for spattering

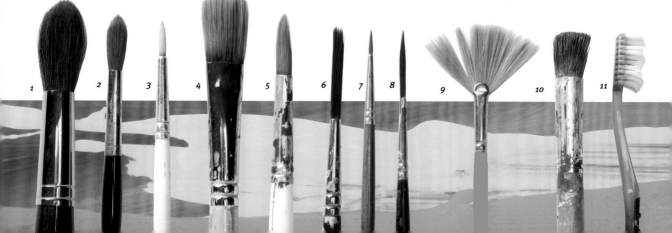

46

How to hold the brush

To control a brushstroke, move your wrist rather than your fingers. For even greater control, rest the side of your brush hand on your other hand (protect your work by putting a sheet of paper under your resting hand if necessary).

Support the brush hand on the fist of your other hand, which rests on the painting surface.

To get close to a detail, create a bridge around the area with the fingers of your free hand.

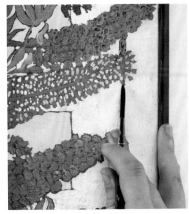

To paint a straight line, use the painting edge as a guide, and run your little finger down it as you paint.

47

Brushes on the move

If painting on location, don't trust your brushes to a plastic bag. It is so easy to make a roll-up brush holder: Cut a square of felt large enough to take your longest brush, then stitch a strip 2.5 cm (1-in.) wide across the centre. Stitch down the strip at intervals to accommodate the different size brushes in your collection.

A brush roll is the best way to store brushes on the move.

48

Storing brushes

Brushes for daily use should be stored upright in a jug or a jar, with heads upward. For longer-term storage, put your brushes in an airtight container to keep out moths and woodlice that love to eat brush hairs! Unless they are nylon, shape the hairs with a little petroleum jelly; this will prevent deterioration and can be easily washed out with soapy water later.

Brushes are easily visible and accessible when stored head-up in a pot or jar.

49

Cleaning brushes

Acrylics can and will destroy brushes permanently if paint is left to dry on them. Observe these points and your expensive brushes will serve you well:

1. Never leave a brush unrinsed, even just to make coffee or answer the phone. A brush forgotten is a brush destroyed.

2. While you are working, it's crucial to rinse brushes often in a large jar of water – don't be mean! – and change it often.

3. Leaving brushes lying in a tray of water, as sometimes suggested, will quickly rot the handles.

4. Work any remaining paint out of the ferrule with your fingernails.

5. At the end of the day, clean all the brushes you've used thoroughly with warm water and a little liquid detergent. Washing with very hot water will loosen the bristles.

6. Dry by gently stroking the brush head on a soft cloth; excess water will splay the hairs.

7. Never, never, never leave brushes resting on their points!

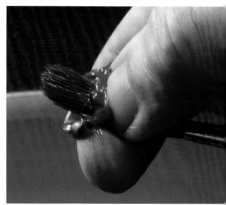

Don't use a scraper to remove paint; it will break the hairs. Using finger and thumb, as shown above, will prolong the life of your brushes.

50

Don't flood it!

To prevent a freshly rinsed, waterlogged brush flooding the palette, keep a blotter beside the water jar. A folded-up soft cotton rag or an old phone directory works well. Get in the habit of stroking the brush dry after rinsing; this also helps keep the point in good shape.

51

Brushes don't last forever

Naturally, your favourite brushes will wear out through sheer friction, however well you look after them. Recognize when they cease to make the marks you want, and replace them. Buying brushes isn't a single outlay, but an ongoing expense. Demote worn-out brushes to other jobs; a jar full of these randomly shaped mark-makers is a useful asset.

▸ FIX IT ▸

With gum arabic

Brush heads that have lost their shape can sometimes be rescued by reshaping the bristles with gum arabic or wallpaper paste. Dilute to a thick paste, coat the hairs, then squeeze into the original point. Leave for a week or so before washing out. Soaking in fabric conditioner may also serve the same purpose.

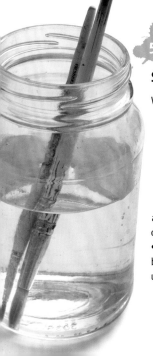

52

Scrubbers, splitters, stipplers

Worn-out brushes can be reincarnated for a number of new uses:

• Scrubbers are usually hog's hair, and invaluable for scumbling or scrubbing colour into canvas roughly, underpainting, or for special effects.

• Splitters are pointed brushes where the single point has separated into two or more. Use these for parallel stripes (grass blades, telephone wires, and so on) and also to create patterns of dots.

• Stipplers are usually fatter brushes with separated hairs used end-on.

Tired brushes with splayed bristles can be used to make a variety of marks.

TRY IT ▶
Make some cuts

Don't be afraid of making surgical alterations to your old brushes to make them do what you want. For example, cutting the hairs off close to the ferrule will provide you with a good dot-painting tool.

53

Keep your brush at arm's length

A painting can be essentially a beautiful picture but may be ruined by poor execution – lots of timid little dabs of the same size and direction, instead of proper, bold brushwork. Painting is a physical activity, so get physical! Painting at arm's length with a long-handled, bigger brush (try taping a bamboo cane to the handle) will give you the same perspective as the viewer, who sees the work as a whole, not the parts. Your arm movements will be freed up; working from the shoulder instead of the wrist adds rhythm and curvaceousness to your brushwork.

54

Deviate from the norm

There are numerous ways of making marks without using conventional brushes. Unconventional brushes include badger-hair shaving brushes, useful for blending; toothbrushes, for spraying speckles; make-up brushes for watercolour washes; and various stiff-bristled brushes for pattern making. Anything that will transfer paint onto canvas, in fact. Feathers, fingers of course, twigs, plant stems, celery … the list is endless. Feel free to use your ingenuity.

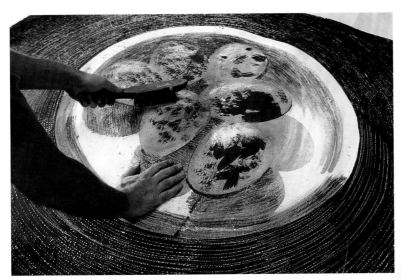

Removing paint is another way to make marks. Here a decorator's wire brush is worked across the surface of the canvas to produce a series of scratch marks.

55

Calligraphic brushwork

The secret of making beautiful brush marks is to remember that pressure alters width. Your brush hand must be free to move in and out as well as sideways, and up and down. Support your wrist or elbow by using your other hand as a pivot. The way you lift the brush off is crucial to the neatness and grace of the stroke. As with so many things, this is a skill that comes with practice—so practise!

For soft, fluid marks, you will need a soft sable or synthetic brush that comes to a good point.

ARTIST AT WORK

Brushwork

Remember that you can use many different shapes and sizes of brush, as well as those not specifically designed for acrylic work. Here the artist uses household brushes to capture the light and movement of the scene in a free and dynamic way. Economy of means is the key to the painting's success, and wet-in-wet techniques combined with the broad brushstrokes allow him to go with the flow of what the paint wants to do, rather than working to pre-drawn outlines.

Palette

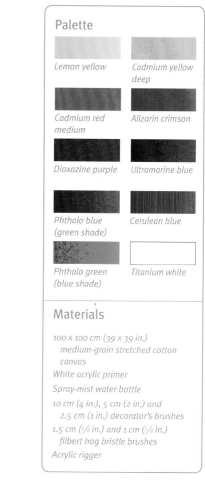

Lemon yellow

Cadmium yellow deep

Cadmium red medium

Alizarin crimson

Dioxazine purple

Ultramarine blue

Phthalo blue (green shade)

Cerulean blue

Phthalo green (blue shade)

Titanium white

Materials

100 x 100 cm (39 x 39 in.) medium-grain stretched cotton canvas
White acrylic primer
Spray-mist water bottle
10 cm (4 in.), 5 cm (2 in.) and 2.5 cm (1 in.) decorator's brushes
1.5 cm (⅝ in.) and 1 cm (⅜ in.) filbert hog bristle brushes
Acrylic rigger

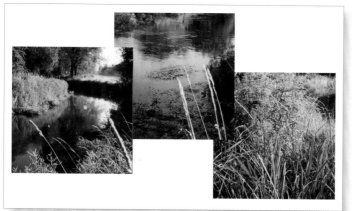

The centre image sums up the mood of the river, while the others provide ideas for foliage.

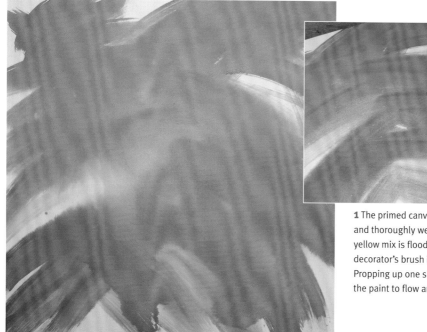

1 The primed canvas (three coats) is laid flat on the floor and thoroughly wetted. A transparent cadmium red and yellow mix is flooded rapidly onto the surface as a large decorator's brush is used to establish the main shapes. Propping up one side of the canvas with wedges allows the paint to flow and diffuse in controlled directions.

56

Working from memory

It isn't always necessary to start with a drawing if you are painting a subject you have closely observed over time. The major shapes and colour relationships will be present in your mind. Trust yourself to rediscover them on the canvas. This truly painterly approach makes the painting process a real voyage of discovery. It's creation, not copying.

2 After drying out thoroughly, the canvas is rewetted. A wash of alizarin crimson is laid down, developing the forms. Working with a spray in one hand and brush in the other infuses energy and movement into the painting.

57

Using big brushes

Bigger brushes call for a bigger palette – a sheet of glass is ideal. Occasionally spray the paint lightly with water to keep it workable and cover with jam-jar lids between sessions. Don't take up too much paint at a time, otherwise you'll have clean-up problems and waste a lot of paint. Just loading the tips of the hairs is usually enough.

58

Warm grounds

Try using a warm ground when painting cool subjects such as rivers, the sea, or winter scenes. Reds and yellows underneath the cold blues, violets and greens of the subject will subtly filter through so that, however chilly the subject, the painting never looks uncomfortably cold.

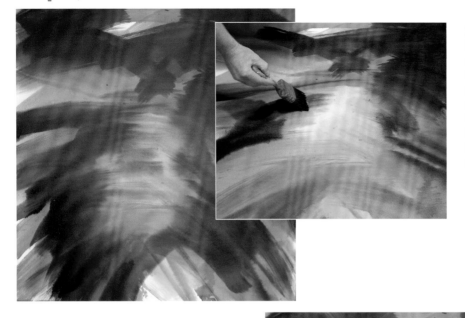

3 A transparent mix of phthalo blue and dioxazine purple is used to lay in the shapes of the dark trees at the top of the painting. The broad brush marks in the lower sections of the painting suggest the river flow and the shapes of the foreground grasses. The result is multilayered.

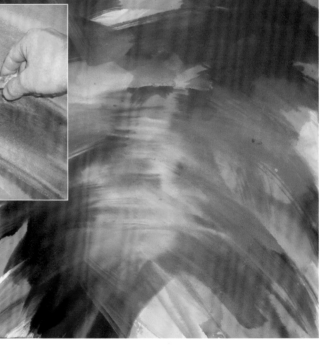

4 To provide a good base for the bankside reeds and grasses, more transparent layers (a cadmium and lemon yellow mix) are added, and opaque paint is worked into the wet surface, producing distinct brush marks. These soften and partially merge into the surrounding paint layer.

59

Colour mixing

Try not to mix colours too thoroughly. Loosely swirled together, two hues will increase each other's vibrancy and add to the subtlety of the result.

60

Textural brushes

Old brushes, worn and frayed, are ideal for making sweeping, naturalistic marks. Or create your own by giving an abandoned household brush a ragged haircut.

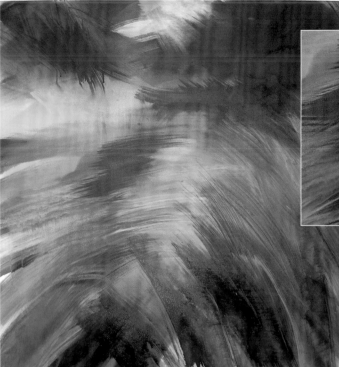

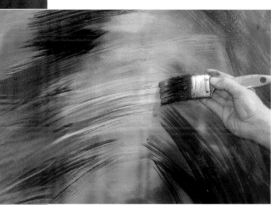

5 When thoroughly dry, the painting is hung on the wall so the composition can be assessed. Now increasingly thick paint and smaller brushes produce marks that capture the energetic movement of the arm and hand. The darks are deepened, and the river's flow developed using cerulean blue with white.

6 Vertical strokes drag paint from the far bank down into the water, creating reflections. The 'broken' brush marks skip over the colours below, giving a sense of the transparency of the water. Tints of blue show the strong tonal contrasts and bright reflections of the sky as the river approaches the bend. Layers of feathery brush marks begin to suggest the profusion of grasses on the bank.

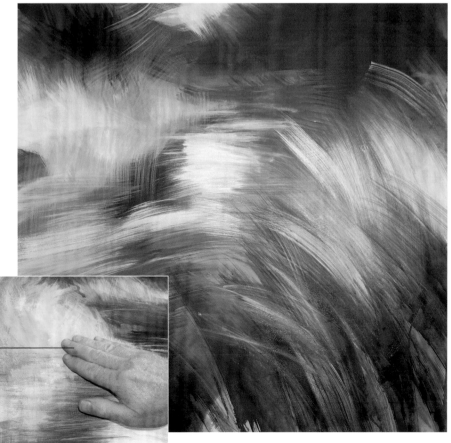

Some blending can be done with your fingertips.

7 Still using decorator's brushes, pattern and texture in riverbank, water and tree are developed further. Filbert bristle brushes are used for more specific marks. It's important to keep focusing on the image as a whole by standing back frequently or checking it in a mirror.

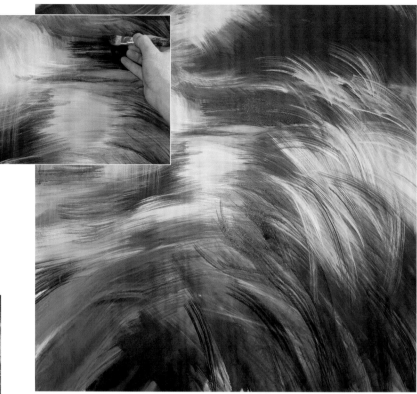

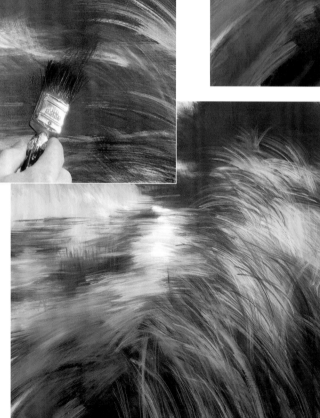

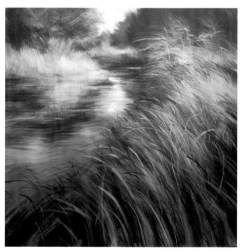

9 An acrylic rigger makes individual, fine strokes for grasses and marks in the water, enhancing the sense of breezy movement. Darks are deepened and highlights added, increasing the aerial perspective through the sharp foreground detail and hazy blue shape of the distant woodland.

8 Subtle adjustments are made to the balance of tones and colours by lightly brushing thin, transparent paint here and there to soften and reduce the intensity of some colours. To avoid overworking the image, the painting is left for a week or two.

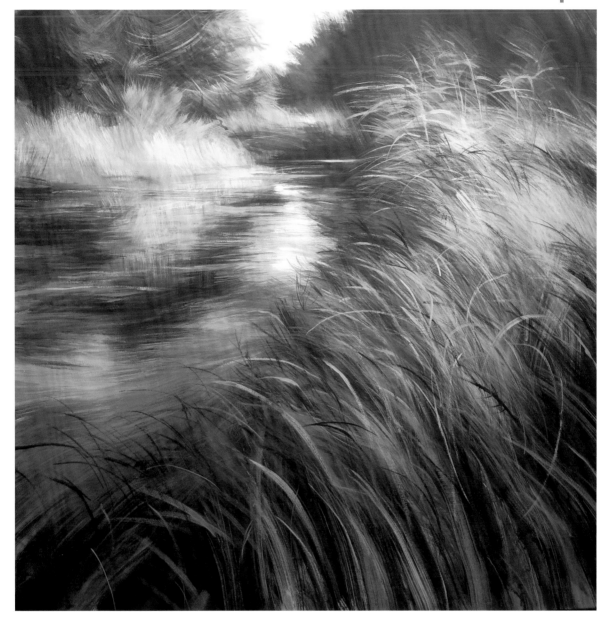

Fipenda (River Wylye, South Wiltshire)
(Acrylics on 100 x 100 cm [39 x 39 in.] medium-grain stretched cotton canvas)

Nick Andrew

61

Lifting off

To create misty distance effects and the sheen of foliage or wet surfaces, remove some paint. You can modify thin layers of dried paint by scrubbing with a stiff, wet brush or gently rubbing with sandpaper. Sometimes a damp finger is enough to lighten and soften the paint if it's not completely dry. Blot off with a sponge, since paper might stick.

Painting knives, shapers and sponges

The versatility of acrylic paint means it can be applied in a variety of ways, depending on the effects you want to create. As well as the numerous types of synthetic- and natural-fibre brushes available, there are many other paint shapers, knives and sponges to suit the way you work and your choice of subject. You could also consider using more unusual implements to transfer your paint: keep your eyes open, and remember experimentation is key.

Mixing with knives

When working with thick paint, mix the paint on the palette using a knife – thick acrylic paint will clog brush bristles very quickly.

62

Palette knives

Palette knives are essentially used for mixing paint and additives on the palette and for scraping up and cleaning away unwanted paint after a work session. In other words, they are not to be used for putting paint onto your support. The knives are typically made from stainless steel, although plastic knives specially made for acrylics are also available. These are cheaper, but more difficult to clean than steel blades.

63

Painting knives

With their flexible, shaped blades, the painting knife is the tool to choose if you like to work with something firm and decisive. More tactile than a brush, and more akin to sculpting paint than conventional brushwork, these knives are used to apply thick, textured wedges of acrylic paint to the destined support, so you will need to be working with heavy-body acrylics, probably bulked out and reinforced with some sort of impasto or texture medium, such as modelling paste. This will enable the knife to create three-dimensional effects. Like palette knives, the blades of these knives are typically made from stainless steel and come in a variety of shapes and sizes, each making their own unique marks. The blades are also cranked – this places them away from the handle and ensures the hand stays free of the paintwork.

Painting tools:
1 *Small painting knife*
2 *Larger painting knife*
3 *Palette knife*
4 *Painting knife making mark*
5 *Paint shaper*
6 *Natural sponge*
7 *Strip of thick card*

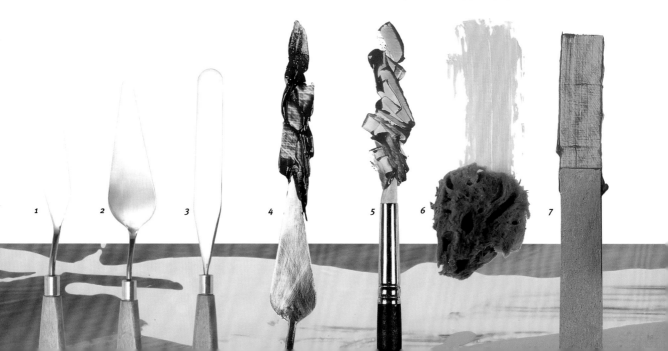

1 2 3 4 5 6 7

Paint shapers

Paint shapers are a relatively new innovation. They resemble brushes but have a shaped silicone-rubber tip, which can be soft or firm, and they are inexpensive, easy to clean and durable. These rubber-tipped sticks are designed to push the paint around, most usefully with thick impasto. They are great for making repeat patterns, so can almost be used like printing tools and are exceptionally good for applying textural marks to wet paint. They are also great fun to use.

The possibilities are endless

Paint can also be applied using rollers, bits of wood and card, rags, paper towels, household implements, celery sticks, toothbrushes and your fingers; indeed, the only restriction is your own imagination.

All sorts and shapes of natural objects can be used to make marks when loaded with paint.

Round, flat, chiselled, or with an angled end, paint shapers can be used to make a variety of distinctive marks.

Sponges

Synthetic or natural sponges can be used to make a variety of effects with either thick or thin paint. Dip them in paint and use them to cover areas with mottled, dappled, or textured colour. Complex areas of colour can be built up when working wet on dry.

Sponges of various shapes and sizes can be used to create different effects, with different viscosities, but work best with fluid paint.

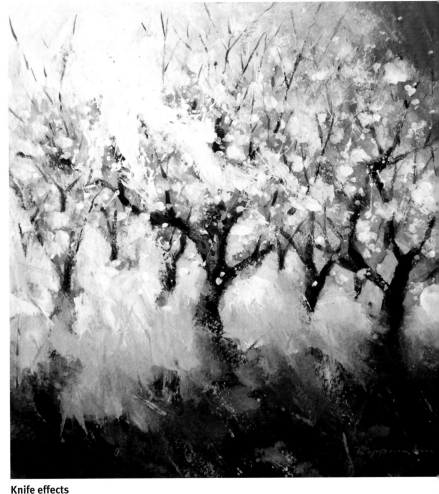

Knife effects
In the hand of an experienced painter, the knife produces marks of astonishing variety, vigour, and precision, as shown above in *Light Through Apple Blossom*, by Stephen Rippington.

Types of support

Before you can start to paint, you need something to paint on. Acrylic can be painted on a number of surfaces; traditionally paper, wooden boards and canvas are the main surfaces used. Hard or soft surfaces change how the paint behaves and how it responds to the brush, so choosing the right surface for your intentions can be crucial to your enjoyment of the process ahead. Here you'll find a guide to various easy-to-obtain supports; choose whichever seems best for your technique.

> ### ◖ EXPLAINER
>
> 'Canvas' is both a general name for types of textile that can be painted onto and a commonly used term for the object that is being painted.
>
> 'Support' is a more technical term, but explains the function nicely: to support and consolidate the assemblage of fragile paint into a strong, unified whole.

67 Types of canvas

Linen, cotton calico, sailcloth and hemp cloth are all suitable. There is no need to buy large rolls: your local fabric shop will have a good range for sale by the metre. Unbleached and unprinted lining materials, burlap, or anything fairly strong and with the tooth you fancy, will do. A minimum weight of 380 gsm (12 oz. per sq. yd.) is recommended. Some of Van Gogh's greatest work was painted on old potato sacks. If you are buying canvas on the roll, as opposed to a ready-made canvas, it will need stretching. For more on how to do this, see page 42.

68 Tooth

This describes the roughness or smoothness of the surface. Particularly with thick paint, you need enough tooth – enough friction – to grip it and drag it off the brush. A coarse tooth will suit vigorous brushwork; a smoother finish is better for fine detail.

Smooth-tooth canvas

Rough-tooth canvas

69 Buying ready-made canvases

Made-up canvases can save time if not money, and if you're short of workspace to make your own, they're very handy. However, the quality varies wildly. Beware! It's wise to buy your ready-made canvases from a reputable art supplier. Buy the thicker 'box' canvases; although they are more expensive, they don't warp and may not need framing either. Canvases that won't be framed should have plain sides without nails or support.

70 Canvas boards

Canvas boards are those painting boards either covered in fabric or simulated canvas grain, and then primed. They are highly suitable for acrylic paint, unless they have been primed with oil. Check with your supplier before purchasing a ready-made canvas board, or try making your own (see *Marouflage*, page 43).

Paint behaves differently on linen than on cotton canvas.

Ready-made canvas

Canvas board

Some more hard supports

There are many sheet materials available from hardware shops, that are more or less suitable to paint on with acrylics. These include:

• Hardboard: You can cut it to whatever size you like. One side is slick, the other excessively toothed. It's inexpensive but can be prone to flaking.

• Masonite: Available in varying thicknesses, masonite is great to use; easy to cut, doesn't splinter and is extremely smooth.

• Chipboard: Only for masochists – it has a rough, flaky texture.

• Cardboard: Sealed with quick-dry varnish; this is a useful support for off-the-cuff work.

• Plasterboard: Highly alkaline; reacts with paint; crumbles. Don't even consider!

• Plywood: Smooth yet with a bit of tooth and very stable, plywood is a durable support with many advantages (see *In praise of plywood*, page 43).

• Perspex, tin, glass and glazed crockery are unsuitable for acrylics, being non-porous, although keying with sandpaper and adding quick-dry varnish can improve grip.

Plywood

Masonite

Painting on paper

There's an art to picking the paper that best suits your intentions; learn by experience.

Thickness is measured by weight in grams per square metre (gsm) (or in pounds per 500 sheets). Thicker paper tends to work better with acrylics.

There are many types of heavy paper available in ring-bound blocks that are perfectly suitable for acrylics. As there are so many brands and qualities available, only experimentation will tell you exactly how each will behave. Use the top page as a tester: check, for instance, whether the paper buckles

after the paint dries. If it does, it will need stretching before use (see page 42). Here are the basics:

• Cheap paper is a false economy. Always buy acid-free.

• 'Rough' paper gives great texture and absorbency – but sometimes may be too much. It's good for dry brushwork (see page 149).

• Cold-pressed paper is the same as 'not', (that is 'not pressed'). It's a little rough and absorbent and usually a good choice.

•Hot-pressed paper is smooth and less absorbent, giving brighter colour. It's better for precision work. For washes,

use flow improver.

• If the paper is too absorbent for your purpose, prime it or seal with a medium or varnish. Many beautiful coloured papers, such as Ingres (intended for oil pastels), can be adapted in this way for use with acrylics.

• Mountboard is an excellent alternative to paper. Buy large sheets from your local art shop and cut these up, or ask your framer for offcuts.

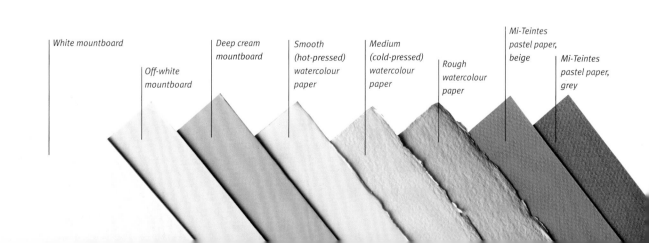

White mountboard

Off-white mountboard

Deep cream mountboard

Smooth (hot-pressed) watercolour paper

Medium (cold-pressed) watercolour paper

Rough watercolour paper

Mi-Teintes pastel paper, beige

Mi-Teintes pastel paper, grey

Making your own supports

Many painters feel that preparing their own supports is all part of the craft, and it helps vary the activity – a bit of hammering is a great antidote to days spent painting pernickety details. You can make supports to the exact size and proportion you need. Invest in a few simple tools and you'll save a fortune and get a lot of professional satisfaction, too.

73

Stretching canvas

Stretchers can be bought in pairs with ready-cut joints that slot together to make canvases of every size. Large ones need crossbars as well. Knock them together and check your square by measuring the diagonals: they should match exactly.

Materials
Stretcher frame, canvas
Tools
Scissors, staple gun, light hammer, pliers (optional)

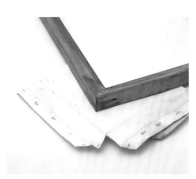

1 Lay the frame on the rolled-out canvas on a flat, clean surface. The bevelled side must face the canvas.

2 Cut all around the frame, allowing for a good overlap.

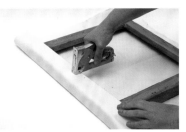

3 Starting in the middle of one side, fold the canvas over and staple to the frame.

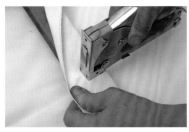

4 Repeat on the opposite side in the centre, pulling the canvas very tight while ensuring the weave is running straight across.

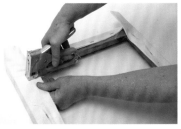

5 Tugging the canvas to keep it taut, staple again either side of the existing staples.

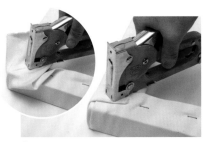

6 Repeat on the first side, and the other two sides, working toward the corners. Fold the corners in and staple.

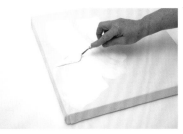

7 Hammer the staples flat and tap the wedges in. Don't overtighten; priming will take up some of the slack.

74

Spring

A well-stretched canvas has a certain bounce to it. When the paint is applied, the canvas gives a little and seems to respond to the energy of the work. Adjust the spring by slightly tightening or loosening the wedges in the corners.

75

Marouflage

This is an excellent way to combine the tooth of canvas with the strength of a hard support. It's quick and easy – just follow the steps shown here. You'll need a sheet of Masonite or fibreboard, a sheet of canvas, a pair of scissors, matte medium and a stiff bristle brush. Alternatively you can buy many grades of canvas board ready-made.

1 Place your chosen board on top of your sheet of canvas. Cut the canvas all around so it is slightly larger than the board it will cover. Using a stiff bristle brush, cover the board liberally with matte medium. Place the canvas over the board and cover with more matte medium to secure it to the board.

2 While the panel is still wet, turn over and place it face down onto an easily cleaned, non-absorbent work surface. Cut across the corners of the canvas and fold in neatly. Secure the edges with more matte medium. Once dry, prime the board with acrylic gesso primer. When dry, your board is ready.

76

In praise of plywood

Nowadays most do-it-youself outlets sell plywood in smaller pieces, rather than the huge sheets that used to put off many painters using this excellent material. Plywood is highly suitable for acrylics, particularly heavy impasto work for which canvas may just not be strong enough –

4 mm (³/₁₆ in.) ply is fine; use 6 mm (¹/₄ in.) for large areas, since it stays flat better. You can simply paint on a primed piece of ply to frame conventionally, or construct a proper wood panel, as shown in the step-by-step sequence below.

Materials

Sheet 4 mm (³/₁₆ in.) marine or birch plywood, 5 x 2.5 cm (2 x 1 in.) planed batten, wood glue

Tools

Measuring tape, steel straightedge, pencil, T-square, craft knife with new blade, medium-grit sandpaper, glove, mitre saw

1 Mark the size you want onto the plywood and check corners are square with a T-square and by measuring diagonals. Using a straight edge and sharp craft knife, cut through.

2 Plywood splinters can be nasty. Wear a glove while you sand the edges smooth.

3 Place each batten on the plywood and mark the lengths accurately by eye.

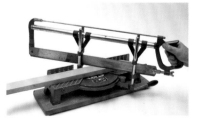

4 Using the mitre saw, cut battens to fit the back of the plywood panel.

5 Glue in position, making sure edges are exactly flush. Put weights on the corners or use G-clamps to prevent slippage. Wipe off any excess glue before it sets.

6 Sand the front and edges, and then prime. (For instructions on simple stylish framing for wood panels, see page 168.)

Priming and coloured grounds

Primer forms the vital bond between the support and your painting. All absorbent surfaces need to be sealed. Without this treatment, your work will sink feebly into the surface, or just fall off, but with a few coats of primer properly applied the support is transformed, and the painting given more body and visibly improved quality. Do your work a big favour by priming it well. At the same time you can create coloured grounds to get the painting off to a promising start.

77 Quick-dry primer

Available from all hardware shops, this is simply white acrylic paint with plenty of body, or 'clagg' as some call it. Primer dries very quickly, and many coats can be built up in a short time. It primes all surfaces excellently. On hard surfaces, the first coat should be thinned 10 per cent with water to improve absorption. Then build up to the texture required, crisscrossing coats, and sanding lightly if necessary. The less sanding, the more tooth. On canvas, a first coat of gesso will seal the weave and can be followed by quick-dry primer. This system is ideal if you wish to take the canvas off the stretcher later to roll it up, since it will prevent it from cracking.

78 Gesso

Acrylic gesso is a thick, flexible priming paste designed to fill the holes in the weave of canvas. Use it if your canvas is coarse, or if normal quick-dry primer sinks through it. Just follow the instructions on the jar! However, make sure it's acrylic gesso. The other kind is basically plaster of paris and brittle. Gesso can also be used to build up a mirror-smooth surface for fine detailed work, if that's what your work requires.

Gesso gives a very thick, quick priming coat and helps keep the canvas taut.

79 Priming with gel medium

If you are working on a beautiful natural ground, such as handmade paper or linen, you may want to prime it without losing the original colour. Use gel medium thinned 20 per cent with water and/or quick-dry varnish to seal without obscuring the surface.

Prime handmade or coloured papers with gel medium or quick-dry varnish to seal the surface and preserve the colour.

Quick-dry primer has so many uses. It fills and smooths the weave of canvas or grain of wood, bonding the support and paint strongly together.

80

Preparing coloured grounds

This is a wonderful way to start a painting. Although it's possible to rub or scumble neat colour into a primed white ground, this can give a streaky effect. It often works better to give the whole canvas a coat of well-mixed flat colour. By mixing your chosen tint into a quantity of quick-dry white primer, you can produce an opaque coat that gives the painting an even base to start from.

Quick-dry (water-based) blackboard paint is a useful additive for large areas of darker tones, or if you like to work on a black background. A coat of quick-dry satin varnish will reduce absorbency of the primer coats and make the colour flow more smoothly.

1 Squeeze a small amount of acrylic paint in your chosen colour onto a plate or palette and mix it with a brush loaded with a generous amount of water. For a more fluid consistency, you may need to add more water to enable the paint to spread easily over the paper surface.

2 Using a brush, spread the paint over the paper, adding more water to the palette if necessary. Be sure to work quickly – if the paint starts to dry, hard edges will begin to occur.

3 As you are painting, you will notice the brush marks are apparent. These can be either left as they are or smoothed out (as shown in step 4) if they are too dominant.

4 While the paint is still wet, use a damp rag to spread the paint further to the edges of your paper and smooth out some of the brush marks. Once dry, your paper is ready to work on.

81

Multicoloured grounds

The usual choice for a coloured ground is a neutral brown or grey, but for a more striking result, try working on a multicoloured one. Here the artist has worked on a blue and purple base.

The blue and purple undercolours make it easy to be bold with the darkest tones. Here pure black is used over the base (above). Yellow is used for the reflections (left). Black paint is then applied thinly as a transparent glaze, allowing some of the previously laid ground colour to show through.

82

Seal it

If your paint seems to be being sucked away, sinking into the surface beneath, your support isn't sufficiently sealed for the paint to ride upon. If it's too late for more primer, give it a coat of quick-dry varnish to help solve the problem.

ARTIST AT WORK
Working on a coloured ground

Starting from a black background, the landscape painting below is worked from dark to light with broken brushwork. The artist uses the underlying colour contrasts and the black ground itself in a controlled way to give definition and depth to the image. A distant village is added to provide a human presence and a focal point, and the sky is lightened to give a realistic early-morning atmosphere.

Palette

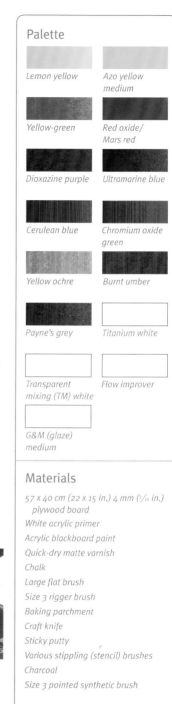

Lemon yellow	Azo yellow medium
Yellow-green	Red oxide/ Mars red
Dioxazine purple	Ultramarine blue
Cerulean blue	Chromium oxide green
Yellow ochre	Burnt umber
Payne's grey	Titanium white
Transparent mixing (TM) white	Flow improver
G&M (glaze) medium	

Materials

57 x 40 cm (22 x 15 in.) 4 mm (³/₁₆ in.) plywood board
White acrylic primer
Acrylic blackboard paint
Quick-dry matte varnish
Chalk
Large flat brush
Size 3 rigger brush
Baking parchment
Craft knife
Sticky putty
Various stippling (stencil) brushes
Charcoal
Size 3 pointed synthetic brush

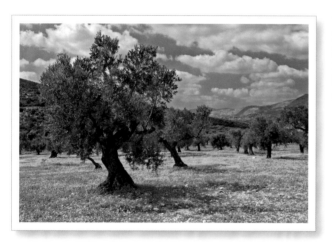

The sky is perhaps too busy for a painting, and the tree lacks definition, but all the elements are there.

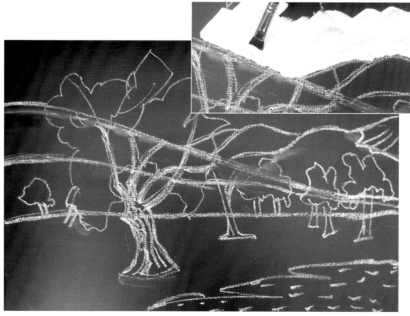

1 The artist prepares the board with two coats of white primer, two of blackboard paint and a sealing coat of varnish. The scene is then roughly sketched on with chalk that can easily be adjusted as needed. The sky is blocked in with primer.

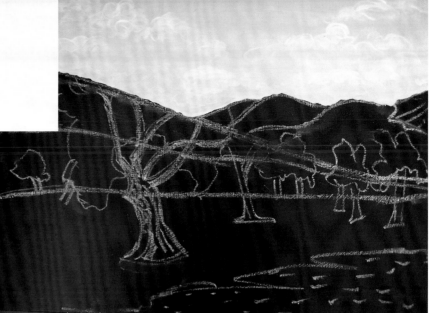

2 A thick, fluid layer of TM white is applied to the sky with the flat brush, and a little cerulean blue is swiftly worked into it from the top down, keeping the horizon white. When dry, a few clouds in TM and titanium white are added with a fingertip and a light touch.

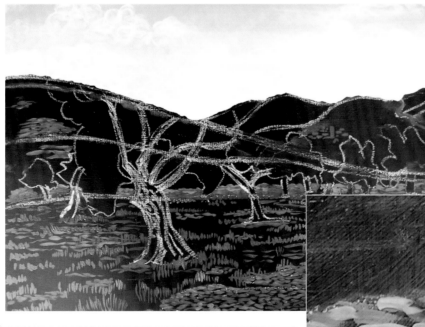

3 Areas of exposed earth are painted in broken brushstrokes with red oxide and yellow ochre. Patches of grass are put in roughly with chromium oxide green. Yellow-green grass is painted over this vibrant base in short, rhythmic flicks, using a rigger and flow improver.

83

Painting sky

In a painting such as this, the sky sets the atmosphere and lighting levels for the whole piece, so decide on these factors at the outset. It's much easier to paint sky as a unit, 'wall to wall', so that tones can be evenly blended and clouds shaped freely. So, even when working front-to-back, as in this painting, paint the 'backdrop' sky and clouds first.

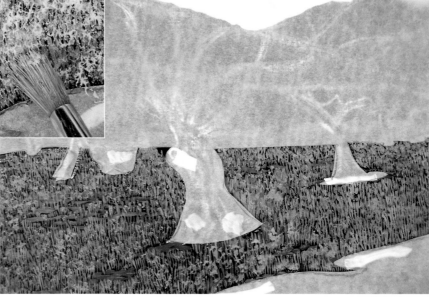

4 The tree trunks and bare earth are masked out using baking parchment stuck down with sticky putty, and then the flowers are put in roughly with a variety of stippling brushes. The artist uses azo and then lemon yellow, working several layers dark to light.

5 After sketching an outline with charcoal, the foliage against the sky is put in with Payne's grey, then various blue-green mixtures (ultramarine with yellow-green). Trees against the hillside are lighter toned. Layers of brush marks, getting progressively lighter with yellow ochre and white, build up the body of foliage.

84

Stippling

When you need to create a random spread of paint dots – too many and too fine to be individually painted – try stippling. Tap excess paint off the brush on a rag before lightly applying it to the canvas. Using several brushes to apply different-sized dots and distinct layers of colour adds depth and complexity to the effect.

85

Masking large areas

When applying paint with imprecise tools such as rough brushes or sprays, a quick way to protect surrounding areas from splatters is to wrap baking parchment around the canvas and cut a hole for the painted area. You can fasten down the edges with sticky putty. Take care not to scratch the canvas!

6 The patches of bare earth are progressively lightened by adding white, and the nearer hillside is painted with an assortment of colours and a small pointed brush. Yellow-green, used neat, yields patches of sunlight and helps push back the hillside by lightening it.

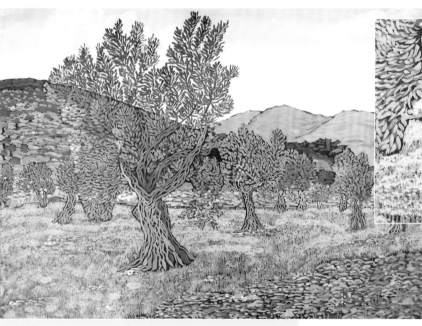

7 Ultramarine and red oxide with white create a mauve-grey colour for the far hills. The chalk is now wiped off to reveal the black of the trunks and branches beneath. With the rigger brush and the same grey mixtures, the gnarled bark is indicated with interweaving lines.

86

Masking small areas

When working on a hard support, an easy way to preserve ground colour or to mask small areas is to scribble over them with chalk. This serves as a reminder of the main lines of the drawing. Wipe off only when the paint is thoroughly dry, using a clean, damp cloth.

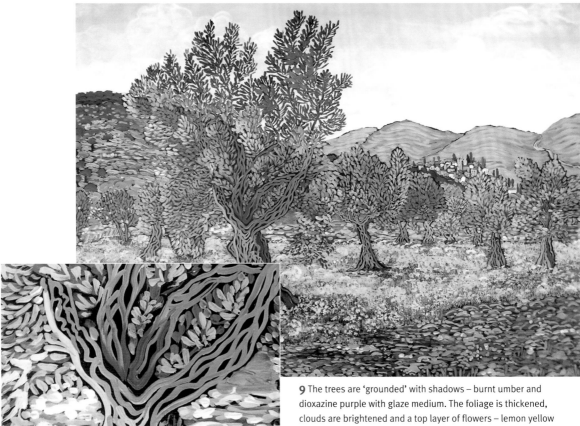

8 The village is developed with the earth colours and some greens. (The area was first blacked out to return to the ground colour and give definition to the small brush marks.) It fits naturally into the scene, being made from the same colours.

9 The trees are 'grounded' with shadows – burnt umber and dioxazine purple with glaze medium. The foliage is thickened, clouds are brightened and a top layer of flowers – lemon yellow with white – added. Touches of red earth colour between the green leaves give contrast and depth.

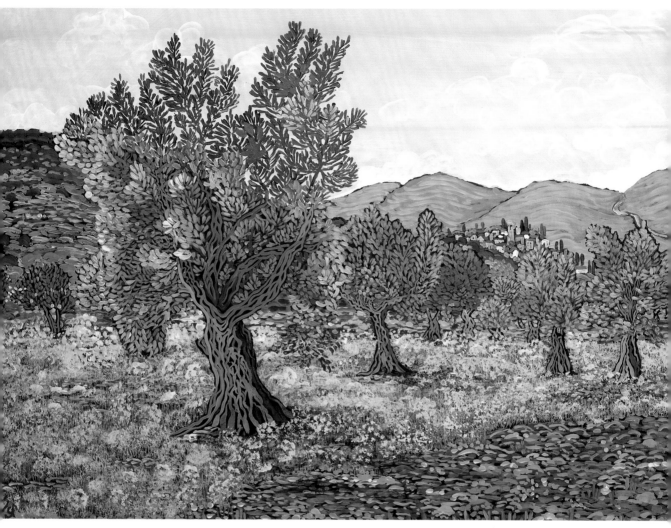

The Cool of the Morning
(Acrylics on 57 x 40 cm [22 x 15 in.] 4 mm [³/₁₆ in.] plywood board)

Gill Barron

87

Animating a landscape

Landscapes can be given more viewer appeal by adding hints of human presence. In this painting, ladders leaning against the trees or a donkey loaded with bundles of prunings were possibilities, but the village doesn't disturb the serenity of the olive grove and fits the focal point (see *Understanding picture dynamics: the rule of thirds,* page 75).

All about mediums

As a water-based paint, simply mixing the acrylic with water will give you a wide range of effects. But there are a few specialized substances available to mix into your paint to give greater versatility. Choose tubes or wide-mouthed pots rather than glass bottles, which contain laughably small amounts, much of which will be wasted.

EXPLAINER

'Medium' has many meanings. In an acrylic context, it will usually mean gel, unless otherwise specified. Here it is simply a liquid vehicle or carrier with which pigments are mixed.

88

Gloss and matte medium (G&M)

G&M medium is primarily designed to make paint highly transparent. It can be used as a glaze or for other thin applications, such as with watercolour work. G&M medium has no generic name. Be aware that it's not the same as gel medium.

It helps if you start off with a naturally transparent pigment, of course! But even strongly opaque pigments, such as red oxide, can be made substantially more see-through with this additive. Some pigments (mainly reds and dark blues) have unusually strong tinting qualities: these will require more medium. G&M medium allows you to mix colours optically; that is, by overlaying them transparently on the canvas, rather than mashing them together on the palette. This creates a very pure and luminous effect of intriguing subtlety called glazing (see *Classic oils* on pages 140–141 for lots more about this). Below are examples of the effects varying amounts of these mediums have on acrylic paints.

Gloss medium

	Opaque (cerulean blue)	Translucent (cadmium orange)	Transparent (alizarian crimson)
Pure paint			
+1 brushload of gloss			
+2 brushloads of gloss			
+3 brushloads of gloss			

Matte medium

	Opaque (cerulean blue)	Translucent (cadmium orange)	Transparent (alizarin crimson)
Pure paint			
+1 brushload of matte			
+2 brushloads of matte			
+3 brushloads of matte			

89

Gel medium

Gel medium makes the paint more transparent, and is ideal for glazing over thicker applications or for building up layers. It adds bulk and viscosity and so is useful for impasto effects, helping paint retain stiff peaks and troughs. As a general-purpose medium, its adhesive properties make gel medium ideal for collage and for adding to mixing water as a binder. Gel medium is particularly useful where straight lines are required, because it prevents paint from migrating under masking tape.

For applications where you want the paint to stay exactly where you put it, use gel medium with masking tape.

90

Matte, gloss, or satin?

Acrylic paints straight from the tube are of variable sheen. This can be distracting, altering the perception of colour, and is curable by adding one of the non-gel mediums to even out the reflectivity.

As with all painting matters, personal taste is key, so experiment with all three. Below are examples of the effects created with each.

Matte finish
Matte tends to work best for this purpose, since it reduces reflected light and any excess shine.

Gloss finish
Gloss is particularly good for intensifying colour, making it easier to judge the effect of glazes, but light bouncing off it can be optically deceiving.

Satin finish
Satin is usually a happy compromise: If unobtainable, try mixing your own from the other two.

91

Don't rush in

There are a wide variety of mediums out there. Don't invest in a whole range until you have established your style and way of working, since they can be fairly expensive.

92

Altering drying times

All mediums will affect the drying time of your paint, according to type and how much you use. Water evaporates fastest and can be encouraged with a hair dryer. Other mediums are best left to dry in their own time; with the help of a mahl stick (see page 68), you can continue working over wet or sticky paint without risk of smudging.

A few seconds with a hair dryer is enough on thinner paint. Impasto should be left to dry in its own time.

93

Using flow improver

This additive lowers the viscosity and surface tension of liquid paint, making it wetter and more easily absorbed into paper. It also helps the paint to spread evenly as a layer of flat colour across large areas. Only a few drops are needed. Don't be tempted to use glycerine or glycol as substitutes as is sometimes suggested. These chemicals will destabilize the paint film and reduce the lifespan of your work.

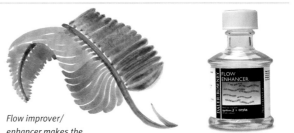

Flow improver/ enhancer makes the paint behave more like watercolour.

94

Impasto effects

Impasto just means 'thick paint', as in paint that projects stiffly from the surface. Heavy-body (high-viscosity) acrylics will give you the body and stiffness required to hold brush marks, peaks and troughs. Adding impasto gel medium to soft-body paints will bulk them up for the same purpose.

Impasto work is usually carried out with a painting knife or stiff bristle brushes, since normal brushes don't cope well with the extreme plasticity of the paint.

Acrylics, with their faster drying times, are ideal for impasto work, but even so should be built up in layers to ensure even drying. Thorough varnishing with a removable, soluble varnish (not quick-dry) is recommended, since such three-dimensional artworks are prone to collect dust and atmospheric pollutants.

Paint can be thickened with impasto gel medium.

95

Adding dimensions with texture paste

An ultra-stiff version of gel medium, texture paste is designed to be mixed with various other substances, such as sand, beads, fibres, tissue paper and so on, to give 'nubble' to the work. Some texture pastes already contain other substances. With or without colour added, the paste can also be combed, pushed into ridges, scraped, scribbled into, or whatever else takes your fancy. The paste can be painted over when dry and is a popular base for all kinds of mixed media applications.

Texture paste is often used to lay a textured pattern, which is then painted over.

96

Working modelling pastes

Modelling pastes are hard, carveable substances that take impasto to another level, turning paintings into something more like low-relief sculpture. Pastes add tremendous weight, so you will need a very strong support and hangings. You can use the pastes neat, and overpainted, or you can mix the paint (or raw pigment) in first. To experiment with the possible effects, why not try using ordinary decorator's filler pastes or powders, with some medium or quick-dry varnish mixed in for added plasticity?

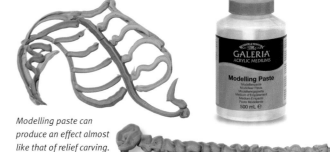

Modelling paste can produce an effect almost like that of relief carving.

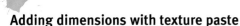

97

FIX IT ▸
Bring it back to life

Your painting has somehow lost its juiciness. There's a strange mixture of matte and glossy patches, the colours look dull, and the surface is dragging at the brush. You're losing enthusiasm. Give the whole thing a coat of quick-dry satin varnish and see the surface come back together in a very pleasing way.

Mix mediums into your paint using a palette knife.

Extender

This is a special and very clever substance that stretches the volume of the paint considerably without losing any of its colour or viscosity. Buy it in bulk when painting large areas, such as murals.

Extending medium makes the paint go a long way, so use it whenever you have large areas to cover.

98

Specialist mediums

Labelled as pearlescent or iridescent, these mediums alter the colour perceived according to the direction of the light falling on them.

Iridescent medium, also known as pearlescent, produces lovely metallic colours, which become more reflective as they dry. The medium works best with the more transparent colours.

99

Quick-dry varnish

This is a pure, transparent, economical acrylic and it makes a very versatile medium. It comes in gloss and matte versions (just mix for an eggshell/satin finish). The milky colour disappears as it dries. Keep a special, super-clean brush exclusively for quick-dry purposes. Get the varnish in a handy-sized tin from any hardware shop, and use it in some or all of the following ways:
• As a 'size' or transparent primer, when you want to keep the natural colour of the ground.
• To seal the back of paintings on hard supports that may encounter dampness.
• As a substitute for art store 'gloss medium' and an extender for pigments when covering large areas.

• As an intermediate coat between layers of the painting to enrich colour and improve adhesion.
• As a final varnish, especially for flat artwork. Quick-dry varnish provides a very tough, scrubbable, long-lasting finish, which won't flake or yellow.

Apply varnish to a finished painting and see the colours spring to life.

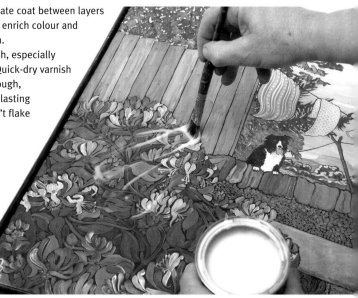

100

Using mediums

Those who are not familiar with acrylics may be surprised at how much various mediums can alter the look and handling qualities of the paint. Mediums offer exciting possibilities that are fun to experiment with as you explore the nature of acrylics, and they may help you discover what techniques really suit you.

White acrylic primer – here mixed with sap green – is a cheap, useful medium for adding opacity and making expensive pigments go further.

101

Mixing mediums

Always use a painting knife to mix mediums into your paint. Mix thoroughly, on a clean plate, then transfer the mixture en masse to the palette. Any other method risks making a mess and ruining the brush.

102

Water – control it

Control the amount of water you are adding to the palette by keeping it in a squeezeable bottle, such as an old detergent bottle, which can be dripped or squirted as required.

103

Water—a warning!

To make sure your acrylics keep their adhesive powers, never thin them more than 50 per cent with water. Beyond this point, add some medium to act as a binder, otherwise the pigment particles will fail to stick. You can add a proportion of medium directly to the water bottle so it's always there. Remember to shake the bottle sometimes! For a very low-viscosity pouring mixture, add 25 per cent water, 25 per cent medium to 50 per cent paint, which can include quick-dry primer.

> **TRY IT ▶ Distilled water**
>
> When defrosting the refrigerator, save those lumps of ice in a clean container, and when they've melted – hey presto! – distilled water. It has the advantage of being entirely free of chemicals such as chlorine, which may slightly affect paper and colours when working in watercolour-style techniques. It's also sterile, so the danger of importing fungal and mildew spores to your stay-wet palette is lessened. Tap water that has been boiled and cooled has many of the same advantages.

104

Water – keep it clean

Often water is the only medium you need to thin the paint. Tap water is fine, although if your water is hard or chlorinated, you may prefer bottled or distilled water. If you are using water as the medium, ensure your colours are pure and unmuddied by keeping your mixing water and your brush-cleaning water separate. Keep a bucket in which to tip the dirty water and a watering can of clean water to replenish your water pot. When painting on the move, take a large bottle of water with you.

Using retarder

Retarder is a highly recommended addition to your toolkit. One of the advantages of acrylic is that it dries so fast – but this also means you have to make irreversible decisions quickly, perhaps before you've had time to think through the alternatives. Retarder buys you time to try out different effects. Paint mixed with retarder has the experimental possibilities of oil paint – and yet still dries within a reasonable time, unlike oils, which can take weeks. To use it, just mix a small quantity (read the label!) into your paint on the palette. Alternatively, paint a thin layer of retarder straight from the tube onto the areas of the canvas you're working on, then paint normally on top. To remove anything you don't like, just wipe it off. What you do like can be left to dry naturally, it will take an hour or two – a blast from the hair dryer helps.

TRY IT ▸ Thin over thick

Oil painters have to worry about the 'fat over lean' rule, which means you can never put thin paint over thicker paint: the layers would crack, fall apart and destroy your painting. This never happens with acrylics – paint any way you want to – as long as you stick with water-based mediums, you'll have no problems.

Thick, textured paint helps describe the papery ruffles of Lexi Sundell's petals in *Iceland Poppy* (above).

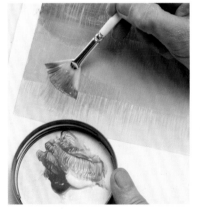

To blend colours smoothly, add some retarder to the first layer to keep it workable for longer. A little extra retarder on the fan brush will help to achieve a seamless effect.

When using acrylic as a watercolour medium, keep your washes fluid by adding flow improver (see page 54) and a little retarder to the mixing water. Working wet-in-wet will be much easier.

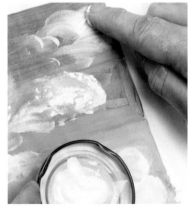

When you want to just play with the paint to see what happens, add retarder. This gives you longer to push it around and to wipe it off if you change your mind. It's a great method for painting clouds.

Setting up your studio

To work, you need a workplace. Few of us are lucky enough to have the ideal studio – a dedicated, interruption-proof personal space, with north light, plenty of room to pace around, and soundproof so you can play loud music whenever you feel like it. Here we look at several ways to help you organize the next-best thing – a complete, painter-friendly environment, so you can maximize your chances of producing good work.

106

Finding a studio

A studio can be almost any kind of weatherproof space with light, so if you have the option of working away from home, explore the many possibilities, such as:

• **Group studios:** Shared by an artists' collective, these are fun, encourage hard work, share equipment, usually hold exhibitions, and have many benefits that will repay the rent. Check your local art college; if no group studios exist in your area, consider setting up your own – a long but probably rewarding process.

• **Studio shares:** Exchange workspace in your home with a friendly fellow artist. He can use your conservatory or garage; you use his. This avoids domestic distractions and feels more like going to work. Alternatively an elderly neighbour may have a spare room she would gladly rent to make some pocket money.

• **Rent a shop:** Empty shops make marvellous temporary studios. Large windows give plenty of light, and you can even display your work! This atelier, or workshop, concept appeals to the public imagination and will attract publicity. Cheap rents can be negotiated, since you would be in a caretaker role for the empty building. Many functioning shops have empty rooms upstairs, which can likewise be rented.

• **Group studios:** Local businesses, health centres, and so forth may like the idea of having an artist in residence if your work has some affinity with what they do. Ask!

For many of us, the studio may be a corner of the kitchen or a garden shed, but for some lucky artists, it is also a desirable living space.

107

Working at home

There are many benefits to working at home. It saves paying rent, and you waste no time commuting. You can paint any time the fancy takes you. There are also some major drawbacks. One is getting family and friends to respect your need to work; another is giving yourself permission to ignore the chores and buckle down to painting. Having to clean up after yourself after every session, or having to endure the scrutiny of those nearest and dearest to you while the painting is at an unlovely stage, can be inhibiting. It helps enormously – but is easier said than done – to keep regular working hours. This disciplined approach may not always work, but the ideal of a structure will help you into good habits and give some defence against interruptions.

108

Artificial light

On darker days, or to continue working by night, you'll need backup lighting. Ordinary household light bulbs give a warm, yellowish light, which alters the perceived hue of your artwork. Cold blue daylight bulbs are available, which push colour in the opposite direction. Try a combination. Bulbs mounted in positionable lamps, such as flexi-stemmed reading lamps that can be aimed at the painting, are better than shadow-casting overhead lights. Special clip-on easel lamps can also be bought.

You'll get a softer, more even quality of illumination if you use reflected light, bouncing the light beam off a white or silver surface onto your work. Fluorescent (neon) tubes give a useful boost; their light is fairly neutral in temperature but hard on the eyes for periods of concentration.

109

Climate control

It's difficult to work with acrylics in high temperatures. On a hot day, they'll dry on the brush before they reach the canvas. Opening windows for a draft will only intensify the drying process. Misting with a water spray or adding retarder to the paint will help; fans won't. When working indoors, a large bowl of water on the floor or wet muslin hung at the windows will add vital moisture to the air. Many painting problems are caused by studios being too warm. Cold weather – below 8°C (46°F) – can also sometimes affect acrylics, making them rubbery, although, on the whole, cooler temperatures are more conducive to wakefulness and concentration and make the paint behave better.

110

Natural lighting

Paintings are made of colour, and colour perception depends on light, so always try to work in similar light levels to those where the painting will, in time, be displayed. Good galleries strive to simulate daylight, so work in natural light as much as possible. North light is famously the best for painting. Unaffected by direct sun rays, it changes little during the day, is of a gentle intensity, and not tiring to the eyes, making it good for judging tone and hue. South light changes often, casts shadows and overheats. Large areas of south-facing glass are best avoided.

111

Organizing materials

Heaps of tubes, palettes, jam jars and other equipment soon gets out of control. An old-fashioned tea cart with at least two decks, on castors, so it can be trundled to wherever it is needed, is a great asset. Keep smaller items such as pencils in a cutlery tray, so you can see what you have got at a glance, and store jam-jar lids, rags, small tools and other indispensable items in labelled ice-cream tubs. This will give an illusion of order to your workplace.

The studio store cabinet

An uncluttered working environment is a great help to concentration, so storing your excess materials, tools and finished work outside the studio is a good plan. Storage space also enables you to collect cheap or free materials, so they are easily accessible when inspiration strikes. Since good light isn't a requirement, such a space is often easier to find than a studio. So even if you have to work at home, remember, a shed is a painter's best friend.

Equipment checklist

Rubbish bin
Hair dryer
Mirror
Bulletin board
Bag of rags
Easel
Bar stool
Armchair
Water jug and buckets
Rollers for baking parchment and paper towels
Squeeze and spray water bottles
Jugs and jars for brush storage

112
Studio consumables

Most painters go through large quantities of disposable materials in the process of producing art. Here is a list of commonly used items you will need:
- An ample supply of old newspapers, telephone directories and paper towels
- Jam jars and lids
- Baking parchment for palette lining
- Sponge cloth for palette lining
- White vinegar
- Liquid detergent
- Cotton rags
- Quick-dry primer and varnish
- Medium-grit sandpaper

113
The studio toolkit

You'll find all of these items come in useful sooner or later:
- Steel straightedge – 1 m (3 ft)
- T-square, compass, drawing instruments, rulers and measuring tape
- Cutting mat, scalpel, craft knife
- Staple gun
- Pliers and G-clamps
- Reading lamps
- Magnifying glass
- Mahl stick
- Decorator's brushes and paint scrapers for cleaning them

Extra equipment
Apart from the actual painting equipment, there are various useful extras, as listed above. Keep them all together, and to hand.

114
Cheap and free materials

Art-shop materials tend to come in small quantities and at premium prices. By using your eyes and imagination, you can source many similar materials that are cheaper, or even free.
- Large drawing paper: For rough design work you won't need to keep, use rolls of lining paper from DIY outlets. It's strong, but not acid free. Local newspaper printers often have ends of rolls free to take away.
- Brown paper: The rougher, ribbed side is great drawing paper, as used by Degas and Toulouse-Lautrec.
- Check charity shops for secondhand heavy cotton curtains and upholstery fabrics; these make excellent painting canvas. Prime well.
- Hairspray is fixative: Use it for charcoal drawings, pastels and so on.
- Large sheets of cardboard, primed, from electrical goods shops make good grounds for preliminary sketches.
- Bubble wrap is invaluable for wrapping paintings en route to exhibitions.
- Baking parchment makes good tracing paper.

115
Minimum mess, maximum comfort

As the saying goes, 'If you can't make a mess, you can't make anything'. This is surely true of painting, an activity that calls for some freedom to splash around. A bare floor is a blessing, but if you have a carpet or other precious furnishings, old shower curtains are an excellent source of handy-sized, hard-wearing plastic sheeting for covering vulnerable areas. Likewise some type of overall – the traditional painter's smock – hanging up at the door to the studio, where you'll be reminded to put it on, is a good idea. A smock can be used for wiping brushes; in time becoming (almost) a work of art in its own right. Shoes get splattered – and you'll be on your feet most of the time – so bouncy-soled studio slippers are a good idea, too.

Keep your overalls where you'll remember to put them on.

117
Storing your finished work

As they say, 'Art isn't art until it's sold; until then it's just a storage problem'. You'll be surprised how soon your work expands to fill the walls available. Building a storage rack is a good idea, as it keeps work in pristine condition, prevents casual damage to frames, and saves space as well.

116
Life support in the studio

Remember, you need to spend plenty of time sitting back, studying what you've done and thinking about the next move. Relaxing is all part of the process. Make it more enjoyable still by keeping a few comforts at hand. Be good to yourself.
• A kettle for coffee; cookies optional.
• A radio: Spoken-word programmes provide a semi-interesting background burble, which keeps your left brain occupied and stops it from interfering with the nonverbal work in progress.
• Audiotapes: Listening to a story helps pass the time while you're dealing with the less exciting parts of a painting.
• Music: Both soothing and stimulating.
• A chaise longue is traditional studio furniture, but any comfy chair will do if suited to taking little afternoon naps.
• A do-not-disturb sign.
• Art books, paint catalogues, idle reading of a work-related nature.

Dedicate a corner of your studio to various forms of inspiration and refreshment.

Painting in the open air

The exhilaration of painting the great outdoors, on the spot and face to face with nature is hard to beat, and acrylics are the ideal alfresco paints. It's a challenging undertaking, so improve your chances of a successful expedition by taking the right equipment and planning ahead, using these tips and techniques to guide you on the wilder shores of art. Seize the day, and don't forget to take a few home comforts along. You deserve them – you'll be working hard.

Equipment checklist

Flat-bottomed backpack, a wheeled cart, or even a wheelbarrow
Folding easel or drawing board
Folding stool or camping chair
Drawing materials
Viewfinder (see page 74)
Paintbox and painting knife
Disposable palettes and wind shield
Rags or old apron
Squeeze and spray-mist water bottles
Brush-wash jar
Brushes in a tool roll
Canvases and carrying case
Life support such as insect repellent, hat, umbrella, awning
Camera with zoom
Binoculars

EXPLAINER

'Plein air' is the French for 'alfresco', which is 'fresh air' in Italian. No doubt every language has such a phrase, but these ones are traditional painting terms. 'Alla prima' means working spontaneously, without underpainting or other elaborate preparations.

118

Outdoor easels

Many designs of specialized easels are available, including 'donkeys', which can be used to sit on and have a box for materials. Weight, price and bulk are factors to consider. Avoid the flimsy ones with telescopic legs, or use guylines and tent pegs to secure them against the wind.

A drawing board may be all you need. The over-the-shoulder strap adjusts the angle. Use plenty of clips. Make your own!

119

The paintbox

To save carrying weighty tubes and possibly losing the lids in the long grass, put a good blob of each likely colour in a box palette before you set out. The ideal box is moulded plastic, with a tightly fitting lid and permanent, non-adjustable, compartments, so that paint won't leak between them. Button boxes and fishing tackle boxes work well. Line the compartments with damp sponge cloth and tracing paper, and make sure you transport the box in a flat position. Take a tube of white as well; you'll probably need extra.

A box like this lets you carry lots of colours with little weight, and it keeps the paint moist while you work.

TRY IT ▸ Keep it going

If you're heading out to work in warm weather or a breezy location, mix some gel medium and flow improver thoroughly into each colour before loading them into the paintbox.

120

Start quickly

When painting outdoors, travelling, choosing a view and setting up equipment are all time-consuming. It's vital to use what's left of the day fruitfully. These tips will help you to work fast:

1. Using a viewfinder (see page 74) of the same proportions as your canvas will help you compare compositions and select your scene exactly.

2. If your canvas is already squared up to match the viewfinder, transferring the main elements of the image will take moments.

3. Get the structure of the image down before tackling the changing effects of light and shadows. You can paint only one version of these surface phenomena, leave them to the end.

121

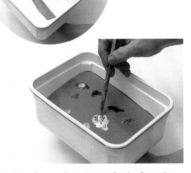

Dealing with bright light

Painting on a white ground in full sunlight intensifies colour. When you take the work indoors, all your hues will look far too dark. Since the painting is destined to be seen indoors, you'll have to adjust everything. Better by far to keep the canvas in the shade. Choose a spot to work that's already shaded (preferably not by flickering trees), or create your own shade: a large black umbrella can be clamped to the easel, or use a portable awning made by stringing up cloth between trees. Painting on a mid-toned ground, rather than white, helps enormously, both with judging tones and preventing eyestrain.

122

Managing the palette

Your colours are in the paintbox, which needs to be kept shut most of the time to prevent drying, so a mixing palette is needed. Use a ready-made, disposable pad, or make your own from varnished cardboard, with a built-in wind shield.

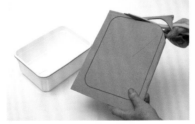

Make a windproof palette

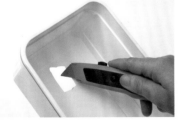

1 Take an ordinary plastic ice-cream tub (a deep one) and cut a thumb hole in the bottom of the box.

2 Cut a piece of cardboard to fit inside it and give it a coat of quick-dry varnish to make it waterproof.

3 Transfer small amounts of paint from the paintbox to the cardboard, using your painting knife – your palette is now ready. Make new liners as needed from any old pieces of cardboard, and remember to replace the lid when not in use!

123

A method for alla prima

Don't draw the scene, but study it through the viewfinder (see page 74) and decide where to place the horizon, and where the edges will be. Using a large brush – 2.5 cm (1 in.) or 5 cm (2 in.) at least – and transparent paint well thinned with medium – water may drip – block in the main areas and shapes of colour first: sky, sea, shore, rocks. Turn the canvas upside down, stand back, and see whether the layout is pleasing. Refine the shapes until it is. Remember, this is painting, not photography; you don't have to be literal. Carry on refining and adjusting the colour, tones and shapes, building up depth and distance, still with a large brush. Only swap to a smaller brush when you really must. Ignore detail, or select just one telling feature, and lightly suggest it. Alla prima painting is all about evoking the poetry of the scene, atmosphere and flavour, as exemplified by the following sequence. Leave plenty of room for the viewer's imagination. Less is truly more.

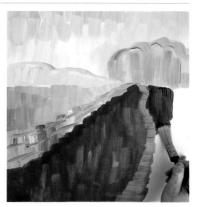

1 A few moments spent working out the background shapes make for faster working, when speed is of the essence.

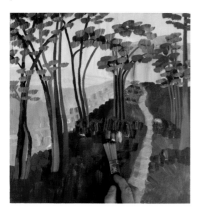

2 Using the same broad brush on its edge, the trunks are slashed in. The leaf blocks are then added with several greens at once.

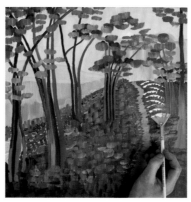

3 The abundance of wildflowers is indicated simply with a fan brush, and the stones in the wall with a hog's hair flat brush. Shapes are the focus here, not detail.

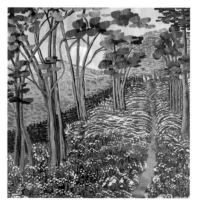

4 Minimal details of meadow grass, bark and a distant pathway are added as simply as possible to keep the painting fresh and light in feeling.

124

Chance is a fine thing

While you work, keep alert for that random detail or event that gives life to the landscape. A girl in a red dress cycling past, a kite flying, a scampering dog. Photograph it and paint it in as a finishing touch.

125

Inquisitive bystanders

Even the most remote spot will yield at least one, and some days you'll attract a small crowd. It's perfectly fine to ignore them. They won't think you rude, just fascinating. Enjoy the charisma, and give them your card.

126

Open acrylics

A newly invented type of acrylic, open acrylics are specially formulated for plein air work, so if you plan to paint outdoors a lot, it may well be worth investing in a set of colours and a carrying case to get paintings home. The term 'open' refers to the long time during which the paint remains workable.

127

Transporting your painting

Once dry, as they soon will be, acrylics are smudgeproof (unlike oils) and waterproof, too. You can even use your canvas as an umbrella as you run from the rainstorm! If, however, you've built up a thick impasto, you may need to protect the surface from knocks. Canvas can be incurably dented if leaned against lumpy objects. To protect against these dangers, special carrying cases can be bought, or spacers improvised from pieces of sponge, thread spools and so on. Plywood makes a light, thin, indestructible support for outdoor work; don't glue the back ribs on until the work is finished. Or take several canvases in sizes that nest inside each other to save space.

128

Not so fast!

The quick-drying properties of acrylics mean you can get a lot done in a day, and your work won't get smudged on the way home. On a hot, windy day, however, paints drying too quickly become a problem. Take a fine spray-mist water bottle with a little retarder added, and use it often on both the palette and the canvas. Rinse brushes frequently.

129

Back to the studio

The vast majority of alfresco paintings are completed in the tranquillity of the studio and are the better for it. The energy infused by actively engaging with nature can be tempered and balanced by more painterly thoughts. So if you get rained off, blown away, or simply exhausted, don't battle on. Make sure you have plenty of reference photos (wide angle and zoom), and sketches if possible, and retire to finish the work in peace and quiet.

130

Take care

Remember to take water or a thermos with you – painting out in the sun can be a thirsty job. Take some sun cream too!

Making equipment

There's great satisfaction in making your own equipment for painting. The things you use every day in the studio become part of the integrity of your work, and you can take pride in this evidence of your serious hands-on involvement with the craft as well as the art.

A basic studio easel

A basic studio easel is inexpensive, sturdy and folds away flat when not in use. It can be adjusted for height – yours and the painting's. Best of all, you can get your feet under the front, allowing you to get up close to the work when you want to. Most commercially built studio easels take up a lot of space and are too heavy to move around. They also have low undercarriages on which to stub your toes. So-called 'portable' easels are generally too flimsy to stand up to the vigour of active painting, falling over, or blowing away. This easel is a happy compromise, costing very little, and taking only a short time to make. It's suitable for paintings up to 1 m (3 ft) square.

Make your own easel

An easel is an indispensable painter's tool. It enables you to see and work on the whole painting in the position in which it will eventually hang, to walk away and move up close. It allows the maximum freedom to your arm and the movements of your brush. You must have an easel. Yet this can be a very expensive piece of kit when first starting to paint, so make your own.

Materials

9 m (30 ft.) 3 x 5 cm standard-size batten (1 x 2 in. planed softwood)
2 strong 5 cm-square (2-in.-square) hinges
Screws for hinges
1 ft. (32 cm) ½ in. (12 mm) dowel
2 cuphooks
50 cm (20 in.) lightweight chain
16 screws, 32 mm (1¼ in.), size 6 or similar
Bolt and wingnut

Tools

Measuring tape
Hand saw
Power drill
Drill bit – pilot holes for screws
Drill bit – slightly smaller than dowel size
Countersink bit
Screwdriver
Medium-grit sandpaper
Masking tape
Trimming knife

1 Start by cutting your lumber to length:
2 front uprights at 2 m (6 ft.)
2 back uprights at 132 cm (52 in.)
4 crosspieces:
 A 28 cm (11 in.) bottom back
 B 33 cm (13 in.) top rail
 C 41 cm (16 in.) centre rail for hinges
 D 64 cm (25 in.) front bottom rail

2 Tape the two front uprights together, ensuring the bottom ends are exactly level.

3 Measuring from the bottom end, mark a row of 6 holes, 10 cm (4 in.) apart, on the midline. The holes should start 61 cm (24 in.) from the bottom and end 50 cm (20 in.) from the top. These are your peg holes.

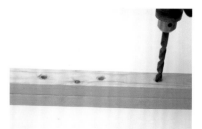

4 Drill holes all the way through the front uprights, then remove the tape.

5 Lay the two front uprights side by side. Move the bottom end of one 26 cm (10 in.) to the side. Move the other 26 cm (10 in.) in the other direction, so there is a 50 cm (20 in.) gap between them. Tape firmly to the surface. Move the top ends apart 11 cm (4½ in.) in each direction, making a 22 cm (9 in.) gap. Tape again. The uprights should both slope at the same angle.

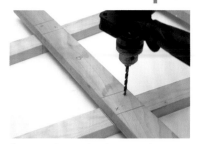

6 Lay crossbars B, C and D across the uprights at roughly 6 in. (15 cm), 48 cm (19 in.) and 140 cm (55 in.) from the top. Make sure they don't overlap any peg holes. Mark and drill two holes in each crossing, countersink them and screw.

7 The front frame should look like this. Saw off the protruding ends of the crossbars, and sand any rough parts.

8 Putting the two back uprights back to back, saw off a 45 degree angle from one end.

9 Lay the two back uprights flat and parallel with 20 cm (8 in.) between them. Lay crossbar A over them about 84 cm (33 in.) from the angled end, and screw into position. Trim the protruding ends.

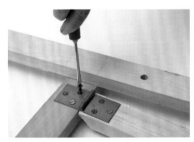

10 Screw the hinges to the longer ends of the back rails, angled side away from you, and, placing the front frame over the back, screw the other half of the hinges to the middle crossrail of the front. The frame is complete.

11 Screw cuphooks into the facing sides of the bottom crossrails and loop the chain between them. This lets you adjust the easel to a more vertical position if you want. If it wobbles, you can put a weight on it.

12 Cut the dowel into two 15 cm (6 in.) lengths and whittle until they fit snugly in the peg holes. These will support the painting at your chosen height. Any batten left over becomes a rail to sit across the pegs for added stability.

13 For larger paintings, a gripper is useful to hold the top firmly. Take a leftover piece of batten and drill a row of 4 mm (³/₁₆ in.) holes about every 5 cm (2 in.) along it. Screw this to the two upper crossrails so that the top half stands above them. Take a block of wood about 5 x 13 cm (2 x 5 in.) and drill a 4 mm (³/₁₆ in.) hole in that. Connect block to upright with a bolt and wingnut and tighten to secure. The length of the bolt equals the usual thickness of your supports, plus block and batten. You can clip an easel light to this upright.

More equipment you can make

It's extraordinary how quickly artwork mounts up, especially if you do life drawing, and all those papers need storing safely for future reference, or for transporting. One portfolio is seldom enough. You need at least one for rough and one for best. Manufactured portfolios are expensive to buy, dull to look at, and useless once the zip is broken, so why not make your own? A homemade mahl stick will also certainly come in useful.

133

Make a mahl stick

A simple device, the mahl stick is invaluable for those who use slow-drying mediums and paint wet-in-wet. It enables you to work over wet areas with a steady hand and with no fear of smudging. To use it, rest the round (non-slip) end on the edge of the canvas and use your non-brush hand to hold the stick a few inches away from the painting surface. Your brush hand rests on it, firmly supported yet able to move freely.

Materials and tools

About 60 cm (24 in.) length bamboo, dowel, or copper pipe, (not too thin)
Soft cloth or sponge
Tape
Felt or suede
Elastic band
Thread
Scissors

All you will need to make a mahl stick.

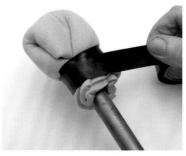

1 Wrap a small bundle of soft cloth around one end of the stick. Secure tightly with tape.

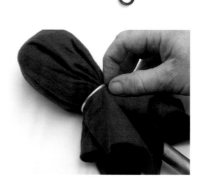

2 Cover this with a piece of felt or suede, held in place with an elastic band.

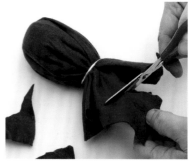

3 Bind firmly with strong thread and trim off excess felt for a neat finish.

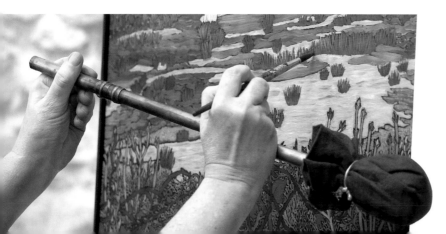

Warning!
When working on a soft support, the mahl stick must always press against the stretcher to avoid making dents in the canvas.

134

Make a portfolio

It costs very little to make your own portfolio for your large drawings, and it is almost indestructible. You can make it as conservative or flamboyant as you wish.

Here is an easy pattern for making an old-fashioned folder.

Materials

2 large sheets of cardboard (mountcard or recycled)

½ roll jazzy vinyl-coated wallpaper or gift wrap (for front and lining)

Duct tape

Wallpaper paste

2 m (6 ft.) strong cloth tape (for the strap)

Tools

Craft knife and steel ruler

Scissors

Glue spreader or brush

Needle and thread (for the strap)

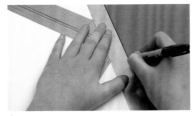

1 Cut out five pieces of card as shown in the pattern above, to the size most useful for you. Use a sharp knife and steel ruler to keep the edges crisp. Cut all the corners at a 45 degree angle so the flaps close neatly.

2 Roll out some duct tape sticky-side up and lay the pieces of card on it, leaving a gap of about 2 cm (¾ in.) space between the edges. Now put more duct tape on the top side, and rub down to stick firmly, making a wide, flexible hinge. Do this with all the card pieces.

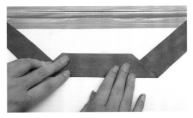

3 Lay out your wallpaper, plain side up, and place the cardboard ensemble on top of it. Draw around it, about 5 cm (2 in.) from the edge. Cut out the paper.

4 Cover one side of the paper with wallpaper paste, and lay the cardboard down on it. Press down firmly to stick.

5 Spread paste around the perimeter and cut and fold all the edges of the wallpaper over carefully, regluing as necessary. Rub down to secure.

6 Using the folder as a pattern, now draw its shape on your chosen lining paper and cut it out around 1.25 cm (½ in.) smaller all the way round. Spread glue over the inside surface and stick the lining paper down. Press down firmly and trim edges carefully.

7 Pierce holes in the side flaps and attach tie-tapes to hold drawings in position. If your portfolio is large, make a carrying sling. To do this, measure the height of the portfolio, double it and add 1 m (3 ft.). Apply this measurement to strong cloth tape and stitch the ends to make a loop. Put the portfolio in the cradle and the free ends over your shoulder.

Your own portfolio

Show off your creative talents by presenting your work in a handmade portfolio.

2

Designing
the Painting

This section explores all of the essentials of picture making: the things to consider, both before you start and during the painting process. The 'how' of painting you can learn as you go along, and here we provide you with useful answers to many practical questions you may encounter. The other perennial painter's question – what to paint? – is also addressed, with an inspiring collection of images to spark your imagination.

Composition

The rules for successfully composing a painting have evolved over many centuries and are solidly based on factors that have been proven to produce the most enduringly satisfying results. They are the hard-won fruits of trial and error, disappointments and mistakes that need not be repeated. Yet times change, and with them our perceptions. There is scope to experiment with the rules: first know them, then break them!

A nice head-on arrangement, with little perspective and a good sense of pattern.

Receding perspective adds drama as well as a feeling of space.

The curves and rounded shapes of the fruits are echoed by the basket and handles, giving rhythm to the composition.

Here there is an exciting contrast between the soft curves and the geometric shape of the board on which they sit.

135

First draw your map

Painting is seldom the frenzy of creation depicted in movies, but a more deliberate activity. Far from inhibiting your spontaneity, time spent composing lets ideas develop, so the painting gains depth. Potential mistakes can be spotted early. Once the basic structure and ideas are in place, you have your 'map', and you can paint with freedom and confidence and really have some fun.

A rough sketch is all you need to lay out the main blocks of the painting. Once you have your basic 'map', you can take time to build up the colour and detail of the painting.

136

Tips for achieving balance

A primary aim of composition is to achieve a stable, balanced whole that rests easily within the canvas.
1. Odd numbers of objects are easier to balance than even ones.
2. Things in groups work better than those loosely sprinkled about.
3. Shared tonal values hold blocks together.
4. Although nice for a decorative piece, beware the inertia of perfect symmetry.

137

Choosing the size

Factors to consider when choosing the size of your painting:
1. Producing paintings in a range of sizes broadens the range of potential buyers.
2. Few people have large empty walls nowadays. Paintings over 2 m (6 ft.) are also inadmissible to most exhibitions.
3. Large paintings cost more to frame and also create storage problems.

4. Think about transportation. Measure the space in your car, and make sure that the largest of your canvases will fit. Roof racks are disastrous to artwork.
5. If you want to work on a large scale, consider using several adjacent smaller canvases with the image spread across them, as with works of David Hockney.

6. Paintings should be big enough to accommodate the subject without cramping. Err on the generous side to allow for freedom of brushwork.
7. Keeping an assortment of support sizes lets you choose one suitable to the subject – smaller for close-ups such as still lifes, larger for landscapes.

138

Choosing the format

The three basic formats, or aspects, are landscape (horizontal), portrait (vertical) and square. Consider your subject in all formats. Diptychs and triptychs (double and triple canvases) or box sets (several canvases hung in a square) are interesting variants. A panoramic landscape with several canvases hung as a series, for instance, can be very effective.

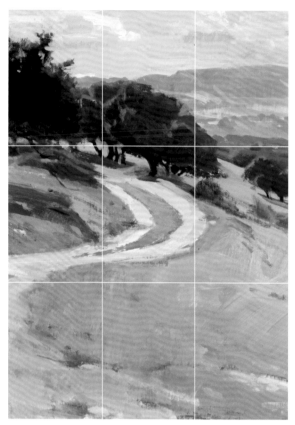

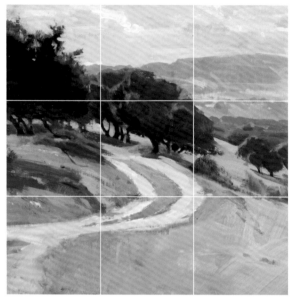

The scene sits comfortably within this square, with all its essentials in good proportion, well-observed and balanced. The path is the subject.

The vertical format expands the foreground and so makes the eye travel further into the image, making for a more dramatic and involving composition. Here the distance is the subject.

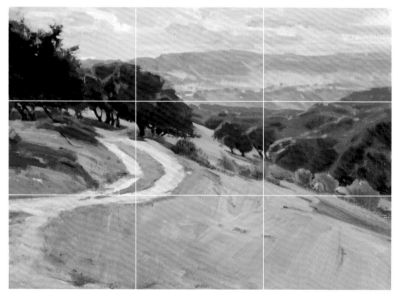

TRY IT ▶ Hands up

Look through your fingers for a snapshot impression of the scene's artistic potential.

The classic landscape format gives an expansive vision of the whole valley, which is the subject. The sense of space created invites the viewer to enjoy the place and the moment. A conventional solution, but successful nonetheless.

139

Make an adjustable viewfinder

If you've already chosen a canvas, this simple viewfinder can be calibrated to match its proportions. Just slide the sections to produce a window that's the same shape. Look through and decide where you want your edges to be. Decide what to include and what to leave out. Alternatively, slide the sections until you find the natural proportions that suit your subject best, and then make your canvas to fit. This is very easy if you paint on plywood. See pages 84–85 for more on *Tools for seeing*.

The view
An exciting subject, full of potential, but it might benefit from a change of format. Cutting the foreground could give more prominence to the mountain.

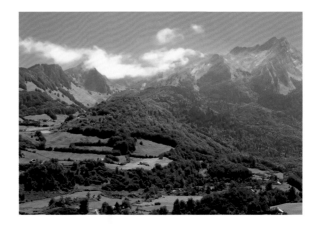

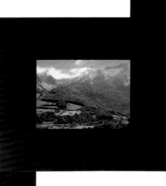

An upright rectangle may seem an unusual choice, but it works well, emphasizing the height of the mountains.

Here the foreground has been cropped a little, while still retaining the exciting patch of yellow in the middle distance.

This long, thin format, focusing on the mountains, has possibilities. It might work well for a textured collage treatment.

140

Magic numbers

Certain ratios and proportions have been found harmonious and pleasing since ancient times, and underpin much successful architecture and art. Use them to decide the proportions of canvases and the placing of elements.

Centre of interest

5:8 ratio

5:8 ratio

The golden mean
First devised by the ancient Greeks as an architectural planning aid, this mathematical formula produces interesting aesthetic possibilities for the artist. The idea is to divide your picture plane into a ratio of 5:8, and place your focal point (main centre of interest) on or near the division. Leonardo Da Vinci's *Mona Lisa* uses this very design. This ratio is commonly found in nature. See, for example, the ratio found in the spiral design of the lovely nautilus shell (shown left), as well as that found in many flower petals and pinecones.

141

Understanding picture dynamics: the rule of thirds

Ask yourself: what is the vital item at the heart of this painting? Now place it where it will have most impact. The diagram (right) shows the four traditional focal points based on the rule of thirds. This is perhaps the most ancient of artists' trade secrets. The key is to avoid the centre. The center is static, without energy. If you place the point of the painting in the middle, the eye goes straight there, dismisses the rest, and the bored viewer moves on. By placing key elements, including horizon lines, at thirds intervals, you'll engage the eye and lead it around the painting on an entertaining journey. Encourage this with triangles and diagonals in the underlying structure, pointing the way, and you'll have a truly dynamic and engrossing painting.

The four focal points
Having established the layout for the main design elements, you can use this method to compare possible placings for the 'furniture'. Below, three drawings of sheep have been reversed and resized, and are moved around to give a range of compositional alternatives.

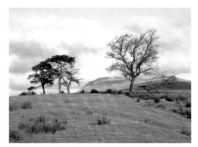

1 The otherwise pleasing landscape shown here is divided in half by the horizon, and as a result is quite static. Is there some way to improve the composition? Let's try.

2 Divide a rough sketch of the main elements into thirds, both horizontally and vertically. This will help find the focal points.

3 Copy the sketch onto tracing paper, leaving room to experiment with the placing of new foreground elements.

4 Scan a drawing of potential foreground elements into a computer, then reverse and resize them to make a selection of alternatives: large for the immediate foreground, smaller for further away. In keeping with the scene, we have used sheep.

5 By moving the scanned (sheep) drawings around under the tracing paper, you can test numerous possible placings relative to the focal points.

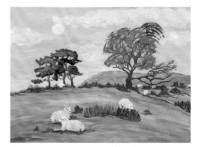

6 Finally, you can decide on the option you find most pleasing. Here the sheep are placed to lead the eye into the landscape in a zigzag. Ultimately the afternoon moon is the focus, close enough to the focal point to balance the picture.

142

Closed and open composition

An important consideration is one of atmosphere: will your composition be closed or open? Closed compositions contain the whole subject, a microcosm. The painter presents a fait accompli: take it or leave it. In an open composition the subject overflows the edges, leaving something to the viewer's imagination.

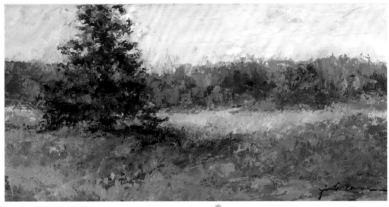

Closed and open: The comparison

A subject that in itself contains everything the painter and viewer needs to absorb their complete attention is a happy find. Closed compositions, such as Stephen Rippington's *Shaded Lane* (above) have the completeness of a poem. But open compositions are exciting in a different way. In Jennifer Bowman's *Lavender Fields* (right), the slice of landscape includes, by suggestion, the world beyond its boundaries, so the viewer can imagine taking a stroll in it.

143

Negative space

This, the shitao of Eastern masters, comprises all those areas of the canvas where the objects are not: the spaces between and the 'uninteresting' backgrounds and foregrounds. These areas will also have to be painted, and 'nothing' can be harder to paint than things. So consider this aspect carefully, and make these shapes structural and pleasing in their own right, however vague their content!

1 The shapes, shines and interaction of these two friendly teapots are a sufficient subject. No further props or background 'story' is needed.

2 The light areas around the teapots link and define them, making shapes from empty spaces. The background has enough 'design' to place them in context without cluttering the image.

144

Transfer the design

With your basic outline drawn onto tracing paper, and your transfer paper and pencil at the ready, transferring your design to the support is easy, just follow the steps below. If working on canvas, it's wise to put something hard behind it to avoid denting the surface.

1 Slip your transfer sheet, black-side down, between your drawing and the support. Using pencil, repeat the drawing.
2 Having drawn the basic layout in as much detail as you want, place your drawing onto your support. Repeat the drawing again to reproduce it exactly, ready for painting.

145

Cars Passerby

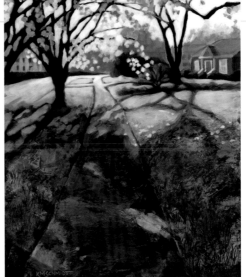

Editing down

Stripping out the transient clutter from the world we see every day reveals timeless images of great serenity and paintability. Details such as the cars and the passerby in the photograph opposite have been removed for the purpose of the painting: it's the same place, same day, but a different world.

Less is more

An important point to note, here are some tips to help you translate this to your painting:

1. Know what the theme, focal object, or beating heart of your painting is and get in close. Make it shine: a cupful of focus is worth a bucketful of brainwaves.

2. You can't include everything you like in just one painting, so eliminate all the random elements; confusing the viewer with irrelevancies is unhelpful.

3. Keep a list of all those spontaneous ideas for future reference, but don't feel you must include them here and now.

4. Consider splitting a complex subject into three simpler panels – a triptych.

5. Simplify, simplify, simplify wherever possible.

146

Turn to light

The strongest unifying force within a painting is the light source. If the work seems incoherent or the objects unrelated, consider where the light is coming from, and emphasize it. A single source always works best; even if the sun doesn't shine into your studio, pretend it does!

Here a bright light from the side bleaches out the highlights, an effect known by photographers as 'soot and whitewash'. This provides ideas for the painting.

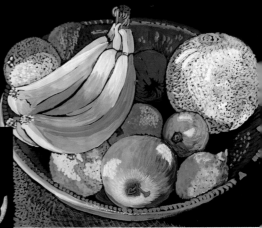

The flat frontal lighting reveals little of the forms of the fruit, and fails to create enough tonal contrast to make the subject exciting.

The artist has used both photos and her own experience to produce a delightful rendering of the subject that clearly defines the shapes and forms.

ARTIST AT WORK
Making compositional choices

The basis for any painting must be the artist's personal involvement with the subject. The painting must say to the viewer, 'this is how I experienced it' rather than 'this is what it looks like'. When basing work on a photograph, spend time sketching alternative designs, so the painting doesn't just look like a lifeless copy. Here an artist's thoughtful approach has created a painterly image that evokes the spirit of place.

Palette

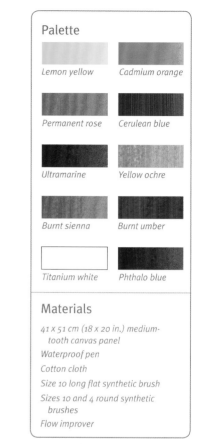

Lemon yellow	Cadmium orange
Permanent rose	Cerulean blue
Ultramarine	Yellow ochre
Burnt sienna	Burnt umber
Titanium white	Phthalo blue

Materials

41 x 51 cm (18 x 20 in.) medium-
 tooth canvas panel
Waterproof pen
Cotton cloth
Size 10 long flat synthetic brush
Sizes 10 and 4 round synthetic
 brushes
Flow improver

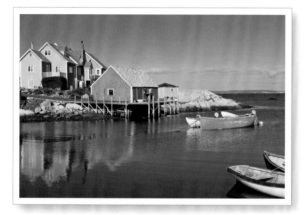

An attractive photo, but the foreground is dull, and the boats in the right-hand corner attract unwanted attention.

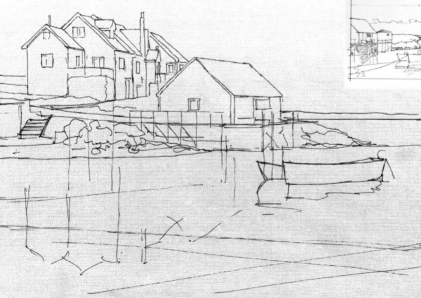

1 Four draft design layouts have been considered, leading to a decision to use most of the photograph but with crucial adjustments: the blue buildings and the boats are moved inward to tighten the composition; the steps are emphasized, since they lead the eye into the group of buildings; and clutter is eliminated, including the foreground boats, which lead the eye out of the picture.

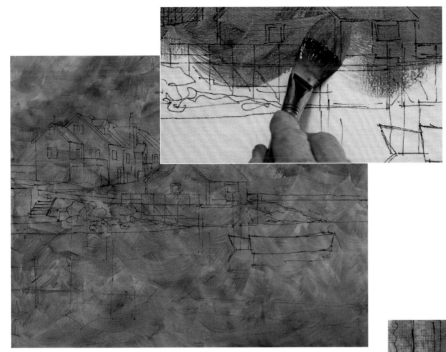

2 Having drawn the design with waterproof ink, a coloured ground of loosely mixed phthalo blue, cerulean blue with flow improver, and a touch of permanent rose is laid down with the size 10 long flat brush, using quick, crosshatching strokes. These vigorous marks introduce energy and set a tempo for the following stages.

A soft rag wrapped around the artist's forefinger enables him to lift out colour quite precisely.

3 Here areas of colour are being 'lifted out', using a clean cotton rag dipped in water, while the paint is still slightly wet. The flow improver has helped prolong this 'open' stage. The aim is not to recover white areas but to begin to establish the tonal structure and movement in sky and sea.

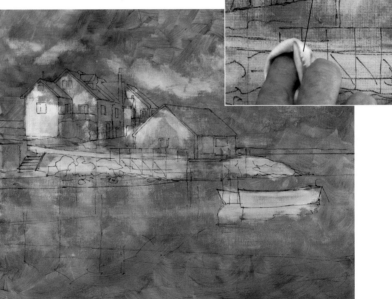

147

Preserving the drawing

When you want the drawing to show through the paint – which can give a stylish effect – use a waterproof pen, so the marks won't dissolve. You can add further linear or scribble detail to the work at any stage. If penwork is a strong feature of the finished piece it should be called 'mixed media'.

148

Killing the white

When painting on a coarse-woven canvas, nothing looks worse than leaving accidental specks of white ground showing. It makes the work look thin and careless. Applying a coloured ground right at the start, when it's easy to work into all the tiny hollows, is the best way to avoid this 'moth-eaten' look.
For more on coloured grounds, see page 45.

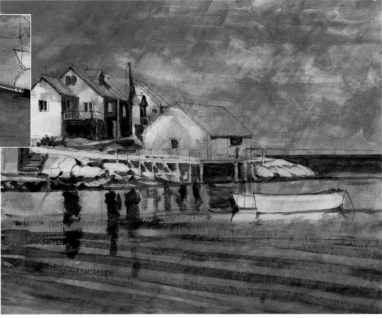

4 The darker areas are put in using concentrated step 2 colours and the size 10 round brush. The balanced construction of the painting relies on this 'dark pattern' and the masses of the horizontals and verticals are carefully judged. The slightly diagonal movement of the water offsets any rigidity. A painting has to work as an overall design at every stage.

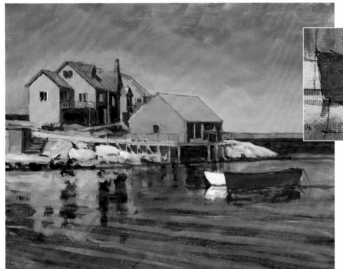

5 Now the 'light pattern' is being developed. The boathouse is permanent rose with white on the bright side, and rose with blue on the shaded side and the red boat. The rocks are white with yellow ochre, the third primary colour. A mix of the three primaries makes a pale, warm grey for the boathouse roof. The size 4 round brush is used for these more detailed areas. White with phthalo blue and the size 10 flat brush lighten the further sky.

149

Brush-holding techniques

When holding the brush in a penlike grip, it's easy to become too fussy. Holding the brush between all the fingers leads to more vigorous and gestural marks. Two common holds are the penholder grip and the finger grip.

The penholder grip is a natural way to hold a brush and useful for accurate details. The movement comes mainly from the wrist.

The finger grip makes horizontal marks freely, with movement coming from the shoulder. The thumb grip makes vertical marks firmly, with movement coming through both elbow and shoulder.

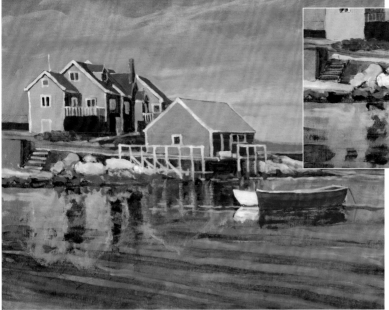

6 The painting so far has good visual unity based on a restricted palette of mainly cool colours, and now it's time to be more adventurous. Burnt sienna and orange add warmth to mixes for roofs, rocks and reflections. White, with a little rose to modify its 'chalkiness', picks out building details, railings and (softened with a rag) the clouds.

7 Burnt umber, phthalo blue and a little permanent rose make a chromatic black for the darkest darks, put in with the smallest brush for accuracy. The dark line where rocks and boats meet the water gives weight to these objects. To give the water more character, dark, flowing strokes are laid in with the big flat brush and worked over quickly with a damp rag.

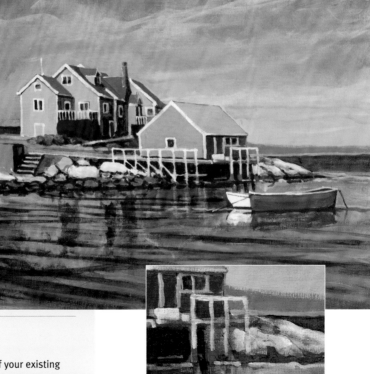

150

Staying in key

When introducing new hues to a painting, see if your existing palette can provide a mix to do the job, or if perhaps adding one extra colour as a 'mixer' is a possibility. For instance, here the greens are made by adding lemon yellow (new) to the blues, rather than introducing a pigment green. This way all the colours stay in key; they are related, and no one dominates.

Dark colour is laid around the edges of the white railings to give them clearer definition.

8 Glazes are used to blend and unify elements of the painting. Ultramarine diluted with flow improver intensifies the blue of the upper sky and water. This powerful pigment can be used very thinly so the underlying work remains visible. The clouds and their reflections are refreshed with a white glaze containing a little rose/phthalo blue. A rose glaze picks out the distant coast and reflection of the boathouse, and yellow ochre softens the darks between the rocks.

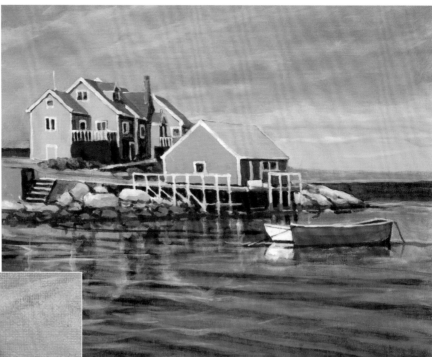

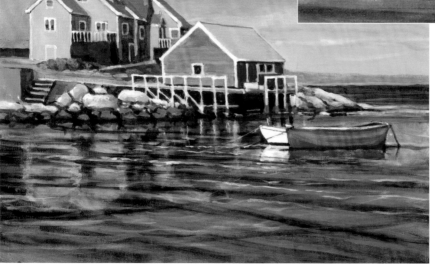

9 After leaving the painting for a while, it's easier to see what small touches may finish it without overworking. Cadmium orange highlights on the roof ridges create a diagonal of warm colour on the boats, via the boathouse, now also glazed with orange. Pure white highlights are added sparingly on the sunny side, including wavelets crossing the reflections, bringing life and movement to the painting.

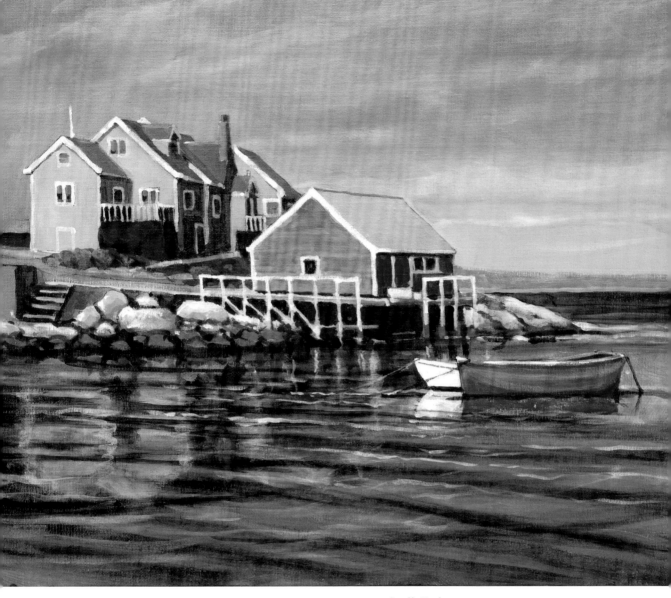

Sunlit Harbour
(Acrylics on 41 x 51 cm [18 x 20 in.] medium-tooth canvas panel)

Bob Brandt

Tools for seeing

The secret of composing a painting is not just knowing what to include in it; it's also knowing what to leave out. In practice this means locating the edges. These simple, easily made gadgets are versions of tools that artists have been carrying around in their pockets for centuries. Looking through them, holding them closer or further away, left, right, up, or down in relation to your subject, you will find the setting that pleases you most. You don't need to know a lot of complex aesthetic theories; just carry one of these handy gadgets. Let's call them paintoscopes.

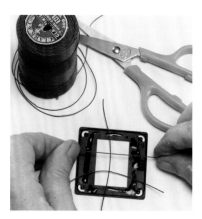

151

A pocket paintoscope

These simple framing devices help you isolate what you want to paint and then translate what you see onto the painting surface.

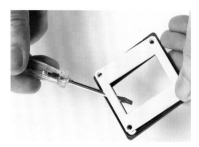

1 Find an old colour slide, and open the mount carefully. It should just pop apart.

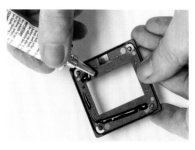

2 Apply some strong glue to the inside of the mount.

3 Cut three lengths of dark thread and place them in a grid formation across the glued surface.

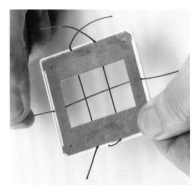

4 Snap shut the back of the slide mount and pull on the threads to make them taut.

5 Once the glue is dry, snip off the excess thread from the perimeter of the mount.

6 Burn a small hole in one corner with a hot needle and thread some string or ribbon through it. Once finished, you can wear it round your neck, or attach it to a keyring, so it's always handy. Make several different paintoscopes using a variety of grids.

Attach the gridded paintoscope to the arm of an old lamp. This will help to keep your hands free.

152 Studio paintoscopes

This is a bigger grid for use in the studio. It may just be a cardboard sandwich with an acetate window. You can make a stand for it – perhaps just a wooden block with a groove to splice the frame in, or just use the bendy arm of an old reading lamp. Both devices leave you free to work without having to hold the frame. Artists' studios are full of such gadgets – the real tools of the trade that can't be bought in art shops.

1 Draw a grid on paper. You can use large or smaller subdivisions depending on the complexity of the subject you want to draw.

2 Lay a sheet of acetate over the hand-drawn grid, and trace it.

3 Place the acetate onto a larger piece of cardboard and pierce through corner markers. Cut out the central area of the cardboard to make a frame.

4 Run double-sided tape all around the edges of the acetate, and stick it to the frame. The frame helps you isolate the areas you want to draw and supports the acetate sheet.

153 Using your paintoscope

Set up a simple still life and look at it through your paintoscope. See where you want the centre and edges to be. Draw the same grid on your painting surface, then draw in the main shapes of the still life, carefully observing where the shapes and lines of the still life intersect the grid lines. Alternatively, sketch onto a grid on paper first, then transfer the drawing to your painting surface.

More ways to improve your vision

As a visual art, painting deals with the artist's ability to see and to translate the fruits of that seeing into a two-dimensional experience on canvas that can be shared. Casual looking is not enough: to really see is to go beyond what we think we know about the world, penetrating the surface appearances of things and arriving at a deeper appreciation. How to convey the vision to the canvas is every painter's ongoing conundrum, but there are many simple techniques that can help greatly to refine your powers of perception.

154

Squaring up

The traditional way to enlarge drawings by means of a gridwork of squares is explained on page 150. Another method that works well for still-life or figure painting is to draw a grid on a piece of paper and hang it behind the subject. You'll immediately see how the parts relate to each other spatially. Heights, widths, and foreshortenings can be measured optically, and quickly transferred to the support, marked up with the same grid.

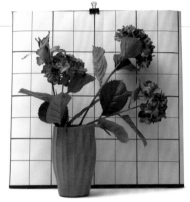

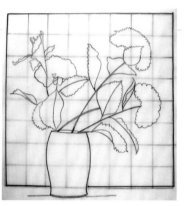

1 Place your chosen subject against a drawn grid. Take time to assess the relationships of the parts, their sizes and their positions.

2 Now draw a grid with the same number of squares onto your support. Transfer the content of each square across your support; the content of each stays the same, only the scale changes.

155

Do away with detail

Look at the subject through a sheet of fine netting to reveal the main shapes and colours. Or, if you're working from a photograph, scan it at very low resolution so that it pixelates, for the same effect. If the picture doesn't work when the details are removed, it won't work with them either.

156
Three dimensions into two

In everyday life we deal with a layered, three-dimensional world; when we paint, the brain often has trouble switching off this complex knowledge to deal only with that which is strictly visible. The canvas is a flat plane, so the round world must be flattened to fit it. All you need to do is shut one eye and your depth of field will disappear. It may take a few moments for the brain to register the new mode, so try wearing an eye patch (pirate style) while drawing. Squinting is a somewhat uncomfortable alternative.

157
Upside down and backwards

Finding simple ways to reverse an image fools the brain into seeing the 'known' in a completely fresh light. Halfway through a painting, it's a good idea to check for anomalies by looking at it in a mirror, over your shoulder and also possibly between your knees. Not necessarily all at once. Or you could just turn the painting itself upside down, of course. You'll be surprised what you discover: things such as imbalances in composition and tonal blandness become immediately apparent.

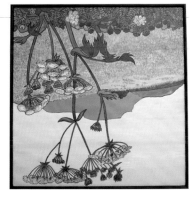

See through new eyes
Turn your work upside down for a brand new take on your painting.

158
Make a lightbox

Much used by animators and graphic designers for preparing drawings from printed material, or trying out alterations and overlays, lightboxes can be easily made at home from recycled computer scanners.

Recycling an old scanner
Unscrew the glass plate and insert a low-wattage (11W) light bulb. Cover the glass with tracing paper or frosted plastic to diffuse the light, and hey presto!

159
Right-brain vision

There are many books on this fascinating subject. In short, the left brain deals with language and logic, the right with nonverbal perceptions. Your right brain sees, draws and paints the whole field before it, just as it is, and functions much better if the meddling, know-it-all left brain is kept otherwise occupied. So the common painter's practice of listening to the radio while working has a scientific basis! With practice you can learn to access your right brain directly – the best place to be when you want to really see.

160
Quick comparisons

A transparent ruler and your thumb can be used to measure relative sizes of distant objects. Line up the top of the ruler with the top of the object, slide your thumb to the bottom, and note the length. Repeat with each item. A pencil can be used instead, but the ruler method is more accurate.

Perspective does not alter the width of the circular bowl, which is 17.5 cm (7 in.). Use these measurements to draw the ellipse.

Because the perspective shortens the bowl, the seen measurement of the ellipse is 12.5 cm (5 in.).

The relative positions of the eggs can then be checked and drawn using the same method.

ARTIST AT WORK
Achieving accurate drawing

The photograph was taken especially for the painting, and it is thus important to transfer all the elements of the composition faithfully onto the working surface, using the squaring-up method. A slight rearrangement of the background flowers on the left is all that is needed to improve the composition. With the drawing complete, the artist is able to work with confidence to convey the delicacy and fragility of the backlit flowers.

Palette

Cadmium yellow light	Cadmium yellow medium
Cadmium orange	Cadmium orange deep
Permanent red	Anthraquinoid red
Quinacridone red	Ultramarine violet
Chromium oxide green	Yellow-green
Green-gold	Raw umber
Titanium white	Gel medium

Materials

Soft (2B) pencil
Ruler
122 x 71 cm (48 x 28 in.) stretched cotton canvas (or smaller: any 12:7 proportion)
Various sizes of flat and pointed synthetic brushes
Fan brush blender
Hog bristle flat brush

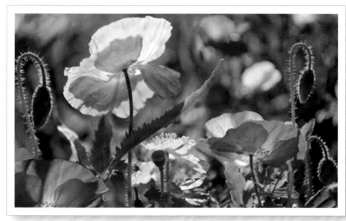

This photograph has been taken specifically for the painting, so little or no 'editing' is required.

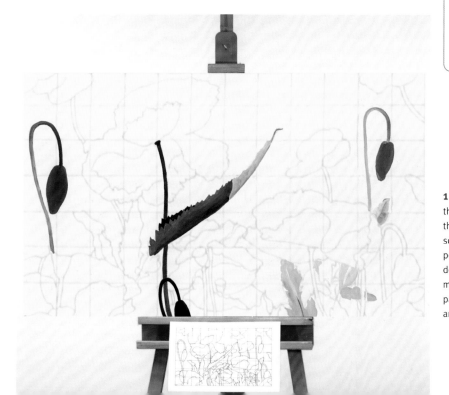

1 A grid of lines is drawn lightly onto the photograph and then, scaled up, on the canvas. The outlines are copied square by square, using a very soft pencil and minimum pressure to avoid denting the canvas or leaving heavy marks that may show through the paint. A few dark and pale green areas are filled in to set some tonal values.

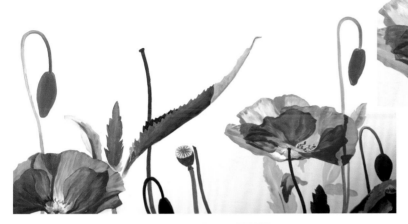

2 The major stems, leaves and buds are painted, using chromium oxide green and raw umber, and blending in white for the graduated colour changes. Less green, more umber provides neutral hues, as in the pod caps. The brightest leaves are yellow-green, green-gold and white. The foreground poppies are blocked in with quinacridone red plus white, using permanent red for the shadows of petal overlaps and stamens. The centres are white with minimal violet, cadmium yellow light and yellow-green.

3 Two paler poppies appear, painted with mixtures, further back in the picture plane and catching the light. Again, this shows how dark colours advance and pale ones recede. Creating a layered look to the poppy petals involves sculpting the frilly shapes and shadows with light and dark tones. The pink mixtures, having lots of white, are very opaque, so painting over them is easy. Neat quinacridone red, which is transparent, gives emphasis on mid-to-darker tones.

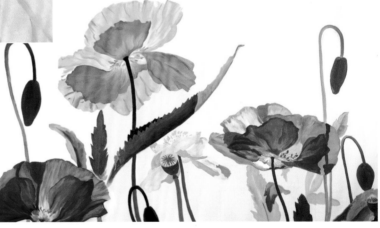

161

Mixing good greens

This painting requires a variety of greens, so it relies on mixing hues that are pleasing rather than dirty looking, as greens made from certain blues (such as ultramarine) often are. Here, chromium oxide green provides an opaque mid-toned green that, mixed with raw umber and white, produces a range of tones. These mixes, added sparingly to pigment greens, will 'knock back' excess vividness. The brightest greens here are yellow green and green gold, plus yellows and white. Note there are no blues in this palette!

162

Working with red

Red pigments are expensive, but luckily, they have powerful tinting strength – a little goes a long way. When mixing pinks, always start with the white and add red cautiously. To lighten reds while keeping the hue pure, either paint as a thin glaze over a white ground, or try adding lemon yellow. Adding white will give you pink, a completely different hue.

4 More poppies are added, interwoven with the existing stems, leaves and petals to create three-dimensional effects. Using opaque paint means the new flowers can be painted as wholes and the greenery simply repainted on top. The new poppies are mostly white, with cadmium orange and permanent red. The centre-bottom poppies, seen from above, have stamens showing. These are touched in with cadmium yellow.

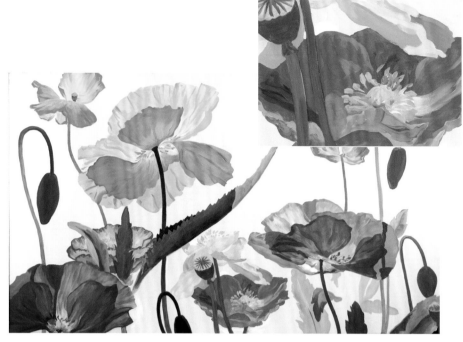

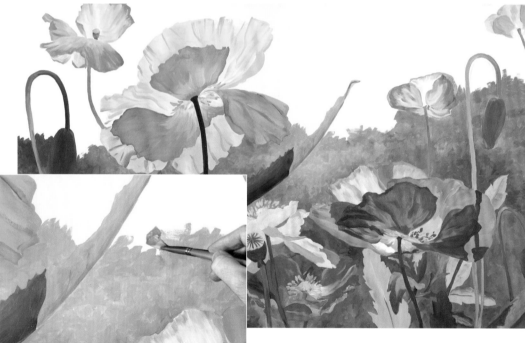

5 The background filling in can now begin. Close attention must be paid to the tones – not only to keep enough contrast, but also so the foreground stays darker. Shadowed ground under the flowers will be dappled with lighter patches. Using combinations of all the green mixtures already in play and a flat brush will achieve these broken colour effects.

163

Improving the original

Comparing the painting at this stage with the photograph shows how the composition has been altered so that the fore- and middle ground (in sharp focus) take a pleasingly balanced curve. Now the uncluttered, out-of-focus background (negative space) will give distance and spaciousness to the painting. This also prevents the piece from becoming choked with detail.

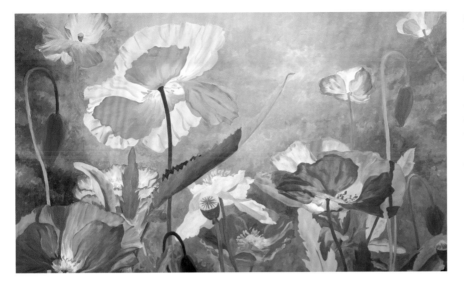

6 The far background is added in paler tones, blending brushstrokes with the fan blender for a soft-focus effect suggesting distance. The painting is balanced – weight at the bottom, airy space at the top. Now it's left to dry thoroughly, since the thick layers of opaque paint may have trapped moisture, leading to unstable patches. The painting is then coated with gel medium, using a hog bristle brush and following the contours of the forms. Patches disappear, replaced by an even sheen that really pulls the image together.

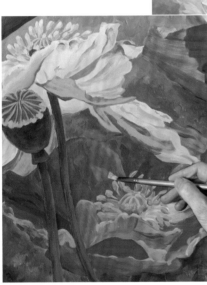

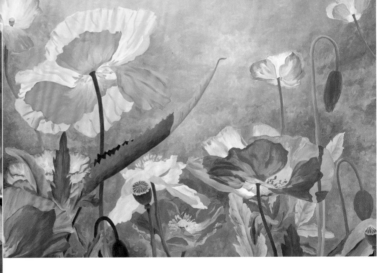

7 Now that the whole painting is sealed, delicate details will flow on smoothly. Using smaller pointed brushes, every flower is refined using anthraquinoid red, a transparent pigment that blends easily. Ultramarine violet with permanent red produces deeper darks and raw umber gives more shadow in the leaves. The poppy centres get some accurate botanical detailing, with yellows and oranges adding sparkle to the colour scheme.

164

Angles of vision

When painting forms in nature, it's important to observe details accurately to avoid confusing the viewer. The angle of vision must be consistent throughout. In the steps above, some poppies are seen from the side or from above, so their centres have yellow stamens. For poppies seen from below, only shadows (in a darker shade of poppy) are visible. The anatomy of the flowers gives important clues to what is going on.

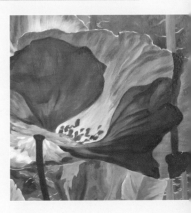

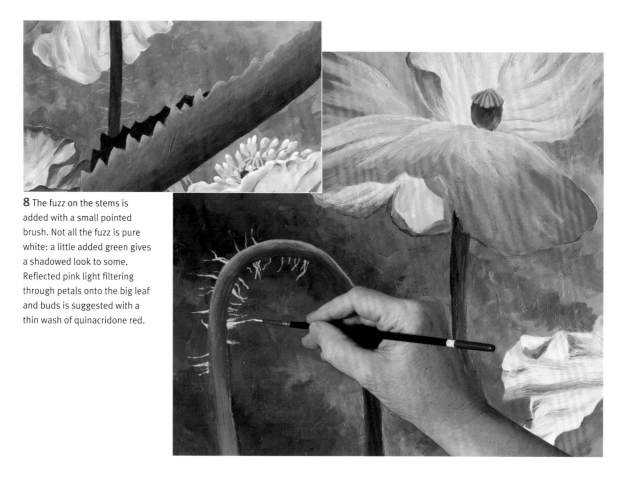

8 The fuzz on the stems is added with a small pointed brush. Not all the fuzz is pure white: a little added green gives a shadowed look to some. Reflected pink light filtering through petals onto the big leaf and buds is suggested with a thin wash of quinacridone red.

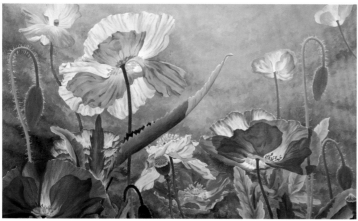

9 The contrasts of stems against leaves and the veins in the leaves are strengthened to increase the three-dimensional effect. The last of the highlights are added.

165

Delicate highlights

Problems can arise when opaque white paint is used with a thin pointed brush for super-fine highlights. The paint sticks to the brush rather than the canvas, or it comes off in lumps. The remedy is to dip the very clean brush in flow improver before each stroke. Now twirl it lightly through the white and make the mark. Repeat this for every single stroke. Your patience will be rewarded.

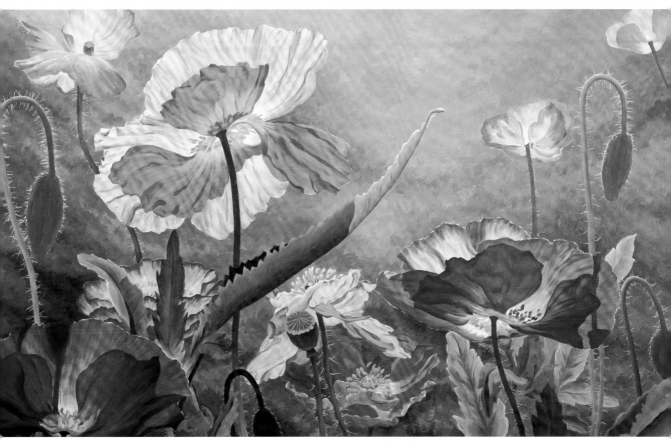

Poppies
(Acrylics on 122 x 71 cm [48 x 28 in.] stretched cotton canvas)

Lexi Sundell

Good subjects

As an artist, it's your freedom and privilege to paint anything you choose. Where subject matter is concerned, anything goes. People may criticize how you paint, but not *what*. It's much easier to persevere if you pick a subject you truly love, but leave yourself room for surprises, too. In time your ultimate subject will find you, so until then, don't be afraid to explore and experiment. Keep an open mind and be guided by your hunches. You'll arrive somewhere original and have an entertaining journey getting there.

166 The artist's viewpoint

Study your subject from every angle, not just the obvious one you first saw. Anyone could see that! For the painting to have depth, the subject needs to be thoroughly explored. Seek out the unexpected, the revealing, the dramatic potential. If you find no fresh thrills, abandon it.

The same group of trees seen and drawn from different angles suggests a variety of ways to paint them.

167 Best-seller subjects

These vary depending on your locality; visit local exhibitions to gauge the most popular. Then avoid them. Or, if you really must, find a very fresh angle! Local views are always in demand, but paint places off the beaten track, not the picture- postcard views. Some subjects have been so overdone that they are now incurably corny; often they are also unsuitable for painting. Sunsets, for instance, are lovely in the sky, lurid on canvas. Originality is always the best policy.

168 A reference collection

Whatever your range of subjects, a good store of reference images is invaluable. Cut out and collect images, and file them away in separate folders for a quick retrieval system.

169 Representation or abstraction

All painting is just an approximation of reality, so always feel free to digress from literal accuracy – therein lies the adventure. There's absolutely no point in reproducing a photograph, however perfectly. Use your source material as a jumping-off point, not a slave driver! What people seek from art is a chance to see the world through other eyes – yours. So develop your vision, wherever it leads you. Be fearless.

In this much-simplified interpretation of a landscape, the most important aspects are the interrelation of shapes and colours.

Here the artist has simplified the subject even further, producing an abstract rendering in a more geometric arrangement.

170

Still life

Still-life painting is perennially popular because it allows the artist total control, and the chance to explore more complex forms of beauty under the skin of everyday appearances. Still-life painting is all about working from reality, painting what you see, not what you think you know. This gives the work truthfulness and integrity. Of course, you can digress and be fanciful, too. See right for some useful hints, and turn to pages 102–105, for one artist's approach to painting still life.

171 **Hints for painting still life**

1. Choose pleasing but simple objects with some colour or shape relationship to each other. Avoid fussiness and crowding.
2. Decide whether to aim for three-dimensional with tonal effects, or a flat pattern.
3. Build a strong structure with verticals, horizontals and diagonals.
4. Be aware of geometric shapes, cylinders and spheres.
5. Odd numbers of objects balance better than even ones.

◀ **Cropping**
Never be afraid to cut off some of the subject, as in this painting, where the bowl has been cropped on the left.

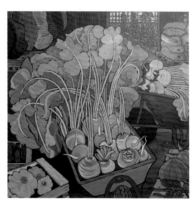

◀ **Movement**
In order to make still life look alive, rather than dead, try to create a sense of movement. Here the turnip leaves seem to be reaching up to the light.

🖌 **TRY IT** ▸ **Be original**

Although conventional still-life subjects such as fruit, crockery and dead fish can be satisfying to paint, there are a lot of other examples out there to compete with yours. Look around for more original ideas. Hats on a hat stand, a collection of colourful purses, or natural groups of everyday objects gathered together in a serendipitous way rather than self-consciously arranged, are a few examples of less commonly used subjects.

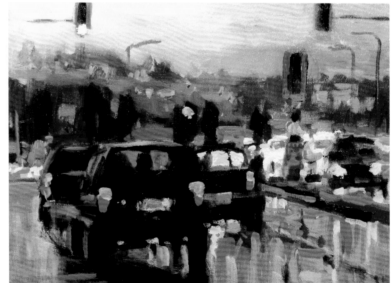

▲ **Found subjects**
Still life need not be something you set up in the studio; any kind of inanimate object in its natural habitat will do. Cars in a traffic jam, tools in a shed, or cakes in a shop window: all such subjects qualify as 'found still life'.

172 Flowers and trees

Plant life is a subject that you can treat as loosely or accurately as you please. Everyone loves to have flowers that won't fade on the wall, so plant paintings always sell well. More importantly, you, the painter, have a fine excuse to sit out in the garden all day, and even buy yourself bouquets! You don't have to be a botanist, but the close study of the wonders of nature will enrich your life as an artist in so many ways.

Trees are the perfect models and an enduringly satisfying subject, full of grace and poise. Don't try to copy every branch, but catch the gesture instead; think of the tree as a dancer. Try painting the negative spaces among the branches, the sky rather than the wood. For the extremities turn the painting upside down so the brush naturally tapers just as the twigs do. Every tree is unique, and its habitat is part of its character. Unlike some subjects, you can trust them to stay just where they are!

173 Approaches to painting flowers and trees

1. The scientific: Show the plant as a specimen, arranged on the white background of the paper with shadow to enhance three-dimensional realism.
2. The habitat: The plant is the focus, but its home context is included for interest. Fill the canvas.
3. The decorative: Emphasize pattern, colour and swirl – energy and shape rather than detail.
4. The abstract: Zoom in on one aspect of the living plant or garden and find your inspiration.
5. The macro: Think big. Paint the whole scene just as it is, weeds, junk and all. Go for atmosphere.

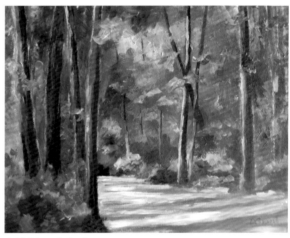

▲ **Light and shade**
Although the sky is not visible, the shadows across the path and the patches of bright foliage are evidence of a fine summer day.

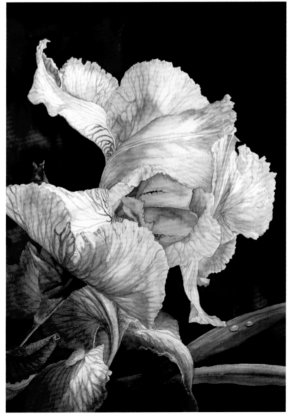

▲ **Close-up**
Flowers like these, with strong and exciting shapes, deserve a close-up treatment. The dark background highlights the light and middle tones of the petals.

▲ **Pleasing diagonals**
The verticals of the flowers and post contrast with the diagonals to form a pleasing composition in which the eye is led from one area to another.

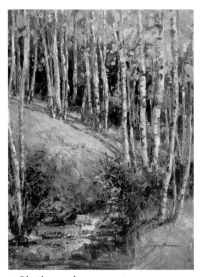

▲ Rhythm and movement
The verticals of the trees combine with the opposing diagonals of the stream and the top of the bank to create a strong sense of rhythm.

▲ Atmosphere
The sheds and pieces of wood in this piece give a hint of continuing horticultural activity.

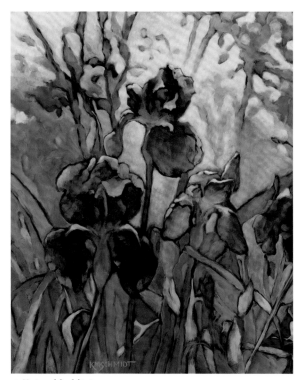

▲ Wildflowers
The bird in the middle distance emphasizes the naturalness of the scene.

▲ Natural habitat
Much of the background and foreground detail has been edited down in order to focus on the irises.

174

Landscapes

Fitting a big world onto a small canvas is the challenge of landscape painting. Since you can't include everything, be selective; define your boundaries and hone in on telling details that give the feel of the whole.

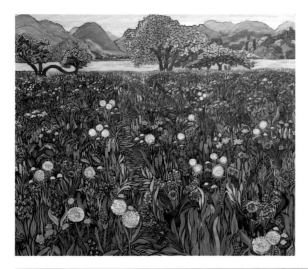

Hints for painting landscapes

1. Keep the composition open. Include by suggestion the landscape that overflows the painting's edges. For example, include paths that vanish round corners.
2. Include framing devices – foreground interest, trees, views through windows – as these establish a human scale and presence, and by contrast make the distant landscape vaster.
3. Don't always seek out the awesome. Intimate landscapes such as parks and gardens have great atmosphere, too.
4. The aim is to make the viewer feel they're there; so include details for them to discover.
5. Think carefully about how much sky you want/need to include and how it will affect the atmosphere you seek to evoke.

◀ **Foregrounds**

Here the foreground occupies most of the picture space, and is treated in detail.

▼ **Choosing the light**

This landscape could have looked dull on an overcast day, but the low sun creates a wealth of colour contrasts.

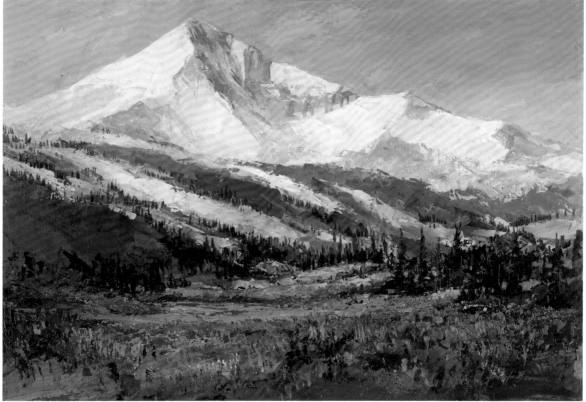

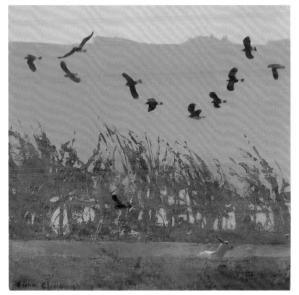

▲ Creating interest
The landscape itself has been simplified in order
to focus attention on the flight of birds.

▲ Cloud effects
Skies are often the most exciting aspect of a landscape,
and here they have been given the 'starring part'.

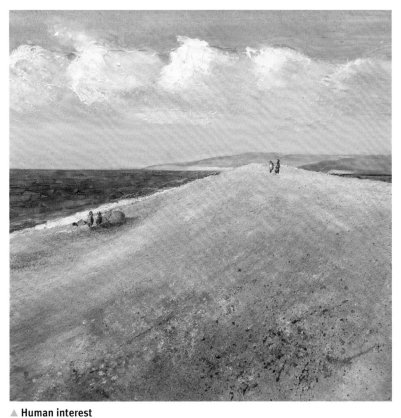

▲ Human interest
The small figures at the top and side of the hill draw
the eye into the picture and hint at a story.

▲ Sunsets
An ever-popular subject, but the effects are
short-lived, so have your camera ready.

▲ Simplifying
All detail has been suppressed to create a
semi-abstract arrangement of shapes.

176

Buildings and townscapes

Buildings, whether inside or out, singly or in groups, are a subject area that offers a wealth of possibilities. For buildings in towns or cities, you may have to rely on photographic reference, as it is often not possible to find a suitable – and safe – place to set up your easel. And the light will change, so again, use photos as a back-up.

177

Hints for painting buildings and townscapes

1. Simplify wherever possible. It's the building as a whole you are painting, so don't let details dominate.
2. Study the Masters: Cézanne, Stanley Spencer and Edward Hopper, for instance, had interesting ideas on the subjects.
3. 'Contre jour' (against the light) is a good approach to painting the shapes of buildings and skylines, dark and bold against a brightly-lit background, thus eliminating all tiresome detail.
4. Consider colour temperature. For unity, the scene should be clearly warm or cool.
5. Beware of perspective inaccuracies. Check all angles against the horizontals of a viewfinder (see page 74).

▲ **The centre of interest**
The red awning, intersected by the lamppost, forms the obvious focal point of this attractive study.

▲ **Buildings in landscape**
This is more a landscape than a picture of buildings, with snowy road and lit windows giving a strong sense of atmosphere.

◀ **Urban landscape**
Unlike pure landscape, towns and cities are seldom unpopulated, and people going about their business will add an extra element to your work. Market scenes are always popular with artists.

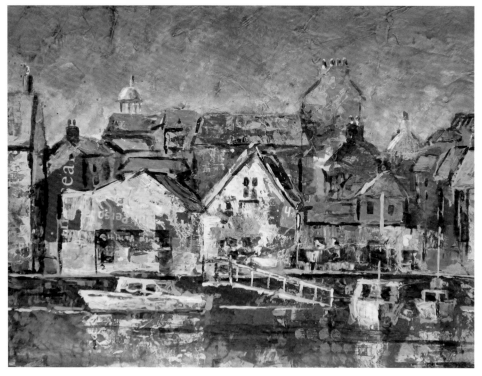

▲ **Playing with shapes**
Most buildings are based on variations of a cube shape, and here the artist has exploited these simple geometric shapes, together with the tall oval of the tree, to produce a satisfying composition with strong abstract values.

◀ **Groups of buildings**
In this rendering of a seaside village, detail has been kept to a minimum to stress colour interactions.

ARTIST AT WORK
Painting from life

Painting from life is a satisfying exercise since the painter can examine the subject closely, in the round, and arrange it to his liking. Lemons have been chosen for this piece because they don't droop or wither, and so the work can proceed at a leisurely pace. A disciplined use of colour and close attention to detail give this piece its classic painterly quality.

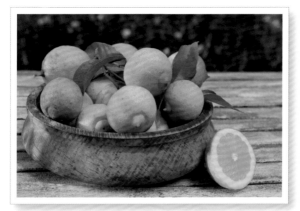

Arranging the group is the first step to composing a still life, so take your time at this stage.

Palette

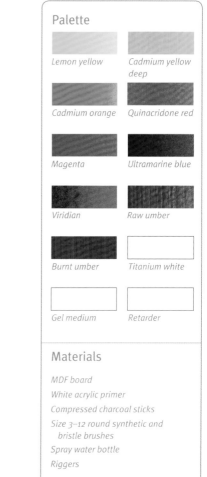

Lemon yellow

Cadmium yellow deep

Cadmium orange

Quinacridone red

Magenta

Ultramarine blue

Viridian

Raw umber

Burnt umber

Titanium white

Gel medium

Retarder

Materials

MDF board
White acrylic primer
Compressed charcoal sticks
Size 3–12 round synthetic and bristle brushes
Spray water bottle
Riggers

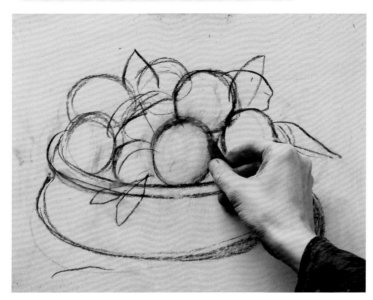

1 The image is drawn freehand onto the primed board (two coats); in the process the painter gets to grips with the geometry of the shapes and shadows and makes adjustments to improve the balance. Compressed charcoal gives a crisp line, smudges well for shadows, and can be altered with ease. When the composition is settled, all the dust is shaken off.

178

Handling charcoal

Drawing charcoal is made from hand-peeled, half-burnt willow twigs. Each stick is slightly different, so breaking it into short lengths gives different facets of different blacknesses that make different marks. However, the dust and crumbs can be a nuisance, especially if they get into wet paint, forming nibs. A soft brush (a baby's hairbrush is ideal) will remove most of it, while a slice of soft white bread makes an excellent blotter to remove any remaining powder.

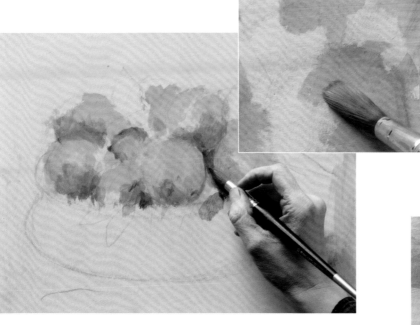

2 The lights are now laid in with the two yellows, with touches of viridian and burnt umber to develop the roundness. Using a big round brush helps keep the shapes bold. More green and umber block in the shadows among the fruit. The background area, which will be dark, is used to check hues before they're applied to the piece.

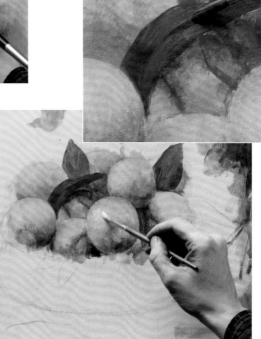

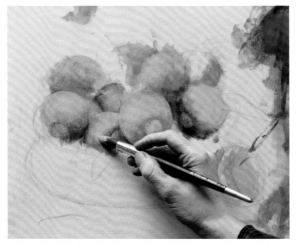

3 The paint is built up further to give a rich, buttery surface, adding gel medium for extra body plus retarder to keep it workable longer. The edges of the lemons are defined by tonal changes, not lines, so the paint is worked outward carefully on each fruit until the edges are 'found'.

4 The leaves are painted with an opaque mix of viridian with cadmium yellow, plus burnt umber for the veins and shadowed parts; the leaves give movement and a lift to the composition. Then the sunken areas of the lemons are brought forward with highlights of lemon yellow with white and faint touches of orange to warm the mix.

179

Retrieving sunken areas

Acrylic paints tend to darken as they dry. This sinking effect leads to a certain drabness. To get back to a lighter tone, sand the paint back until the luminosity of the white ground returns. On coloured grounds, simply repaint with more white in the mix. With practice one learns always to mix tones too pale!

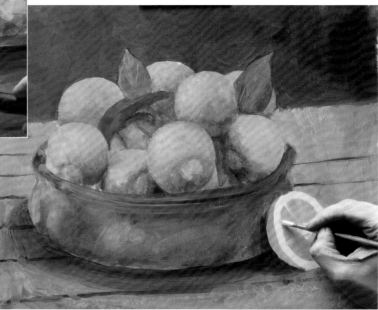

5 Now with different mixes of umbers, magenta and white, the bowl and background are painted in, working fast with a broad brush and roughing in highlights and shadows. Using fingers and a spray of water helps with blending their soft edges. The tabletop lines are sketched with a rigger, a bit 'out of focus' to keep attention on the lemons. The half lemon gets the white detail that makes it stand out.

180

Lighting control for still life

Painting from real objects in the studio is made unnecessarily complicated by shifts in the angle of lighting at different times of day. One remedy is to construct a simple stage-set box – a large cardboard carton may be enough. The front will be open so you can see the subject, giving front lighting. Cut holes and position lamps wherever you want additional lighting. Shines and shadows will stay just where you want them.

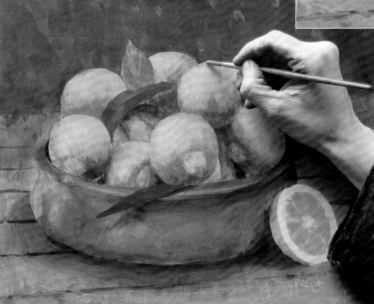

6 To liven up the background, rough strokes of viridian with ultramarine blue give a suggestion of shrubbery beyond the table. Adding yellow to the mix, the shine on the bowl is worked up, then a single leaf overhanging its edge is painted in, with its shadow enhancing the realism. A few touches with a small brush sharpen the edges of the lemons. Finally – and boldly – a glaze coat containing minute amounts of the browns, viridian and a transparent red – quinacridone – covers the whole piece, broadening the colour range and softening the outlines, pulling the painting together.

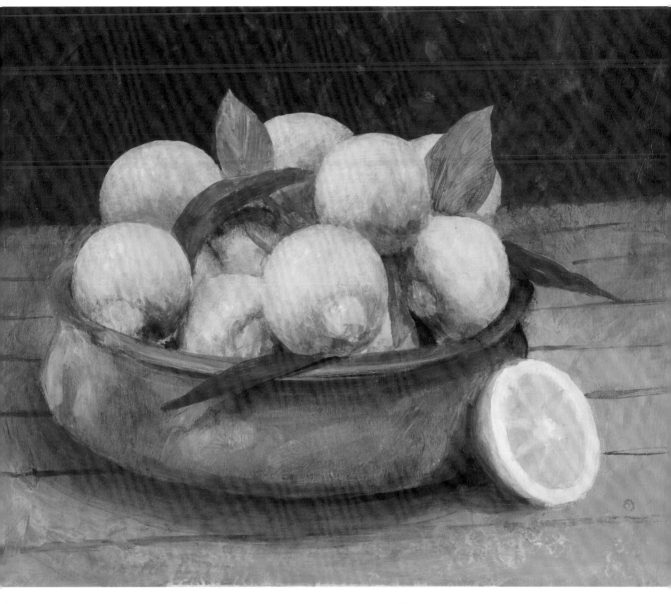

Odd One Out
(Acrylics on 41.25 x 30 cm [16 ½ x 12 in.] MDF board)

Brian Gorst

Colour theory

Understanding colour theory is tremendously helpful in the moment-by-moment decision-making processes of painting. Knowing how colours interact lets you create dramatic optical effects and brings power and confidence to your work. Warm and cool, complementary, low- and high-key colour – a grasp of these concepts will help you select colours that, put together, will determine the emotion and atmosphere of the painting. Here you'll find the most useful ways to apply this knowledge to the task at hand, in a practical, not just theoretical, context.

Yellow-green (tertiary)

Green (secondary)

Green-blue (tertiary)

Blue (primary)

Blue-violet (tertiary)

181

The colour wheel

Colour wheels are available in various forms. Commercial wheels using printer's colours show the generic colours, and although interesting, they tell you less than a wheel made from actual pigments, as here – pigments don't behave in quite the same way as printed colours. But all colour wheels explain the relationship between colours, i.e. which are the primaries, which the secondaries, and which are the complementary colours.

Furthest apart here are the three generic primary colours – red, yellow and blue (each of which has several different versions, for example, cadmium red is much hotter than alizarin crimson). Between these are various hues that can be obtained from mixing adjacent colours. Mixes of two colours are called secondary, while mixes of three primaries, or one primary and one secondary colour are called tertiary, examples being the blue-violet mix and the red-orange mix on the wheel (see opposite for neutral tertiary colours).

The colour wheel also shows which colours harmonize and which do not. Basically, adjacent colours, or those of the same 'family', are harmonious, while those opposite one another create strong contrasts. Try to balance both in your work.

182

Red and green are much the same tone, so don't use them in the same proportions, since the effect will be overpowering.

Violet is much darker than yellow, so may need to be knocked back with white.

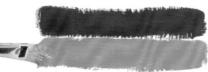

Fully saturated blue is darker than orange, so again may need lightening to work well.

Complementary colours

As you can see from the wheel, red and green, yellow and violet, and blue and orange are opposite one another. These are called complementary colours, and have a vital role in painting. When placed together in equal proportions and the same tones, these colours can have a jarring effect, which can be unpleasant, but a little red in a predominantly green landscape lifts the whole thing amazingly. Likewise, muted purple is often used for shadows on yellowish paths or buildings. When you use complementaries, play with the tones and proportions.

Complementary contrasts

Such contrasts work best when both colours are fairly close in tone, otherwise the tonal contrast may assume unwanted precedence.

Colour wheel
Make your own copy of the colour wheel to pin up in your studio for quick reference and comparisons; it's a very useful tool.

Yellow (primary)

Orange-yellow (tertiary)

Orange (secondary)

Red-orange (tertiary)

Red (primary)

Violet-red (tertiary)

Violet (secondary)

183

Making complementaries work

Each secondary can be mixed with different proportions of its primaries: for instance, violet can be mainly blue, or mainly red. So instead of contrasting orange with a pure blue, which would produce an uncomfortable optical flicker, use a blue-violet. Still plenty of contrast, but not painfully so. Dark-toned colours can also be modified with white.

On the left, fully saturated colours give maximum impact but also eyestrain. On the right, the contrast is softened by modifying the primary blue.

184

Neutral tertiary colours

The tertiary colours shown on the wheel are vivid because they are made from related colours, but if you mix the pairs of opposite (complementary) colours, they cancel each other out to some extent, producing neutral hues. These are also tertiaries, being mixed from one primary and one secondary in each case. Depending on the proportions of each colour 'ingredient', the neutrals can be enormously varied. Shown right are some ideas for achieving rich, warm browns, but you can also make greys and cooler browns, colours that you can use to contrast with purer hues to bring sparkle to your work. Never underestimate the so-called neutrals, as they play a vital role in painting, and bear in mind that they all have their own colour bias, and can look quite bright in relation to other neutrals.

Cadmium red plus deep violet

Sap green plus cadmium red

Sap green mixed with red oxide/Mars red

Deep violet plus cadmium orange

Magenta combined with yellow ochre

Maroon mixed with cadmium yellow

Primary colours
There are different versions of the primary hues of blue, red and yellow, for example yellow could be cadmium yellow or lemon yellow.

185

Understanding colour terms

Basically 'colours' are those of the spectrum, the primaries and secondaries. 'Hue' sometimes means variations on a basic colour: turquoise, a yellowy-blue, or gamboge, a deep yellow, for instance. But, really the terms colour and hue are interchangeable. For 'hue' read 'colour' and vice versa.

'Tone' (also called 'value') means how light or dark the colour is. For instance, a dawn sky is a pale tone of blue, whereas a midnight sky is a dark tone.

'Shade' is another, optional, way of describing dark tones – anything darker than the basic hue.

In practice, the terms 'tone' or 'value'

are used to describe the whole range, to save having to say 'tones and shades' every time.

Think of tone as a single colour on a sliding scale from light to dark via the central, pure colour, the hue. Now you'll see that if you give this hue, or mid-tone, a value of 5, the lightest tone can be described as 1, and the darkest as 10. This is a very helpful mental framework for analysing the tones you see and the tones of paint you mix. Locating the mid-tones, that value 5, enables you to lighten and darken the surrounding areas accurately to achieve maximum tonal contrast in your work.

Judging tones

It's often easier to judge the tones of different hues against a mid-toned ground (as on the central strip), rather than a pale (top) or a dark-toned one (bottom).

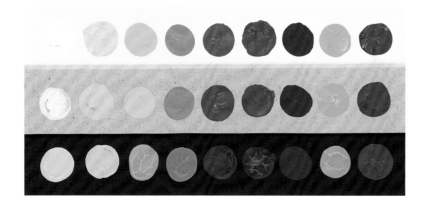

186

What does tone do?

Tone describes the bright and dark sides and facets of the objects in your painting in relation to each other, creating depth, bulk and substance. It's the basis of all realism and builds form.

Perspective is a geometric method of drawing to achieve illusions of distance, but in painting – in colour – it can't succeed without accurate depictions of tone to make the solidity lifelike.

TRY IT ▶

Make a greyscale

A simple sheet of grey cardboard (your value 5) held up to the scene will give a constant point of comparison for establishing relative tones.

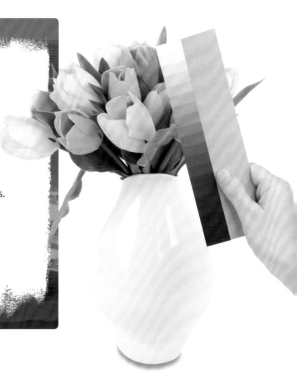

Working with tone

A painting where all the tones are equal is boring – monotonous. Lights and darks not only give contrast but shape also. There are two ways to approach tonality. One is to identify and establish the mid-toned areas, then work systematically up and down to the highlights and darkest shadows. The other is to isolate and place the darkest darks and lightest lights, and work toward the middle tones. Both approaches take a certain discipline, but the effort is well rewarded. Be aware of the direction of the light. Highlights and shadows are usually in logical places!

The important point is that all tones are relative to what surrounds them (as shown on the right), and adjustments are almost always necessary. Don't worry; it gets much easier with practice! Turn to pages 112–117, to see tonal work in context.

A B C D E F G H I

Make a tone filter

From a crafts or photographic shop, or your local theatre, obtain three pieces of colored acetate—yellow, blue and red. Cut three windows in a sheet of cardboard and mount the acetate in them. When you look through, the mid-tones will disappear, and the light and dark tones really stand out. The different acetates work best with scenes in which the dominant hue matches them. Use the filter both for looking at your subject and at the painting. If the painting appears blank, you need to strongly increase your tonal contrasts.

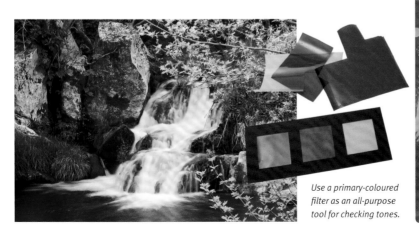

Use a primary-coloured filter as an all-purpose tool for checking tones.

✎ FIX IT ▸
Greyscale a photograph

If your painting seems flat and formless, take a digital photograph of it and convert to greyscale on the computer. By eliminating colour, the tones are revealed. Has the image disappeared in a single shade of grey? Adjust your tones by exaggerating the lights and darks, and see the work spring to life. Of course, greyscaling a photograph of the subject before you start painting will give you a very useful guide! A blown-up photocopy will do the same thing if you prefer to avoid computers.

189

Aerial perspective – the secret of distance

This is the easiest rule in painting. Warm, dark colours advance towards you, cool and pale colours recede. To make something look further away, paint it paler, and eliminate as much of the red as is possible. The sky at the horizon is almost white.

The sky is pale and hazy, enhancing the effect of space and recession.

The colours are much paler and cooler in the distance, with little tonal contrast.

Colours in the middle distance are bluer than those in the foreground.

The green has been knocked back so that the fields take their place in space.

The foreground colours are warm, and the tonal contrast stronger than elsewhere in the painting.

190

Cool and hot colour

The theory is simple: cool colours are the yellow-green-blue side of the colour wheel; hot colours are the red side. Red is hot; yellow is warm; green is cool; blue is cold; and so on around the wheel. In practice pigment colours behave differently. For instance, there are green and red shades of ultramarine, giving cooler and warmer hues. Don't worry; it's all relative. Colour communicates nonverbally and affects mood in a direct way, so 'feeling' your colours will allow you to gauge their emotional temperature. This is as good a way to proceed as any, allowing your instincts to operate.

Warm

Cool

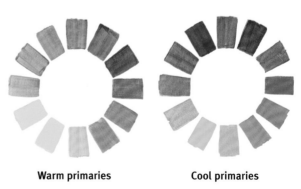
Warm primaries **Cool primaries**

Warm and cool colour variants are very important when mixing colours, especially because warm colours appear to advance while cool colours appear to recede.

191

Low-key colour for subtlety

Some words to describe low-key colour are: calm, cool, subdued, neutral, reflective, yin and minor key. By using plenty of earth colours, tertiary mixes, and pale tones, with knocked-back, unsaturated colour, and understated contrast, you can make paintings that are peaceful and invite intelligent inquiry. In such a context, small splashes of bright colours really sing and avert the danger of dullness.

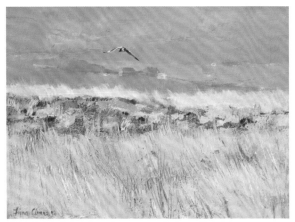

The delicate and precise handling of a few cool hues to depict the calm evening light makes this painting, by Fiona Clucas, a perfectly judged masterpiece.

192

High-key colour for vibrancy

Some words to describe high-key colour are: warm, loud, vivid, sunny, energetic, yang, fun and major key. The danger is that too many strong, saturated colours together cancel each other out and are exhausting to the eye, so they must be handled with purpose and discretion. Paintings that set out to be 'joyful' can end up looking garish or naive. As with low-key colour, it's a matter of personal preference and what you want to express. Both approaches work better when not taken to extremes.

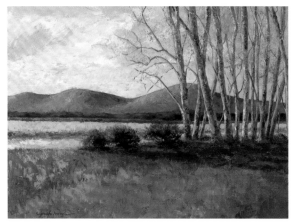

The intensity of evening after a long hot day in wild country is depicted with a passion that gives great power to this painting by Jennifer Bowman.

193

Black, white, and gray

Although black and white aren't colors of the spectrum, they are important ingredients of the painter's palette. Black, as Russian painter Kandinsky wrote, is "a kind of neutral background against which the minute shades of other colors stand clearly forwards." It brightens, by contrast, colors it comes in contact with. With white, on the other hand, "nearly every color is in discord, or even mute altogether." Somehow the proximity of a quantity of pure white has a deadening, darkening effect on nearby colors. And of course white in nature is seldom, if ever, pure white since it picks up reflections of everything around it. The gray made by simply mixing black and white gives neutral tones, a range of noncolors useful for building forms. Many gorgeous chromatic blacks and grays can be mixed, as shown below.

Pure black produces a range of harsh neutral-to-cold greys.

Greys made from chromatic black (here made from ultramarine blue, burnt umber and crimson) are more likely to harmonize with the rest of your palette.

✎ TRY IT ▸
Add a complementary

Sometimes the tone is right, but the hue too strong. Adding white has all sorts of sometimes undesirable side effects, such as opacity and 'pastelized' colour, so that's not an option. You can make colours appear optically paler yet tonally the same by adding just a little of the complementary colour. This has a neutralizing effect on the vividness and calms down the contrasts. Start with a tiny touch and work up. This is known as "knocking back" the color.

ARTIST AT WORK
Using tone in context

It is often easier to understand the visual structure of a composition if it is first analysed in terms of lights and darks – the tones. Here a still life of bags, which are easy to draw, has been built up from a tonal underpainting, saving the excitement of colour for the later stages. A small number of pigments are used as glazes to produce colours with depth.

Palette

For the underpainting, heavy body:

Burnt umber Buff titanium

Titanium white Transparent mixing (TM) white

For the glazes, soft body:

Azo yellow medium Cadmium orange

Napthol crimson Dioxazine purple

Ultramarine blue Cerulean blue (heavy body)

Sap green Glaze medium

Fluid retarder

Materials

40 x 84 cm (16 x 33 in.) plywood panel
White acrylic primer
Tracing paper
Pencil
Charcoal
Acrylic quick-dry satin varnish
Sizes 8, 4 and 2 round white nylon brushes
Old, rough brush

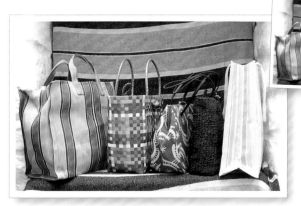

Five bags of varying shapes and patterns are arranged against a background whose bold stripes provide an easy-to-read key to the tones from dark to light, as can be seen in the black-and-white version.

1 A photograph is converted to greyscale by photocopying. Without the distraction of surface colour, the structure is easy to see. A full-scale outline drawing is made on tracing paper taped over the primed panel (three coats), using a viewing grid to get the proportions right, and transferred to the panel using charcoal.

2 Seven tones are mixed using burnt umber as the darkest (7), titanium white (1) and buff titanium (2). This pale hue adds variety and extra warmth to the range of tones. The background shapes are quickly covered. TM white, roughly applied, blends the wall details and sets the 'top note' (1).

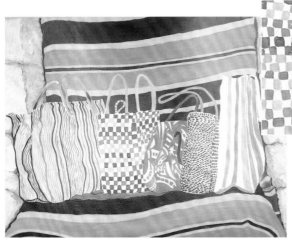

3 The shapes and patterns of the bags are painted using a pointed brush and mixing in-between tones as required. The completed underpainting is varnished to help the glazes flow on smoothly. This also makes it possible to wipe off colours without staining, so alternative colour ideas can be tried out without risk to the underpainting.

194
Hiding the drawing

When transferring a drawing that you don't want to show through transparent paint, use charcoal rather than pencil, because it will disappear. Patting the drawing all over with a slice of bread will remove any dust.

195
Keeping tones organized

Rather than mixing tones at random on the palette, having premixed tones in separate containers helps maintain a consistent approach. Using an ice cube tray makes it easy to mix intermediate tones as required. Use a zip-closure bag to store the tray between painting sessions.

196
Painting hard edges

Where you want to achieve a sharp line between two colours or a striped effect, work from top to bottom. Turn the canvas sideways if necessary. Pulling the brush smoothly downwards is much easier than sideways.

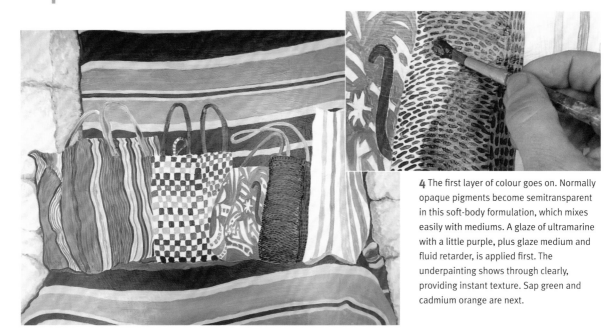

4 The first layer of colour goes on. Normally opaque pigments become semitransparent in this soft-body formulation, which mixes easily with mediums. A glaze of ultramarine with a little purple, plus glaze medium and fluid retarder, is applied first. The underpainting shows through clearly, providing instant texture. Sap green and cadmium orange are next.

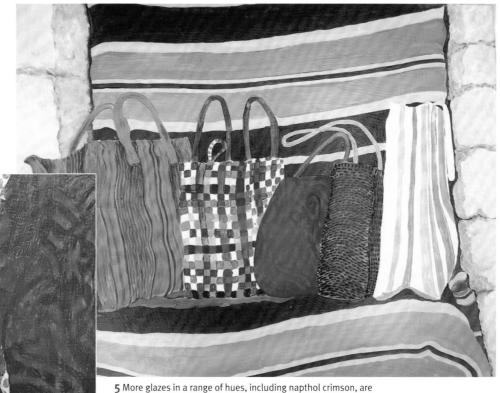

5 More glazes in a range of hues, including napthol crimson, are brushed on, thinning with glaze medium and fluid retarder when necessary to stop the glaze mixtures getting sticky. Several layers of thin colour are more vibrant and controllable than one thick one.

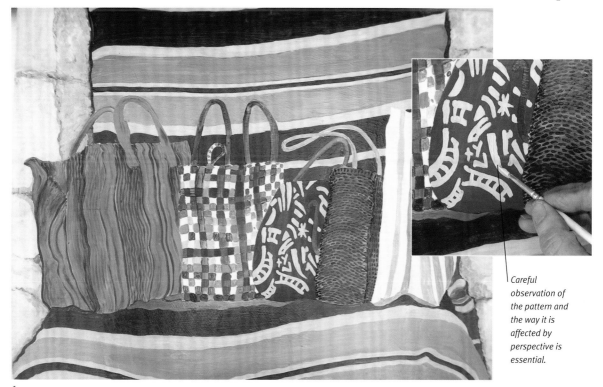

Careful observation of the pattern and the way it is affected by perspective is essential.

6 Using the heavy-body buff titanium, which is very opaque, the pattern is added to the red bag with a small pointed brush. This breaks up the heavy dark tones at the centre of the picture.

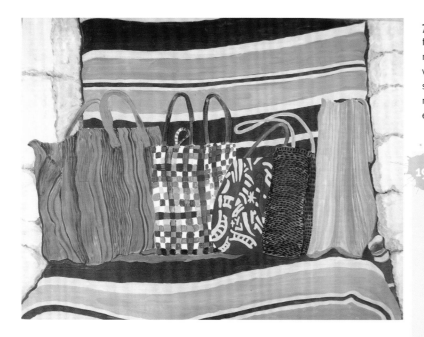

7 The balance of tones is still rather dark, so for the last bag, colours already in use are made paler by adding TM white. This gives variety to the hues while keeping the palette simple. Too many intense (saturated) colours make a painting sombre, so lighten up at every opportunity.

197

Lightening tones

TM white can be used as a glaze with or without added pigment. To lighten a whole group of colours that are too saturated and at the same time unify them, apply some of this white, with a little glaze medium if you want it really thin. Detail will show through, but all the tones will be simultaneously and equally lightened.

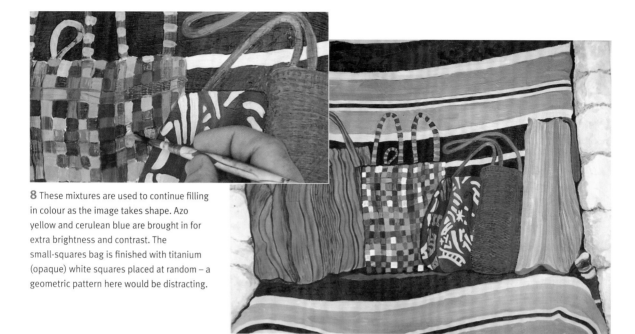

8 These mixtures are used to continue filling in colour as the image takes shape. Azo yellow and cerulean blue are brought in for extra brightness and contrast. The small-squares bag is finished with titanium (opaque) white squares placed at random – a geometric pattern here would be distracting.

9 Now that the image is complete, it's time to consider detail. Stripes in the background blanket are textured by stippling with a rough old brush, dipped in various tones from the first palette – 'striated color' (see detail). Very thin glazes of burnt umber and purple create shadows and darken some of the colours to add contrast and depth. A few transparent white highlights and it's done.

Baggage in Waiting
(Acrylics on 40 x 84 cm [16 x 33 in.] plywood panel)

Gill Barron

3

Techniques

Being the most modern of painting mediums, acrylics are still evolving. New techniques are always developing out of the more traditional ways, yet the basic methods of applying paint are still the foundation on which innovation must build. Here you'll find essential information on all the major painting techniques, plus plenty of new ideas to launch you on your own explorations.

Acrylics

Of course the whole of this book is about acrylic techniques, but here we explore a few recently developed techniques and methods of painting that wouldn't be possible with more old-fashioned paints. Acrylic is very much a medium in its own right and not all of its possibilities are as yet discovered. You too can be an explorer. As always, experimentation is the way forward: be brave and follow your hunches, and enjoy the learning curve.

Impasto

Impasto refers to the technique of applying paint very thickly – thickly enough so that when laid onto the painting surface, the strokes of the brush, knife, or paint shaper remain visible. The consistency of acrylics make them the perfect medium for painting this way.

Impasto paint is sensual and expressive and provides wonderful texture. It also makes light reflect in a particular way, so the artist can control the play of light.

Once dry, your impasto painting can be worked over with glazes, which produces some interesting effects because the glazes tend to collect deep in the painted marks. If you plan to paint large areas impasto-style, you may find it helpful to mix the colours with gel mediums or impasto paste (see page 54). Bear in mind that your impasto mixture will dry slightly darker because mediums are white when wet and colourless when dry.

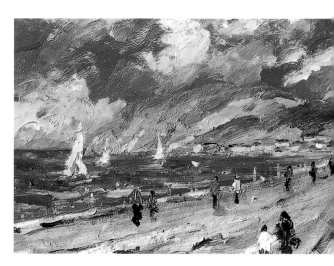

Impasto effects
In *Conveying the Elements*, James Harvey Taylor uses thick paint and expressive brushwork to capture the coastal scene.

Lost and found edges

Many things, especially when in shadow, don't appear to have hard edges, but seem to slide into one another. To replicate these 'lost' edges with acrylic paints, a good blending technique is needed, especially because acrylics dry so quickly. Try any or all of these:
• Slow the drying time with retarder.
• Use a clean, damp hog's hair brush for a bit of friction, or a fan brush with a flicking motion.
• Work fast with a light touch, in one direction only.
• Cover the join with a narrow, fluid band of colour mixed 50/50 from the hues you're blending, plus G&M (glaze)

medium. Spread outward on both sides.
• Lay the painting flat, spray lightly with diluted flow improver, go make a coffee.
• Using a rough old brush or a finger, smudge the paint – known as scumbling. Found edges are those picked out sharply by the light falling on them. To bring out found edges sharply, make sure the shapes are smooth and accurate, maximize tonal contrasts, and add highlights if appropriate.

A fan-shaped blending brush can be used to create soft gradations of colour.

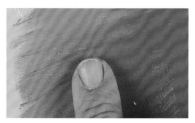

Rub wet paint gently with a finger to soften edges and blend them.

200
Ragging

Usually used on large-scale compositions, a rag can be used to remove whole passages of paint, or simply to blend and diffuse an overworked section.

A rag can be used to remove paint while it is still wet, but paint can also be applied with a rag, useful for laying coloured grounds.

201
Sgraffito

In Italian sgraffito roughly means 'scribbling'. A top single-coloured layer of paint is scraped away to reveal a prepainted, multicolored background. The viscosity of acrylics makes them ideal for scraping back. For a cleaner lift-off, spray the background lightly with diluted retarder before applying the top coat, which is thickish paint mixed with more retarder. Use a fairly broad blade for scraping back, as you want to see plenty of the colours underneath.

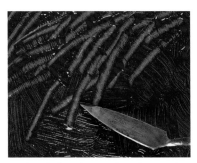

A palette knife makes rough marks, scraping back the top layer of paint to make a 'drawn' image from the colour underneath.

Using a paint shaper produces more even, controlled-looking marks, better for pattern making and a more 'graphic' look.

FIX IT ▶
Remedial methods

Acrylic properties make it possible to make corrections in a number of ways, without damaging the surface of your painting. When working with thick opaque paint, simply overpaint any mistakes, and amend any colours by glazing over them. If your brush wobbles over your outline, use the side of your thumb to gently push the colour back into place, but only when the paint is wet!

202
Tonking

The technique of tonking was invented by Henry Tonks of the Slade School of Art, London, in the 1890s. Professor Tonks naturally used oil paints and turpentine, which can build up into an unmanageable mess, and he devised the method of placing absorbent paper over the canvas, rubbing and then removing it, taking the top layer of paint with it.

Here is a modern variation on the technique, which can be used creatively as well as a remedial measure.

Tonking lets you use pure, fully saturated colour straight from the tube for intense effects. It helps to have a loose concept in mind, such as a landscape. Choose a suitable tetrad colour scheme from the colour wheel and using low-viscosity paint, dilute it cautiously in a jug, drop by drop, with flow improver until slightly runny. Starting with the palest colour, pour or squirt small amounts of paint and tilt the canvas simultaneously. Go horizontal, then vertical. Use a blast of air from the hair dryer (set on cool) to push the paint in rippling formations. Blot the canvas with newspaper to absorb excess paint and peel off carefully to see the result. Finish with light brushwork to emphasize what you've seen. An example of tonking is shown below.

Squashing and removing excess paint leaves a textured and slightly random effect, letting the paint 'do its thing'.

ARTIST AT WORK
Acrylics in action

Acrylic is especially well-suited to achieving sharp, straight edges, but it is best to work on a smooth surface, since rough canvas would break up the lines. It is also the ideal medium for creating textures, and here the contrast between clean lines and impasto textures, plus strong colour contrasts, adds to the visual impact.

Palette

Lemon yellow	Cadmium yellow medium
French ultramarine	Phthalo green
Burnt sienna	Burnt umber
Ivory black	Titanium white
Impasto gel	G&M (glaze) medium

Materials

51 x 30 cm (20 x 12 in.) Masonite board
White acrylic primer
Compressed charcoal
2H pencil
Masking tape
Size 3–12 round synthetic and bristle brushes
2.5 cm (1 in.) decorator's brush
Riggers
Spray water bottle
Fine-toothed saw

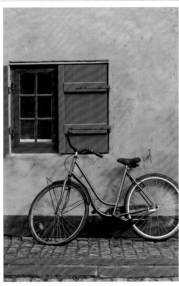

The photograph is carefully composed, though the left-hand shutter is cropped rather too closely.

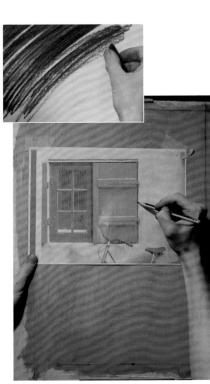

1 The primed surface (two coats) has been given a coat of burnt sienna for a warm underglow. The image has been enlarged by photocopier, and areas of vital information are transferred directly to the canvas by covering the back of the copy with compressed charcoal and tracing over with a sharp, hard pencil.

203

Find your lines

Where an accurate underdrawing is crucial to the structure of a painting, as with architectural details, you can retrace those lines exactly in their original place, should they get lost under the paint layers, by drawing registration lines showing the corners of the source drawing and then completing that section first. Or, with a ruler, continue the edge lines out onto the sides of the support where they won't be painted over.

2 The window area is masked off with tape to preserve the straight edges. Using a broad brush and a variety of strokes and dabs, the yellows for the wall are mixed with some impasto gel and applied vigorously with a dry-brush, scumbling action, allowing some of the ground colour to show through. Below the window, where the bicycle goes, texture is minimal. Burnt umber, used thinly, blocks in the dark areas.

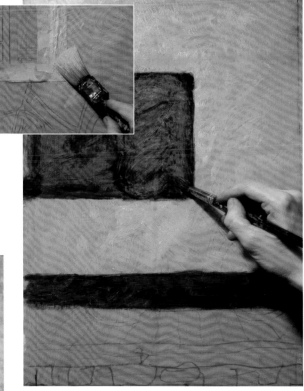

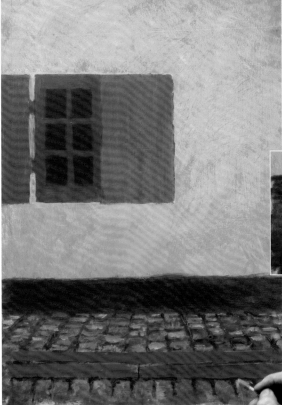

3 The window area is developed with French ultramarine/burnt umber/burnt sienna mixtures and phthalo green for the frame. The interior is black. The foreground gets another coat of sienna with some burnt umber and impasto gel, keeping the paint fluid and workable by misting with water. The cobblestone texture is emphasized with umber and greys, using a small brush.

204

Making random textures

Often textures in nature or the man-made world are rough and without pattern. It can be difficult to reproduce these effects realistically, as most painting tools are designed to make precise marks. Using crumpled newspaper imprints texture without pattern into the impasto. For best effects, use fresh wads of paper for each dab to keep the edges crisp.

4 The bicycle anatomy is carefully transferred to the canvas and the basic shapes painted in, starting with the wheels, handlebars and saddle in black, and the rest a warm mid-toned grey (umber, French ultramarine and white).

5 In this painting only the window, shutter and bicycle require any detailed handling, so it's worth spending plenty of time on them. The fall of light from the right gives sharp shadows (umber) and highlights (a white/sienna mix, pale greys, or pure white), which bring the details into focus; the black shadow of the shutter on the window frame gives the crucial three-dimensional effect.

6 For realism, the broad, cast shadow of the bike must be painted at just the right angle relative to the light, using a thin, 'dirty' glaze (see tip 206, opposite). The lines of the bicycle spokes are redrawn from the photocopy and painted in with a very fine rigger – white against the dark areas, dark against the bright. Finally, the picture area is outlined and the excess board removed with a fine-toothed saw, ready for framing.

205
Painting machinery

Most man-made objects and machines incorporate many precisely shaped components. Their relative thicks and thins are crucial to a lifelike 'portrait'. Use lots of sizes of round brush, which – when squashed and dragged – will give strokes of even thickness. Test each brush for width of stroke before starting. Check the shapes for accuracy and solidity before adding any highlights.

206
Using 'dirty glazes'

A 'dirty' glaze is one used simply to darken without adding any colour. It is a handy way to produce darker tones for shadows without remixing underlying hues. Ultramarine and umber are usually used with variable amounts of glaze medium. It's always wise to test the strength (relative darkness and transparency) against a similar background before applying, since the 'dirt' can be hard to remove if wrongly judged.

Siesta Time
*(Acrylics on 51 x 30 cm [20 x 12 in.]
Masonite board)*

Brian Gorst

207

The working border

Working on a hard support enables the artist to trim the piece to size when the painting is finished. Meanwhile, the border area is useful for trying out colour mixes and glazes close to the work so good comparisons can be made. Also, brushwork is freer when it's not cramped at the edges. Proportions and focal points can be adjusted once the painting exists, rather than by guesswork beforehand. For serious quality control, just select the best and throw away the rest!

Action painting

Action painting is tremendous fun, especially if you enjoy colour for its own sake. Basically you're letting the paint 'do its own thing' with little interference from brushes or tools, and more or less guidance. In time you'll develop dexterity, and an ability to predict and control effects, which is very satisfying – no longer random, but truly creative. Your relationship with the science as well as the art of colour will also be greatly enhanced. Even if you don't see action painting as your artistic destiny, a little time spent playing with these methods will be very educational and will no doubt aid you in your artistic journey.

The art of colour
Sally Trace's exciting and satisfying treatment makes use of both the texture of the paint and the red-green complementary contrast.

208

Choose your hues

Use the emotional power of colour to the maximum. Decide the feelings you want to evoke and select colours that, in combination, have that impact. A few hues mixed from a restricted palette may work better than a cacophony. Try using the primary colours. Working light to dark or vice versa is a good plan – it gives the painting coherence. Try adding splashes of one final 'shock' complementary colour. Think also about whether you'll use all opaque colours so new colours and shapes obscure what's beneath them, or transparent (glaze) colours so layers work together, or in combination.

Your colour palette is of key importance. See pages 18–27 for more on choosing colours.

209

Mixing paint for pouring

Getting exactly the right viscosity for pouring, splattering, splashing and so on comes with experience. Thin paint dries faster than thick, but if it's too thin, it can be difficult to control and sloppy. Too much water dilutes the binder holding the paint together, so consider using quick-dry varnish as a carrier for transparent pigments and quick-dry primer for opaque. Both can safely be diluted up to 20 per cent with water. Store paint in jugs – cut-down detergent bottles are good – ready for pouring, then cover with a plastic bag.

210

Keep it smooth

Producing large smooth colour fields is part of the pleasure and beauty of action painting. Make sure your pigments are evenly mixed into the carrier medium by using the spoon method, shown below.

1 Take a big spoonful of white primer and stir in a small blob of strong pigment until smooth.

2 Then do a trial pour to test the consistency.

211
Wet or dry?

Acrylic is the ideal medium for action painting because it dries so quickly. You can choose whether to let areas of paint dry out fully before adding other colours, so each keeps its original hue. Or you can pour wet-in-wet, allowing colours to bleed into each other as they will.

Treat the random puddles of paint from pouring as a starting point and find ways to create further movement, trying out different tools for a variety of marks.

212

Get physical

Action painting emphasizes the physical act of painting. It's primarily about the process, not the product – though there's no harm in having a gorgeous painting at the end of it! It's a great stress-buster too. Here are some ideas for 'interventions' that will keep the process active:

• Pour and tip, dribble and squirt.
• Throw and flick (off a spoon or a big brush).
• Use a water-pistol (loaded with thin paint).
• Dip objects in paint to leave printed marks – twigs, hands, shoe-soles.
• Feather and marble paint by stirring on the canvas with a bamboo.
• Move paint by blowing with a hair dryer (on a cool setting).
• Riding a bicycle across the canvas is strictly optional. But roller-blades might make interesting marks.

Enhance the natural mixing process by stirring or 'feathering' with a bamboo, producing marbled effects. Use the minimum of paint to achieve the result, and stop when something nice happens. Above, feathering is used to make pop-optical effects.

213

A head for heights

The classic way to action paint is to lay your large canvas flat on the floor and take the paint up a stepladder. Splash effects from a great height can be very dramatic. This is a technique for warm weather, since drying out thick puddles of paint can be a problem otherwise. Preparing the canvas with a harmonious coloured ground gives a more complete look to the finished piece.

This assemblage of drips, splashes, splatters and dribbles will now be put out in the rain to await developments. Time, weather and other random factors can all play an active part in the creative process.

Watercolours

Being water-based, acrylics can be used in the same way as traditional watercolours to achieve effects that are just as delicate and luminous, while also being more robust and long-lasting. There are a few differences in handling to be aware of. Whether or not you've worked in a watercolour technique before, you'll find here all you need to know about the materials and the methods to use.

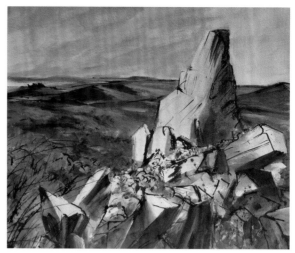

Bold tones
In actual watercolour work, several layers would have been needed to achieve the rich, dark tones and colours of Rita Banks' painting, but acrylic is a robust medium, allowing a bold approach from the outset.

214

Stretching watercolour paper

Stretching paper ensures it stays flat, and it is always worth doing.

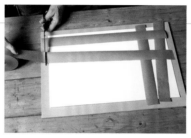

1 Prepare four strips of adhesive-paper tape, cutting each strip approximately 50 mm (2 in.) larger than the paper.

2 Lay the sheet of paper centrally on the wooden board and wet it thoroughly by squeezing water from a sponge.

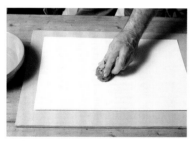

3 Wipe away any excess water with the sponge, taking care not to distress the paper.

4 Beginning on the longest side of the paper, wet a length of tape using the sponge, and lay it down along one edge. Ensure that one-third of the tape surface is covering the paper, with the rest on the board.

5 Smooth the tape down with the sponge. Apply the tape in the same way along the opposite edge, then along the other two edges. Place the board and paper aside to dry for a few hours; or use a hair dryer to speed up the process, but keep the dryer moving so that the paper dries evenly, and do not hold it too close to the surface.

Making the comparison
A sap green watercolour strip (top) compared to a sap green acrylic being used as a watercolour (below).

215

The white of the paper

The bedrock of watercolour technique is that it uses no added white pigment. Instead the paper's whiteness shines through transparent pigments, lightening all the hues. When working with acrylics, plan ahead to preserve some pure white.

Locate the exact position and shape of the highlights. Paint them in neatly with masking fluid. Let it dry before applying washes. You can paint right over it. Peel off at the very end of the painting process to reveal pristine white paper.

1 A clear mental image of where the lights and whites belong makes placing the fluid much easier. Angle the paper – shadows will help you to see the blobs.

2 Once the fluid is dry – test with a finger – you can safely flood the paper with colour. Your whites are safe.

> ✎ **FIX IT ›**
> ### Last-minute highlights
> You overlooked some highlights at the masking-fluid stage and now it's too late to get back to the white of the paper. Just put them in at the end with transparent mixing (TM) white, or zinc or Chinese white, which, being more transparent than titanium white, will sit better with the rest of the watercolour. This is known as 'body colour'.

216

Masking fluid – the secret

Nothing is more frustrating than making a beautiful watercolour then finding that the masking fluid won't come off, or that it tears the paper. This happens a lot. The secret to success is to only use new fluid. Buy small bottles – those with a 'pen-nib' nozzle are worth trying – and throw away any unused fluid after a few weeks. Choose a colourless version since the others leave nasty stains. It's tricky, sticky stuff to handle, yet so useful. To avoid disaster, observe these rules:

1. Use hot-pressed paper; Arches papers are ideal – all others tend to rip.
2. Never use sable brushes, use only cheap synthetics. Dip the brush in liquid detergent first, then fluid for easier wash-out. Pen-nibs and shapers also work.
3. Use enough fluid to make a good blob; you'll need to be able to grip it to peel off.
4. To remove, work inward from the edges. Use the tip of a scalpel to delicately lift the edges of the dried fluid, before peeling away gently.

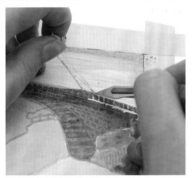

Once dry, masking fluid forms strings that can be gripped and peeled off easily to reveal white.

217

Transparent pigments

Watercolour relies on the staining (or tinting) power of the pigments, which must be naturally transparent and also finely ground. Some manufacturer's charts give this information, or look for the pigments used in standard watercolours and buy the same in an acrylic formulation. Quinacridones, phthalos and Winsor colours are transparent with high tinting strength, so use less in your washes to avoid overdoing the colour.

The soft, atmospheric tones of watercolour are deepened not by adding more acrylic pigment, but simply further coats of wash.

218

Washes

Washes are what watercolour painting is all about. A wash is a veil of colour laid over an area of the paper too large to be covered by a single brushstroke. Washes can be flat (i.e. even) or graduated, that is, lighter or darker in places. Keep these guidelines in mind as you practise:

• Use a plastic palette with good mixing wells, or keep wash mixes in jam jars. Shake or stir every time.
• Always mix more wash than you need.
• Add a little medium (any kind) to the mixing water bottle.
• Test washes on a scrap of the same paper as that used for the painting.

• Use a big, fat, floppy, soft brush (a mop) or a wide, flat, springy nylon one.
• Work fast and evenly, always in the same direction and with the paper slightly tilted.
• Overlap strokes a little to pick up colour that's puddled at the bottom of the previous stroke to avoid stripes – unless the stripes are part of the effect!
• Build depth of colour gradually, as you would with glazes, letting each wash dry between coats.
• Or work wet-in-wet so colour mixes within the paper, giving blended edges. Beware of 'mud'.

1 As the first wash soaks in, the pigment starts to highlight the texture of the paper.

2 Working rhythmically from side to side, the brush picks up excess wash, to even the colour.

FIX IT ▸ Granulation

Some pigments flocculate, that is, settle out in tiny spots, giving a grainy texture you may not want. Hard water worsens the effect. Avoid this by changing the pigment and/or using distilled water. Save these paints; they'll come in handy for pebbly beach scenes, etc.

Sometimes the variety of tones created by granulating pigments may be just the effect you want. Sometimes it isn't.

219

Underdrawings

It's characteristic to have some delicate pencil drawing under the washes, so start by indicating the main features on the paper – 2H to HB pencil is dark enough.

Avoid producing just a coloured-in drawing. Use doughy white bread as an eraser and don't get greasy finger marks on the paper.

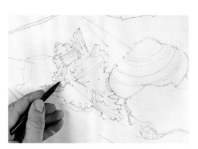

1 Your drawing provides more than a 'plan of attack'. It's the structure of the painting to come; make the most of it.

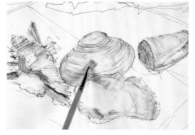

2 Use each brushful of wash to colour all items of that hue across the painting.

220

Making water wetter

Thin washes often won't sink into the paper properly, owing to 'surface tension'. Cure this with a few drops of flow improver medium. Read the directions for quantities. Another way is to wet the paper with a sponge before you start. Or it may be the paper – hot-pressed isn't very porous.

Using a natural sponge ensures that the delicate surface of an expensive paper is not damaged.

221

Creating tones

You can't always use white, because it makes the paint opaque, so create light tones very simply by diluting the pigment in stages. This keeps the purity of colour, and it is especially effective with reds, which get lighter without turning pink. For darker shades, add a little ultramarine (cool) and/or burnt umber (warm), or Payne's grey (neutral), but never black.

Building tone with layers

Always start with maximum water, minimum pigment and try to build tones by adding layers of wash, as shown above, rather than extra pigment. This is the purist approach, but do what works for you.

222

Painting upside down

Skies need to be palest at the horizon, so put your wetted paper upside down and upright on the easel. Put your first thin wash over the whole sky area. The colour will trickle through the paper, taking most of the pigment down into the top of the painting, which is now darker than the horizon. Add more washes as desired, starting each a little below the previous. Remember to blot out some colour while still wet for clouds, or mask out some cloud shapes and paint these in later.

The colour concentrates as it runs down and you add more; it's a fast-paced process. Practise on a small scale to get the knack.

223

Lifting out

Ordinary watercolours stay somewhat soluble even when dry, and by flooding the paper with water and blotting it, some of the pigment can usually be removed, lightening the paper. Nice effects can be created this way. Acrylics, however, dry totally waterproof, so 'lifting out' isn't possible unless you act fast. Use real blotting paper and heavy pressure, too.

If the colour is still very wet, dab with a paper towel to take you back to the white paper. Act fast.

224

Working light to dark

Watercolours are always built up from the background forwards. Aerial perspective dictates that things furthest away are always paler than those up close, so start by laying broad, pale washes. Decide where your horizon line is and place your lightest tones there. Gradually add more pigment to the washes to strengthen and darken them as they approach the foreground. Proceed with caution and bear in mind that two or three light applications of thin colour will build up pigment better than one heavy one.

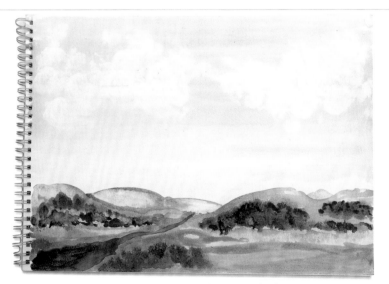

Acrylics make excellent watercolours for producing fast outdoor sketches: Work light to dark to give big, bold shapes quickly; add only the minimum of darker details at the last minute.

ARTIST AT WORK
Acrylics as watercolour

Snow is a subject beloved of all painters, since it provides a surface on which the play of reflected colour forms the main focus. The artist has chosen a watercolour technique to capture the stillness and simplicity of the scene, but has combined it with opaque paint in a way that is only possible with acrylics.

Palette

Cadmium scarlet	Ultramarine blue light
Cobalt blue	Yellow ochre
Burnt sienna	Burnt umber
Payne's grey	Titanium white
Flow improver	Impasto gel

Materials

45 x 45 cm (18 x 18 in.) 180 gsm (110 lb.) cold-pressed paper
Large sable wash brush
Paper towel
Hair dryer
Flat hog bristle brush
Size 4 round sable brush
Card tip (see page 134)
Toothbrush
Penholder and medium drawing nib

The subtle colors of the landscape are invigorated by the web-like structure of the branches, but the tones on the building are a little too dark for the composition, so the artist has modified.

1 Using a mix of ultramarine blue light and cobalt blue, diluted to a thin wash with water and a few drops of flow improver, the sky is washed over with a big, soft brush. Some Payne's grey darkens the tone of the mix to indicate the bulk of the mountains.

225

Controlling runoff

It's much easier to see what you're
doing when your painting is vertical,
but with watercolour techniques there's
a danger of washes spilling down the
paper, staining areas you need to keep
white. Use paper towel to absorb
excess wash immediately and dry the
wet sections with a hair dryer at the
first opportunity.

2 With the same colour mix, but less water, a stronger wash
provides the shadow areas on the mountains and the distant
church and fields. Going back over the darker patches with
extra coats of wash deepens the tone further.

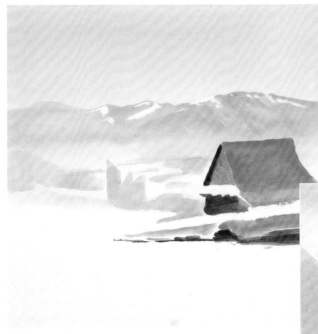

3 With burnt umber and
yellow ochre, the warm
earth tones and wood on
and around the cabin are
introduced. Then the deeply
shadowed areas of snow on
the roof and foreground are
put in with a strong wash of
ultramarine blue light.

4 Titanium white is mixed with impasto gel for
textured effects that will catch the light and give
extra brilliance. Using a hog bristle brush, which
carries thick paint well, the cabin and
mountaintops are given their crisp, white snow
highlights. Then, with watered-down white, the
faraway snow is swept in with a soft brush. Fuzzy
edges imply distance.

5 A card tip is dipped in burnt sienna and/or Payne's grey, and used to mark in the trees, branches and details of planking on the cabin (see *Using a tip*, below). The fine twigs are done with a pen nib. The leaves are yellow ochre, sprayed on with a toothbrush.

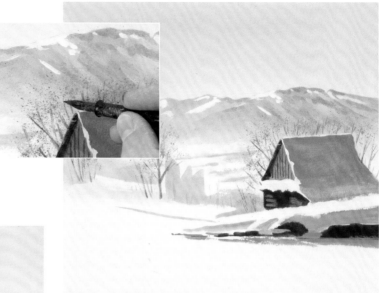

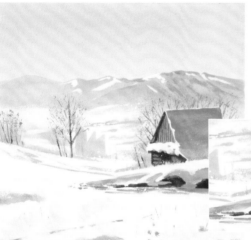

6 The foreground is completed with more shadows, footprints and more impasto snow. The mountaintops are brought into sharper focus with a few subtle extra lights and darks. The unexpected finishing touch – in a painting with many white highlights – is some small spots of red to complete the spectrum of colours.

226

Using a tip

A tip is simply a small oblong of dense card that is used on edge to make sharp, straight lines. Dip it in paint and employ a light touch. Using a thin rigger brush on watercolour paper would require a lot of water as a lubricant, and it would cause the lines to become fuzzy. Thicker paint and a tip give stiff, exact marks.

227

A fine spray

Tiny speckles of colour can add interest to a painting in many ways, whether representationally (as leaves, for instance) or just for the sheer pleasure of exciting colour. Spraying a watercolour requires extra care, since the speckles can't be wiped off. Use very thin paint. Shake the toothbrush to remove any excess, then scrape your thumb sharply backward over the bristles. Practise before you spray a real painting!

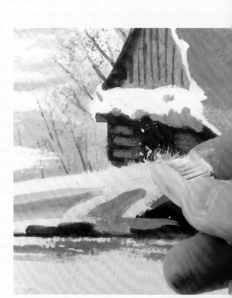

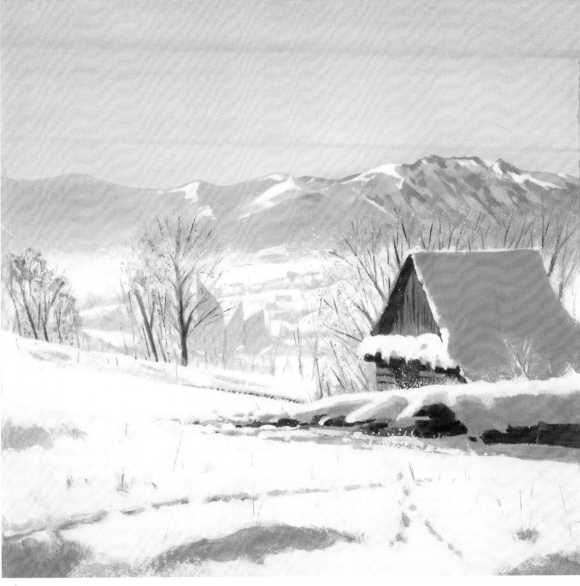

Cabin in the Snow
*(Acrylics on 45 x 45 cm [18 x 18 in.] 180 gsm (110 lb.)
cold-pressed paper)*

Stephen Rippington

228

Using hot and cold colours

There are many practical ways to use the theory of colour temperatures
(see page 110). An ice-cold painting such as a snow scene can numb the
eye. A few flecks of scarlet will shock it into life. Hot colours also pull
objects forward, mysteriously increasing the three-dimensional effect.
Similarly, in a hot painting, the feverish effect of so much crimson and
orange bursting forth can be relieved with tiny spots of ice blue that will
help the picture plane recede back into the frame, where it belongs,
inviting instead of repelling the viewer.

Gouache

Gouache is a favourite medium among designers and illustrators, as well as fine artists. It's the opaque version of watercolours and made from specifically opaque pigments in a gum arabic binder. Overpainting is not always easy, since new colours tend to mix with those below. Gouache only works on paper, not canvas. Overcome all these problems by using acrylics instead to achieve bold and stylish effects.

Bold colours

This bold yet delicate painting is testimony to the ability of acrylic used in gouache mode to combine flat washes with areas of brilliant colour. The background gives an almost watercolour effect, while thicker paint has been used for the flowers, bringing them forward.

229

The gouache look

Traditionally, gouache paintings have a slightly pastel, chalky tinge, all the colours being mixed with more or less white to maximize opacity. This is part of the charm and gives the piece unity. Keep your tones lighter and your hues less saturated than usual to make the most of this look.

The opacity of gouache is much more evident when compared with the watercolour versions of these colours (see page 129).

230

Testing, testing

If the viscosity of the paint is crucial to the effect you seek, try spooning a little paint onto the support to see how it behaves. Too runny? Mash in some gel medium. Too sticky? Add water or flow improver, a few drops at a time.

231

Finding opaque pigments

This can be difficult as opacity levels, even of the same pigment, tend to vary between manufacturers, many of whom fail to indicate this crucial characteristic on the tube, or even in the catalogue. However, certain pigment families are reliably more opaque than others, notably the cadmiums, providing a great range of yellows and reds; cerulean and cobalt for blues; plus opaque chromium oxide for a very dense, dull green, which can be jazzed up in many ways. Add in the earth colours, ochres, oxides and Mars red for instance, and you have a very versatile palette.

232

Good mixers

Adding white will make any pigment more opaque. Titanium white is the best – the more expensive the better. Buff titanium is a pale neutral shade giving subtler results; it is well worth experimenting with. Bronze is another alternative, adding an indefinable glow to the hue as well as good coverage. The mixes made with each of these hues are shown below. Remember always to start with the lightest hue and mix in the darker a little at a time. For economy on large areas, use quick-dry primer as a base. Remember to pour away any clear liquid on top of the can first to thicken it.

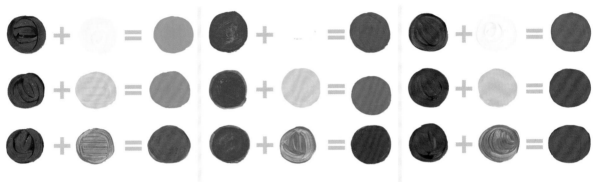

Gouache greens
A transparent, flow-formula permanent green produces three very opaque, versatile hues, when mixed with white (top), buff titanium (middle) and bronze (bottom).

Gouache blues
Thin, cheap ultramarine blue makes opaque hues close to cerulean (top), cobalt (middle) and Prussian (bottom) when mixed with white, buff titanium and bronze respectively.

Gouache purples
Dioxazine purple, an intense, transparent pigment, loses its streaks and gains body, and richness, when mixed with white (top), buff titanium (middle) and bronze (bottom).

233

Hard-edge styles

Perfectly straight stripes and crisp edges are much easier to achieve with acrylic than gouache, because you can safely use masking tape. To avoid leakage under the tape, don't use flow improver; instead bulk the paint up a bit with gel medium. Remove the tape promptly as soon as the paint is properly dry.

1 Any underpainting must be dry before masking. Make sure the tape is straight and corners are at right angles. Press down firmly.

2 When applying the paint, take it up to and over the edge of the tape; don't let the bristles catch underneath.

3 Peeling off the tape reveals a solid edge that would be hard to achieve any other way.

Making the comparison
A gouache phthalo blue strip (top) compared to a phthalo blue acrylic being used as gouache (below).

234

Front to back or back to front?

When working in gouache style, think of the picture plane in a very two-dimensional way. First paint all of your foreground subject. This will fill quite a lot of the surface. Then fill in only those areas of background that actually show. This way only one layer of paint is needed, which helps produce a perfectly flat surface. Alternatively, to avoid lots of pernickety edges, paint the broad areas of background, say, walls or sky, first to ensure absolutely smooth colour. Unwanted areas will be obliterated by the opaque paint of the foreground.

Front to back

1 This family of jugs, painted flatly in thick earth colours straight from the tube, fills most of the painting with its simple, bold shapes and curves.

2 The curtain pattern is painted straight onto the background colour, filling the negative spaces, with just three tones of chromium oxide green. Shadows in front imply an influx of light coming through the curtain. Economy of means achieves the effects.

Back to front

1 Where continuity is important, as it is here, try painting the entire ongoing section first. It will be much easier to then see what's happening. The opaque paint to follow will simply make unwanted areas disappear.

2 The earthy jugs are now sitting firmly on a logical arrangement of stripes, folds, creases and shadows that satisfy the eye. Gouache techniques work best for solid, graphic images like these.

FIX IT ▸ Overpaint

Unhappy with the colour scheme of your painting? Mix a different palette of opaque hues using gouache methods, and overpaint it. You can do this several times, taking photographs to compare alternative colourways. With acrylics it's safe to have as many layers of paint on the canvas as you like, whereas real gouache tends to chip and flake off.

235

Adding detail and depth

Do you need to add further depth or detail? With gouache, less really is more, and an uncluttered design tends to carry conviction. However, you can do whatever you like; add rich glazes of saturated colour, or surface design on fabrics, for instance. It's your painting, after all! Choosing the right varnish is crucial. Chalky, pastel hues generally work better with a matte finish, but experiment.

236

Filling in

For covering large areas, perhaps within a black-line boundary, as with comic-book or stained-glass designs, mix your paint very thoroughly. Streaks are disastrous. Use a palette knife or plastic kitchen spatula to eliminate lumps. Or, perhaps try using an egg whisk for larger quantities. Add just a few drops of flow improver to make the paint 'level' better. Store colours in glass jars so you can see if pigment has settled out, and always stir before use.

1 A simple, very graphic image is drawn on a pale blue background using matte black (acrylic blackboard) paint and a broad rigger brush, which gives a good line of even width.

2 More black is painted in. Now it's one of the colours. The outlines become a part of the whole design, not just doodles. Matte black is a dense, opaque paint ideal for graphics.

3 A strong dark blue, carefully blended with a little white primer for maximum opacity and smoothness, fills in the wide areas of water. Now the pattern of ripples can be seen.

4 Yellow will be the most intense hue in the design, so putting it in first will help balance the tones and saturation of other colours.

5 A strictly limited number of colours (mixed from each other) makes for a strong, coherent design that is memorable with plenty of eye-appeal – the essence of good graphics.

Classic oils

Traditional oil painting techniques evolved in response to the considerable dangers of the medium: if oils are incorrectly used, the painting disintegrates. A lot of know-how is needed to avert disaster. Acrylics, however, are reliable and easy to use. They allow you to work with the freedom of knowing you're producing stable artworks, so all you have to concentrate on is the image. Here we look at how the more antique approach translates into modern acrylics.

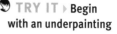

TRY IT ▸ Begin with an underpainting

Rembrandt's underpaintings used both browns and greys, with effects that have never been surpassed. Once you have some practice with simple single-hue tones, diversify. You'll soon get the knack of it!

237

The classic method

Devised as a way of speeding up the agonizingly slow drying times of oil paints, the classic method starts with a series of thin coats mixed with lots of solvents, gradually building up to 'fatter' paint. The approach is structurally excellent, laying down the form of the image in a disciplined fashion before proceeding to the thrilling business of colour. It works even better with acrylics, as long as you avoid the temptation to either plunge ahead recklessly or to be satisfied with shallow surface effects.

238

Watching paint dry

Many of even the most convinced oil painters now use acrylics for their underpaintings, so they can complete in a few days what would take months with oils only. Why not just carry on and complete the work in acrylics? By all means try using oil paints over acrylics if you want to, but never try the other way round! Acrylic primers and undercoats are always a good idea for your first coats; they're completely flexible and won't rot the canvas, unlike oils.

239

Learning to layer

For a first venture into this technique, choose a simple subject and just concentrate on building up the forms of the objects. Think sculpturally.

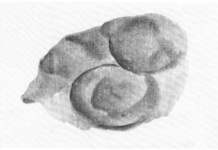

2 The underpainting layer

Also known as blocking in, this stage concentrates on placing and building up the main forms. You can sketch them in charcoal if you wish. Choose a single hue as a mid-tone, for example, burnt Sienna, and mix a few (seven is plenty) tones from it, adding white and burnt umber to lighten and darken. Then, working loosely at first and ignoring detail and colour, just place shapes with their relative lights and darks. Stand back to see the three-dimensional effect. Make adjustments until all the tones are correct, relative to one another. Take a break. Look at the image in a mirror. Use a tone filter (see page 109) to effectively assess, and don't rush; this solid foundation will make the rest of the painting a breeze.

1 The imprimatura layer

An optional stage: this is a thin, transparent wash of colour to 'break the ice' of the white, primed surface. Choose a neutral, slightly warm or cool hue according to your overall colour balance. Burnt/raw sienna for high key and grey for low key are traditional. Thin the paint with water, plus a little medium – any sort. Cover the canvas.

Oil or acrylic?

Many painters who began with oils and then turned to acrylics tend to work in the same way with both mediums. This picture, which makes use of typical oil techniques such as working wet-into-wet, could easily be mistaken for a work in oils, indeed the case of many finished paintings – it can be hard to distinguish between the two.

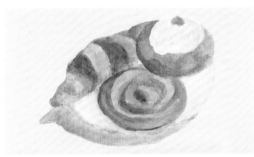

3 The fun stage: glazing

Here at last comes the colour! Using (preferably transparent) pigments well-thinned with G&M (glaze) medium, start applying basic tints across the canvas. It's best to start with the yellows and add the stronger tints like red later. Don't use any white; it clouds the glaze. At first you'll just get a thin veil of almost colour, but soon wonderful depth, subtlety and variation of hues will develop. Optical mixing is the secret (see page 149). All these layers help unify and pull the surface together. Just be quite sure each glaze is fully dry before applying the next; impatient painters use a hair dryer!

4 Finishing touches

To finish up, add details in thicker, more opaque paint. For highlights, a transparent white, such as zinc, may marry better with the 'oils' look. Remember highlights are rarely pure white, though; add a tiny bit of local colour to soften it.

Making the comparison

An oil spectrum red strip (top) compared to a spectrum red acrylic being used as oil (below).

ARTIST AT WORK
Glazing in context

The reference photo is fine in compositional terms, but is a little drab in colour, so the artist decides on a vivid blue-orange colour scheme, given extra depth by layers of transparent glazes. Using opaque paint alone would not obtain the same brilliance of colour; it is the way in which one colour shines through another that gives the unique effect.

Palette

Cadmium yellow medium	Cadmium red medium
Cadmium orange	Quinacridone rose
Prussian blue	Phthalo blue
Turquoise blue	Cobalt blue
Mars black	Titanium white
G&M (glaze) medium	

Materials

61 x 46 cm (24 x 18 in.) gesso-primed Masonite board
Charcoal pencil
Size 4–10 flat synthetic brushes
Flat, multi-angled painting knife
Soft cloth

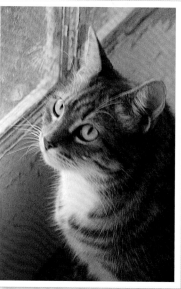

The photograph is excellent compositionally, but fails to catch the colour of the cat's eyes.

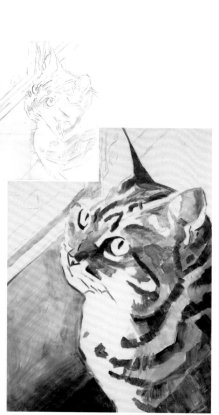

1 A small compositional sketch is worked out, using the photograph, then squared up onto the board using charcoal pencil. The underpainting is done using black paint, thinned with G&M (glaze) medium to produce the various tones. The thicker the paint, the darker it is. Great care is taken not to let the medium values get too dark. White areas are carefully preserved.

240

Palette management

To make a palette that gives you plenty of space and freedom for mixing your colours, lay a sheet of baking parchment over a piece of plywood or Masonite and fasten the ends to the back with broad masking tape. It's easy and quick to change the paper whenever you need to.

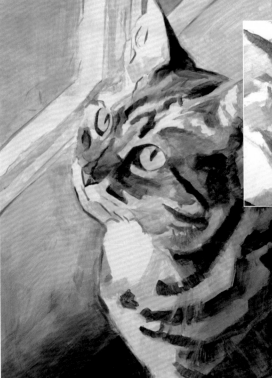

2 A blue glaze made from cobalt with G&M (glaze) medium continues the tonal build-up of areas in shadow: the darks. The glass door pane, opposite to and balancing the very dark bottom right corner, is also blue. Now the very strong diagonals of the composition become apparent. A yellow glaze follows to mark out the medium tones, including the eyes.

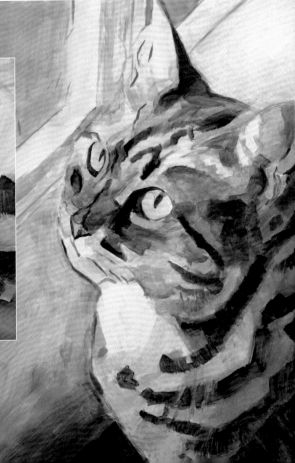

3 Now the painting starts warming up as the blue-orange colour structure starts to develop with a glaze (mixed from quinacridone rose and cadmium orange) that is brushed over the entire cat, except the eyes. The reddish glaze over blue creates deeper, warmer, purplish hues and turns the yellow areas orange.

A soft square brush is used to apply the semitransparent paint to the piece.

4 The underpainting is now well developed, so it's time to turn to the eyes – the success or failure of which is crucial to the painting. A cobalt blue glaze turns them green. The streaky glaze mix gives variety and life to the hue. As this is a large painting, plenty of detail is possible.

241

Painting animal eyes

In all portraits, the battle to portray a good likeness is mostly won by getting the eyes right. An animal's personality lies in its eyes, and they are never just one colour. To create a clear, glassy look, use highlights of all the colours in the mixture, placed close together. Notice carefully the shadow of the eyelid across the eyeball – this gives the roundness. Use white highlights for extra shine – but sparingly! Careful observation is the key to success.

5 More detail is developed in the face and ears, keeping the side nearest the window noticeably lighter than the other, to enhance the glow of outside light coming through the glass. The rest of the fur is worked over as well. The many mixtures of colour already on the palette give plenty of hues to choose from.

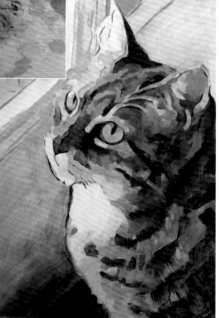

242

Colour mixing with glazes

To make the most of the variable transparency of glazes to produce interesting colour effects, mix the paint very loosely with the G&M (glaze) medium, and apply with a broad, flat brush. The brush will give a combed effect to the colour, producing subtle stripes that alter the intensity of the hue. The viewer's brain will do the blending.

Painting fur

It's not necessary to paint every hair in the animal's coat; a few light strokes here and there are enough to suggest thick, shiny fur. Add a few highlights by picking up a little white in the brushstroke. Remember to keep the brushstrokes going in the direction of growth! Any extra fluffiness required should be added sparingly as a finishing touch.

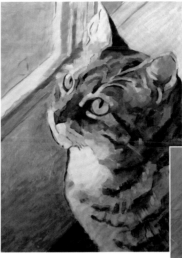

6 The door panel and frame were previously scumbled with a mid-toned mix of colours to fill the space. Now lots of rough texture is added, using a painting knife and a warm red-pink glaze. The glaze is applied and then scraped back, several times, to give a grainy look to the woodwork and a strong contrast with the softness of the cat's fur.

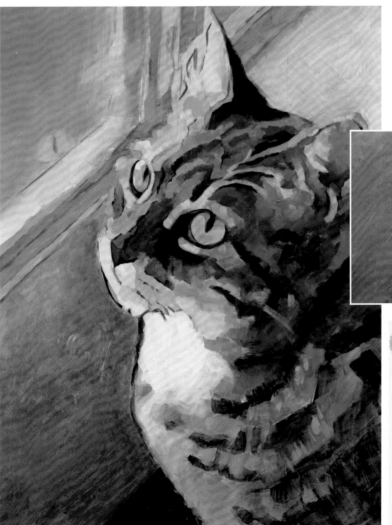

7 The detail of the door frame is developed, still using the painting knife and glazes of yellow and orange mixed with white, keeping the overall colour much lighter than in the bottom of the door frame, to add to the feeling of warm light.

Scraping back

An interesting way to produce layered colour and texture is to use the scraping back technique, where adding and promptly removing the paint is what produces the effect. Working on a hard support enables quite vigorous scraping that will expose the underlayers in places, creating unpredictable yet potentially serendipitous results.

8 The blue of the glass is deepened with a glaze of phthalo blue. A reflection of the cat's right eye is wiped out with a soft cloth around the pupil. To make the edges softer they are blended with some phthalo and turquoise blue mixed with white, brushed on with very light, even strokes. A little fuzzy pink on the glass adds to the impression of a reflection.

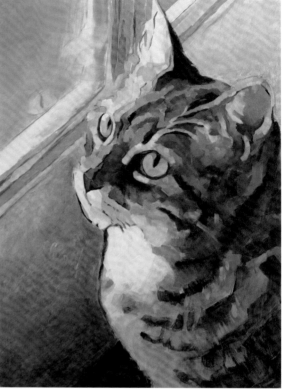

9 Now for the finishing touches. The fluffy fur of the cat's chest is painted in with short, definite strokes of white with a little red and orange added, and finally pure white. The edge of a size 4 flat brush with a long handle is used because it gives good bounce and flick to the strokes, while allowing the painter to stand well back and judge the effects. A light hand is needed to suggest the whiskers – not forgetting the eyebrow whiskers – which make the cat's face so expressive.

Birdwatching
(Acrylics on 61 x 46 cm [24 x 18 in.] gesso-primed Masonite board)

Karen Mathison Schmidt

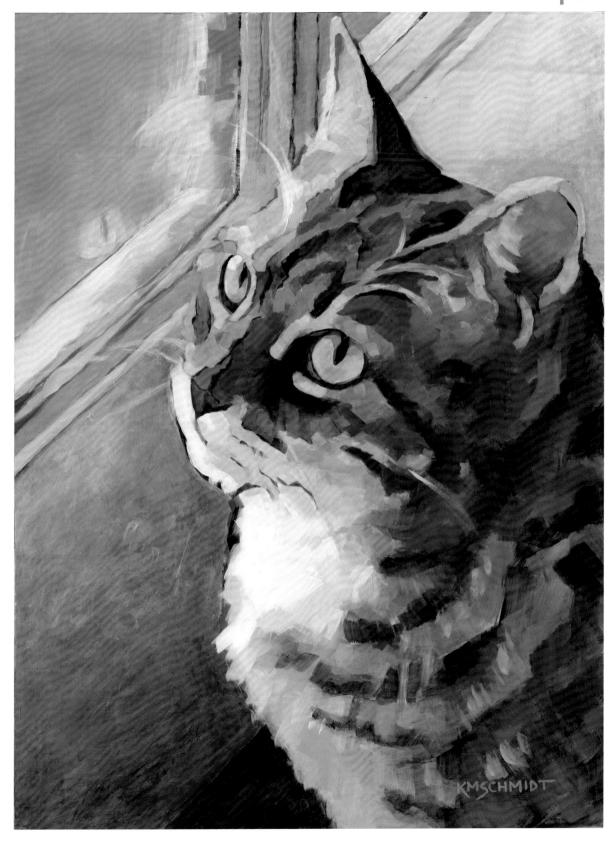

Modern oils

The oil painting techniques we are familiar with today, such as working alla prima and painting on the spot rather than in the studio, developed in the middle to late 19th century as a reaction to the stuffy approach of the Academicians and the slowness of their painting methods. The Impressionists pioneered the more direct and immediate approach, which is just as relevant today, and used by both oil and acrylic painters.

245

'Opening' time

The greasy push-around-ability of oil paint is part of its appeal, as is the fact you don't have to make quick decisions. It's easy to smudge and blend, creating soft cushions of colour. Make acrylic paint behave the same way by adding retarder medium. If you really enjoy slow painting, invest in some of the new 'open' acrylics now on the market.

Hard and soft edges

It is easier to achieve crisp edges with acrylics than with oils, as demonstrated by the pale tree in the background, which has been painted over the dark blues. For the foreground, the paint has been mixed with retarding medium and worked wet-in-wet.

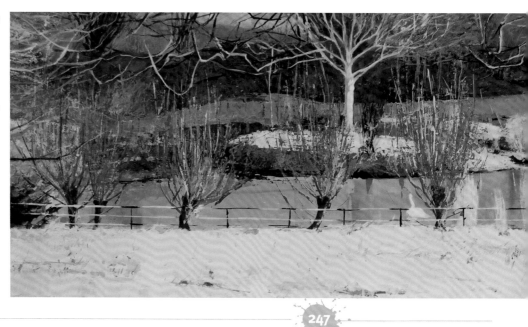

246

Six Impressionist colour tips

1. Don't use a lot of hues straight from the tube: it looks garish.
2. Use a coloured ground so the 'bits you miss' don't glare.
3. Do let some of the ground show; you don't have to cover every millimetre.

4. Use a cool-toned ground for a warm-toned painting and vice versa.
5. Use a creamy ochre ground to make a blue sky look hotter.
6. Put in all the shadows at once, at the end. Balance their colours with the rest of the painting.

Making the comparison

Orange oil strip (top) compared to orange acrylic being used as an oil.

247

Scumbling

Scumbling to achieve 'broken' colour involves smudging or scrubbing a new layer of paint over an already dry one.

Because of its fast-drying properties, scumbling is much easier with acrylics than with oils.

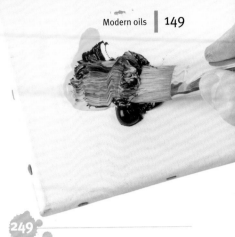

248

Optical mixing

When you can't give a precise name to a colour, put lots of approximate hues close together on the canvas. Grass is never simply green, nor distant hills violet. Thus you're mixing colours, not on the palette, but in the viewer's eye, as happens in nature. Used a lot in art, this technique is also called 'broken color'.

1 A dried layer of cadmium red dots worked over with alizarin crimson is then worked over with ultramine dots. The white of the support is gradually obscured with colour.

2 Once dried, the area is worked over again, this time with painted violet dots. The effect begins to become coherent and the eye begins to the see the colour as purple.

249

Mixing on canvas

As oil paint stays workable, for a long time, oil painters often work wet-in-wet, scrubbing fresh colour into paint already on the canvas. The result can be muddy but with oils this hardly matters: you just scrape back and start again. This is risky with acrylics, which go stringy when semi-dry. So don't over mix; use your palette for mixing colors, and save the canvas for scumbling and optical mixing.

250

Impressionist brushwork

Use a big, robust, long-handled brush, a flat, with plenty of spring. Stand well back from the work. This technique is all about effect, not detail – the whole, not the parts. Work briskly, and don't fuss. Make sure your paint has enough body to retain the shape and crispness of strokes by using heavy-body paint and/or gel medium. Follow the direction of shapes and forms and vary the lengths of stroke. Or use a knife.

1 Use lots of short, swingy brush marks to work up a lively surface, letting layers of colours blend together roughly.

2 As you build layers up, the optical mixing of colours on the canvas will begin to create interesting effects.

251

Dry brush

This is done by lightly dragging a coarse brush with a little stiffish paint over a dry prepainted area so speckles of the new colour catch on the raised parts of the surface. Effective for conveying rough textures such as woodwork or hedgerows, dry-brush effects are best appreciated when viewed from a distance.

Use a fan-shaped brush, as here, or a flat bristle brush with the hairs splayed out.

Mural painting in the 21st century

Murals are probably the oldest art form. 'Have wall, will paint it', so our cave-dwelling ancestors thought. And today murals are just as popular. What has changed is that the paint has improved a trillionfold with the coming of acrylics, which were first formulated for precisely this purpose. There are so many types of wall, and as many ways to paint them. Here are some tips for successful large-scale painting on vertical surfaces, indoors or out. Follow this helpful guidance and your mural is sure to last for years.

252

The wall

First, survey your intended wall. Rough surfaces such as pebble dash are impossible to paint on, and too many intrusions, such as drainpipes, etc., will spoil the effect. Choose another wall! Bare brick, if not too coarse, can be sealed; the mortar courses help with measuring the scale. Walls rendered in concrete are fine, but hit them with a hammer to ensure the rendering is not loose. The plaster on indoor walls must be sound, without efflorescence (a covering of powdery crust). New plaster must be allowed time to dry out naturally.

Most importantly, acrylic will not stick to any wall previously treated with oil-based paints, or any wall that is chronically damp. Mildew, mould and slime are bad signs.

253

Preparing the wall

Scrub masonry sterilizing fluid into the surface to prevent mould, and scrape back any loose areas at the same time. When dry, apply proprietary masonry sealer generously. Next apply the 'blind coat' of acrylic primer thinned with 30 per cent water. This shows any irregularities. To fill them, add two or three coats of full-strength primer to provide a smooth work surface with excellent bonding. On outdoor walls, water-based masonry paint can be used instead of acrylic primer to save on cost.

254

The blueprint

1. Draw an exact scale plan of the wall on graph paper, noting any protruberances or particularly rough areas. A scale of 1:6 – 15 cm (2 in.): 90 cm (1 ft.) – works well.
2. Use this as a basis for your drawings on tracing paper, aiming to place the most detailed sections on the smoothest parts of the wall.
3. Copy the wall plan onto plain paper, and mark up into squares representing 90 cm (1 ft.).

4. Place your finalized outline drawing onto the wall plan, and photocopy in sections so squares are visible. Make two sets of copies.
5. Tape one set together, fold concertina-fashion and attach to a clipboard.

A successful mural begins with a good scale plan of the wall; this plan forms the basis from which all else follows.

Ensure your mural design adequately fits your scale plan before copying and developing your colour maquette (see opposite).

255

The colour maquette

Once you start painting the wall, it will be too late to change your mind on the design or colour, so use the second set of photocopies to plan the colour scheme carefully in advance. You can also make a tracing of your outline drawing and paint it in – a scale version of how the mural will look. If it's an outdoor piece that will affect the neighbourhood, this is good diplomacy.

256

Transfer the design

Mark up the wall into squares matching those on the blueprint, using chalk, a long batten and a spirit level for horizontals. Verticals are marked with a chalked snapline. You'll need a helper. Add diagonals freehand. Now, using a size 14 round brush and creamy paint, copy the outlines on the blueprint, one square at a time, to the wall.

Snapline

257

Mixing the colours

Using white quick-dry primer as a base, mix in your pigments thoroughly, using low-viscosity tube paints or powdered pigment. Keep colours a couple of tones lighter than for a normal painting to increase opacity and brilliance. Where pure hues are necessary, red for instance, school-quality acrylics can be used neat over white; several coats may be needed. Make notes on the rough proportions of your mixtures in case you need to make more.

258

Colouring in

Now is the time to send for your assistants! Go over the wall placing blobs of colour in each area. Do all the reds at once, then the blues and so on. This saves time, energy and brush washing. Once all the basic filling in is done, details and shading can be added.

259

Finishing

Two coats of acrylic satin quick-dry varnish will unify the image and greatly extend the mural's lifespan. Outdoors, it will also help the rain to wash off dust and dirt. Paintwork up to 2.5 m (8 ft.) above ground level can also be treated with a specialized anti-graffitti coating.

Collage and mixed media

Acrylic, with its easygoing nature and adhesive properties, has enabled many new painting methods to emerge. It's famously compatible with every other medium, and provided you follow one golden rule (see below), you can experiment with wild ideas and still produce artwork that won't fall apart. If you want to be on the cutting edge of art, work in acrylic-based mixed media. If you just enjoy making pictures, explore collage. Either way, exciting discoveries await.

260 What is collage?

From the French for 'glue', collage involves sticking real stuff, not just paint, onto canvas to make a serendipitous artwork. Whether it's a nostalgic, personal 'memory box' or just an attractive wall hanging, you can use all sorts of raw materials, provided they won't rot or fade.

1 Here, a primed board is covered in quick-dry varnish (the cheapest acrylic medium) and tissue-paper layers are added.

2 Pushed around by the brush, the medium-soaked tissue-paper breaks up into textures. Transparent layers make interesting colours together.

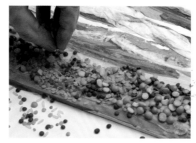

3 It's a seaside picture. Foreground 'beach' details are added, with plenty more medium as both glue and varnish, using various colourful dried pulses.

261 The golden rule of mixing media

Acrylic can be mixed with almost any medium – pastels (both soft and oil), pen and ink, charcoal and even coloured pencils are all popular choices – but bear in mind that water-based paints can't go over oil or any greasy surface, so although you can use acrylic as an underpainting for an oil painting or pastel painting, you can't paint with acrylic over oil.

262 Acrylic is a superglue

Heavy-body acrylic paint is highly adhesive. Stick found objects into the paint itself as you work. Leaves, shells, tickets – whatever you like. Add gel medium to the paint for extra body, or neat for transparent effects. Varnish when completely dry.

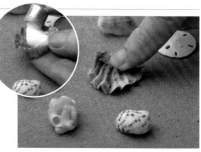

Here, a design of beautiful tiny seashells is arranged on coarse sandpaper and stuck down firmly using acrylic paint.

263 Collage do's

• Do make sure the support is strong enough for the weight of materials. Canvas may sag or tear. Try 3.6 mm (⅛ in.) thick plywood.
• Do prime well, and use a tinted ground. Bits of white background showing through just look moth-eaten.
• Do think before you stick, and beware of perishable materials – ephemera (old paper) fades. Foodstuffs and plant parts may go mouldy. Fixative spray and acrylic varnish or resin will help preserve these.
• Do use painted backgrounds with aerial perspective to increase three-dimensional illusions.
• Do keep the piece as two-dimensional as possible – lumpy work is tricky and costly to frame.
• Do consider composition. Collage too easily becomes a hotchpotch.

264

Layers and textures

Build up interesting bas-relief (shallow-sculptural) effects using layers of scrunched muslin or acid-free tissue paper stuck down with gel medium or acrylic gesso. Materials can be precoloured or painted over. Sand or fine gravel can be thrown at the surface. Try imprinting objects in a layer of medium to leave 'footprints'.

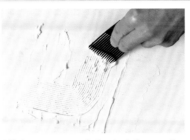

1 Make your own sculpting tools from card or plastic, or use found objects to create three-dimensional effects.

2 Use objects such as coins to make imprints. Modelling paste will stay wet long enough to allow such methods.

265

Pen and ink

Your painting may be enhanced by a small amount of detail added with pen and ink, usually in the foreground; background detail can spoil the illusion of distance. Here are a few tips:
• Ordinary ink bleeds so use India ink; it's waterproof. But beware, it's based on shellac and can ruin fountain pens. Dip pens with disposable nibs are great – they are springy, and don't need cleaning.
• Sepia brown (cuttlefish ink) may look better than black. Or, try the new acrylic inks in brilliant colours, though these may kill pens or brushes if left to dry on.

266

Oil pastels

Add masses of thick, vigorous colour to an acrylic underpainting with oil pastels.

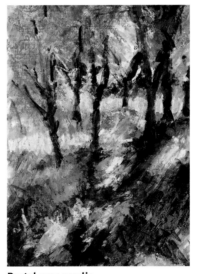

Pastel over acrylic
When you work with pastel over acrylic, make sure you plan both layers, using the same kind of expressive or directional mark-making for the initial painting as you will for the pastel.

Refining details
Here a sepia brown outline is added to the leaves using a dip pen.

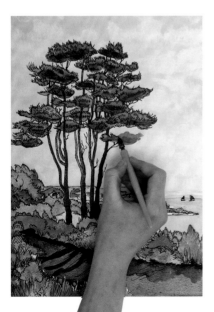

TRY IT ▶ Resist methods

Oil and water don't mix – a hazard, but an opportunity too. Use a greasy medium, such as wax, as a 'resist'. Wherever you draw with it, your water-based acrylic won't stick. Using paper or unprimed canvas, first apply the wax, then let it soak in, or blot it off, as appropriate. When dry, the wax can be removed by ironing the support between several sheets of paper. This is a batik technique, using acrylic colours as a stain or dye. Specialized acrylic inks and fabric paints are also available, but paint pigments do the same job.

Painting light

It seems obvious to say that without light there would be no seen world, but it is not always realized how much the quality of light affects our chosen painting subjects, whether landscape, still life, or figure studies. Try this out for yourself by setting up a small still-life group and carrying it around on a tray from one place to another, or observe a landscape at different times of day. Light is vitally important in describing form, producing highlight and shadows without which objects look flat and two-dimensional.

267

Shine

Shine is a sustained highlight that follows the contour of an object. Sometimes it's picked up from reflected light off a nearby object. The problem of seeing and placing a shine is simple: when you move your head, the shine moves, too. Old masters invented various devices for holding your head still, but nowadays it's sensible to take a photograph and work from this in the last stages of painting. Flash will negate the shine, so use a slow daylight exposure. Setting the camera for 'cloudy' usually works. Of course, changing the light source will also change the position of the shine. With still life it may be possible to angle a lamp to give particularly shapely highlights and shadows. Strong side light gives bolder results than diffuse overhead light.

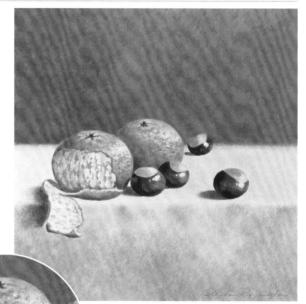

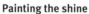

Painting the shine

Highlights are seldom pure white. Use a very light tone of the object, or of any object that's reflected in its surface, with a few tiny spots or dashes of pure white as a 'top note' sparkle.

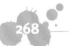

268

Shimmer

Take for instance the dazzle of heat over a hayfield. This optical overload can be recreated with broken colour (see *Optical mixing*, page 149) or by juxtaposing complementary colours (exactly matched for tonal value and intensity), such as perhaps tiny touches of scarlet among foliage or vivid blue and violet shadows amid orange and yellow cornstalks. Build this effect cautiously: too much 'clash' can be visually painful and put the viewer off. Use shimmer effects to enliven large areas of flattish colour. Again, you can make them vibrate just a bit with small strokes of complementary colour. If it looks garish, knock the colour back a bit.

269

Shadows

As Renoir observed, all shadows have a colour. Usually it contains a bit of the complementary of the object casting it. For the shadow under a green bush, try the red end of the purple hues. The complement of yellow sunlight is violet, and so on. Use the colour wheel, plus your perception and imagination. This is painting; you don't have to be literal.

More shadow tips:

• Shadows add a third dimension. A painting without them looks peculiar. Test this by using retarder in your glazes so you can wipe off shadows if you don't agree. Retarder also lets you blot glazes off for speckled light effects.

• A common light source unifies the painting (see *Turn to light*, page 77).

• The depth of shadow determines the tone. There will probably be darker and lighter areas within the shadow.

• A shadow is transparent, so you can still see things within it.

• A shadow is cooler in hue than its surroundings. Use Payne's grey, plus colour, plus G&M (glaze) medium, as a basic colour mix for shadows.

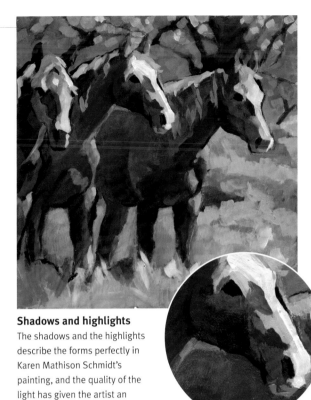

Shadows and highlights
The shadows and the highlights describe the forms perfectly in Karen Mathison Schmidt's painting, and the quality of the light has given the artist an opportunity to use expressive colour.

270

Reflections in water

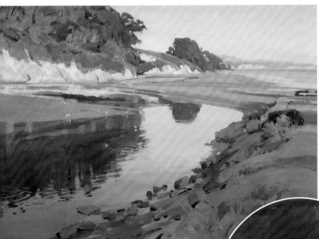

Brushwork
The reflections and small ripples in this painting have been painted with both vertical and short, diagonal brushstrokes.

Even on the calmest water, reflections are hard to analyse, yet they give life to a painting and are deeply satisfying when you get them right. Much depends on the scene you're painting, but here are some guidelines:

• Reflection modifies tone; a dark object gets lighter, and vice versa. Paint accordingly.

• Reflections appear to go straight down into water; they don't broaden as they approach you.

• Slanting objects mirror their angle. If an object slopes away from you, its reflection is shorter; if an object leans towards you, its reflection is longer.

• Choppy water seems to elongate reflections. Reflections of tall masts or trees may be much longer than the real thing. Use short horizontal strokes.

• Keep it simple. For calm or swelling water, a few well-placed squiggles in the right tones to form a pattern are enough.

• Take photographs of the same scene under different wind conditions. This freezes the reflections, making various effects much easier to analyse.

ARTIST AT WORK
Painting natural light

In a still-life setting with strong natural light, such as sunlight streaming through a window, the sense of being present in a timeless moment is greatly enhanced – such atmosphere is what makes paintings meaningful. Here the subject is the light itself, and the way it softens the objects it falls on, blending their 'lost edges' in a space made bigger and warmer by its presence.

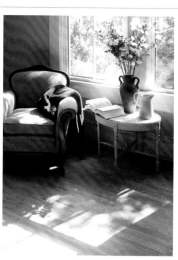

Photographic reference is essential for a subject like this, since the light will change very quickly.

Palette

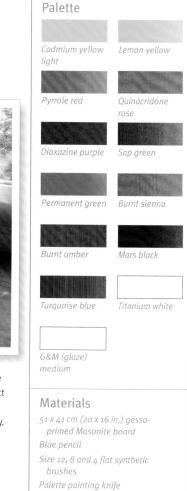

Cadmium yellow light

Lemon yellow

Pyrrole red

Quinacridone rose

Dioxazine purple

Sap green

Permanent green

Burnt sienna

Burnt umber

Mars black

Turquoise blue

Titanium white

G&M (glaze) medium

Materials

51 x 41 cm (20 x 16 in.) gesso-primed Masonite board
Blue pencil
Size 12, 8 and 4 flat synthetic brushes
Palette painting knife

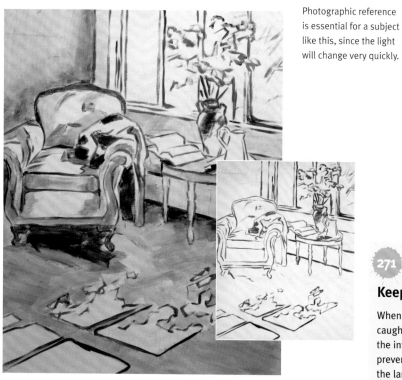

1 Having chosen a vertical format to increase the sun-filled space in the foreground, a careful drawing in blue pencil is made on the canvas. As the angle of the sunbeam, and its shadows, will change through the day, it's wise to make a decision on this at the start. The drawing is developed with pale grey tones (white with Mars black) saving lots of white ground.

271

Keep it loose

When underpainting, it's all too easy to get caught up in excessive detail, which will kill the interest and spontaneity of later stages. To prevent this from happening, decide which is the largest size brush you could use to paint this stage – and then use one size larger.

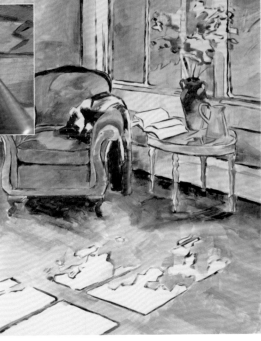

2 Using a variety of hues made transparent with lots of G&M (glaze) medium, large areas of colour are blocked in across the canvas, starting with turquoise blue, to establish a basic colour balance. This stage, which will be overpainted, is an opportunity for the painter to investigate the possibilities of the subject and thus get involved with it.

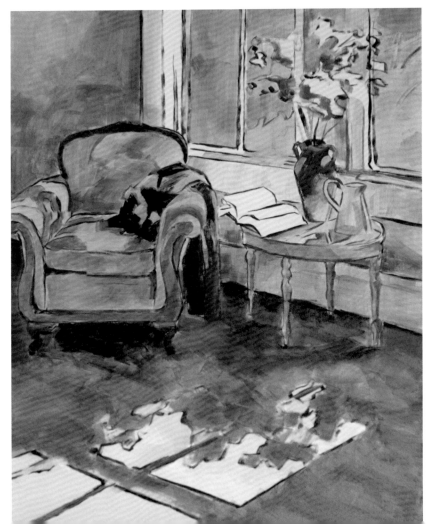

3 On the area directly in front of the chair, a glaze of cadmium yellow is added over a red glaze, warming the colour to transparent orange. A yellow glaze is now applied to the most brightly sunlit areas of the floor.

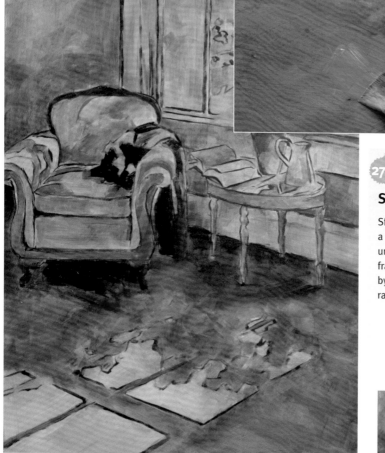

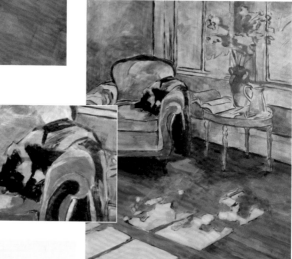

4 When the first layer is dry, a glaze of burnt sienna is painted with a large brush over the whole canvas. This calms the colours, deepens them and unifies the canvas.

272

Sfumato glazes

Sfumato is Italian for 'smoked'. It suggests a thin veil of mist that softens edges and unifies colour. A painting that looks garish or fragmented can be greatly helped, at any stage, by an overall glaze in a neutral hue, such as raw umber or burnt sienna, which is warmer.

5 Adding quantities of white to the colours already in use, and cutting out the medium, the painting moves on into the opaque stage where solid, shapely colour starts to build up and individual areas become more defined. Detail in the wood floor, an almost abstract area, is built up, lightening the puddles of sunlight, making the shadows colourful, emphasizing the wood grain with the direction of the brushwork.

273

Arranging the palette

When laying out your palette, squeeze out separate dabs of white for mixing reds, blues and yellows (or your dominant hues). This will prevent your white from getting muddied by the minglings of unlike colours. Your painting will benefit greatly from the use of cleaner, fresher colour.

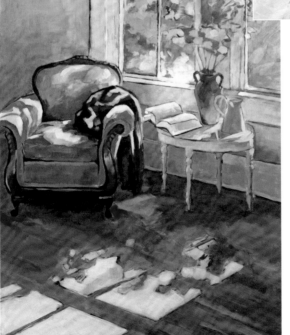

6 The artist now adds detail to the chair. Opaque colours lighten the sunlit areas, the fabric is given more detail, some highlights are added to the wood, and subtle colour emphasizes the shadowy folds of the blanket.

7 Adding detail to the foliage outside the window gives the painting a further dimension. Where the light hits the window frame the edge is 'lost' in the brightness. Objects on the table are painted with semitransparent glazes containing white to catch these reflections, and the wall behind the chair is lightened with yellow to enhance the glow.

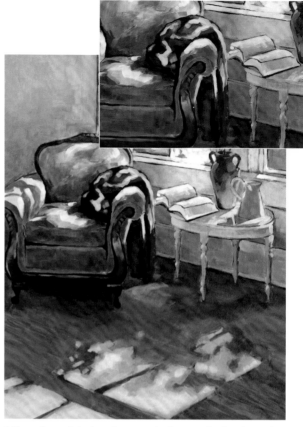

8 The floor area is worked over with rich, hot hues mixed from the various reds with a little purple and/or yellow and white, using a palette knife to drag and texture the paint in the direction of the grain of the floorboards. To cool and darken the shadows under the chair and table, greens are dry brushed over red to produce a chromatic almost black.

9 The unfocused shadow-shapes on the floor, coming from beyond the window, have their edges softened by brushing on some medium-toned colour mixed from the dark and light hues. A thin yellow glaze is sponged on to further soften, blend and illuminate the area. The foliage and flowers are brought to life with greens, yellow, white and pinks which catch the light passing through them and conclude the painting on a high note.

274

Sponging with glazes

To blur edges when you want texture rather than excessive smoothness, use a small natural sponge to dab glazes of a third colour over the meeting point of the other hues. The viewer's brain will have trouble identifying the tertiary colour thus created, making it blur in their mind, especially from a distance. This is an interesting extension of the technique of optical mixing on the canvas (see page 149).

A Splendid Morning
(Acrylics on 51 x 41 cm [20 x 16 in.] gesso-primed Masonite board)

Karen Mathison Schmidt

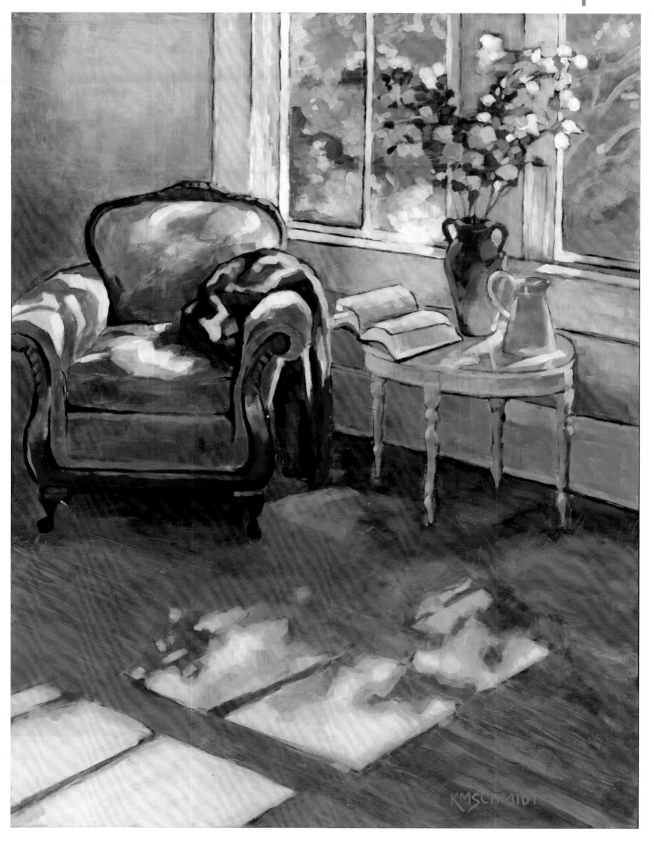

Monoprinting

A monoprint is, by definition, a single, one-off print made from a block or plate of one's own design. The plate may be reused to produce a series of variations, each to a different colour recipe. The excitement of monoprinting lies in the unique, unrepeatable nature of the prints produced, and in the fact that effects cannot be precisely controlled. With practice, you will be producing vibrant, surprising work of originality and freedom.

275 Prepare!

Monoprinting is yet another example of that old artist's adage: if you can't make a mess, you can't make anything. So work outdoors if possible (especially if printing large pieces), out of the wind, or perhaps in a garage with a concrete floor. Failing that, put down some plastic sheeting – an old shower curtain, for instance. Gather your paints and equipment and prepare to be surprised.

Materials and tools

Sturdy table
Water-bucket and sponge for wiping the plate, plus scrapers and lots of newspaper
Drying-line and clothespegs, or a wire rack to dry prints
Hair dryer or fan-heater
Overalls
Rollers and squeegees
Adhesive paper tape
Mixing tubs and palette knives
Icing piping bag

276 The printing plate

Most artists use glass since this allows a guide image to be taped beneath, and seen through, the plate. Others prefer the more free-form method of simply putting paint 'blind' on a plate and seeing what happens. Whichever, the plate must be perfectly flat, smooth, non-porous, and bigger than your paper. Some suitable surfaces are:
• Enamelled tin, e.g. the side panels of an old washing-machine
• A mirror
• Melamine-coated chipboard
• Linoleum
• Acrylic sheet (perspex)
• Varnished hardboard (Masonite)
When using glass, the thicker the better, and don't forget to tape the edges for safety – duct tape is ideal.

277 The paper

Most kinds of paper can be used for printing; different finishes and qualities have different effects. Experiment with whatever you have, and follow your hunches. Shiny, smooth card, or hot-pressed papers produce prints quite unlike those on thick, absorbent watercolour or handmade papers, which can be used damp for interestingly mottled effects. For a clean edge, stick on adhesive paper-tape, which can be easily soaked off when printing is finished. For quality prints, the paper must be acid-free.

278 Monoprinting in action

A small-scale print is much easier to control and less wasteful of materials in the early stages of learning to monoprint. Reference pictures based on simple natural forms provide a good starting point for designing monoprints. Here, a brightly coloured, slightly shiny sheet of craft card is used to produce a run of distinctive prints from a single design.

1 This print design will be based on a 16th-century engraving, chosen for its simple but curvy shapes.

2 Mask the printing side of a thick glass plate with adhesive paper tape, damped in a water-bowl, leaving a window slightly smaller than the paper. Draw an arrow in one corner of this frame as a "registration" mark.

3 Then tape a bold outline drawing underneath the glass (on the non-printing side) so it is visible through the window. Note how the shells have been moved to fit better together on the plate.

4 Mark one corner of the paper with an arrow to ensure the piece doesn't get accidentally printed upside-down. Mix the background colour with some gel medium to keep it moist and, using broad brushstrokes, apply it to the glass. Apply the paper, face-down, and align the arrow with that marked on the frame. Use a small roller or your fist to apply firm pressure.

5 Lift off the paper carefully by opposite corners, to prevent slipping, and dry it thoroughly with a hair dryer. Wipe the plate clean with newspaper. Don't be alarmed if the print isn't attractive at this stage; just think about colours to develop the layers.

6 Place another, contrasting colour on the printing plate, and aim to add more shape and detail. Remember to keep the paint moist with plenty of medium. Spraying the plate with water for this purpose is unwise; colour will run uncontrollably. Use a small pointed brush, or fine-nozzled icing bag to pipe the paint on in thin lines.

7 Apply the paper again, press and repeat step 4. As textures build up, the paint is less likely to stick in the hollows. If you want more coverage, add more paint here, with extra gel.

8 Use the next colour to give more definition or contrast. To vary the shapes and textures of the marks, use a plastic-tipped paint shaper to push the paint around.

9 Finally, apply a highlighting colour with a fairly light touch so as not to obscure too much of the underlying layers. Now press your paper.

10 Peel back your paper. At this stage you want the marks to be crisp, not smudged, so take extra care when peeling back.

11 Try looking at the print within a frame. It's a useful way of assessing its potential. Now you can devise a new color scheme and start the process afresh to build a series.

Completing the painting

Even the most brilliantly painted piece must go through a finishing process before it's ready to show to the public. Careful presentation is the key to its success, and yours. Attention to detail at this stage makes all the difference, and gives you the edge in the competitive world of art.

279

Sign it!

A signature on a painting says far more than simply 'whodunnit'. It's the artist's seal of approval, so add it only to work you truly like, and only when you feel the piece is complete. However distinctive your style, the signature makes the painting much more collectable.

280

Before you frame it

Work to be framed under glass should be photographed and/or scanned first.

Be sure to keep works on paper in damp-proof conditions until they go for framing, so that the paper doesn't go mouldy. There's no need to varnish an acrylic painting that will be framed.

FIX IT ▸ Preventing damage

High-relief paintings are easier to damage, and attract more dust, than flat work. Varnishing is essential, but can be tricky. Keep the work vertical, do small areas at a time and don't let the varnish form blobs or puddles among the peaks of paint. In some cases, several coats thinned with 30 percent water in a spray-mist bottle, and blasted between coats with a hair dryer, give good results.

281

Design your signature

Too many good paintings are messed up by badly executed signatures – incongruous, crude and egotistical. For instance, some people find Picasso's large splashy black name an intrusion on his paintings. Be aware that unskilled lettering makes any painting look amateurish. Better, then, to design a neat, repeatable monogram that will be modest but visible. It's usual to place it in a bottom corner, but anywhere around the edge is acceptable.

A small, easily recognized 'logo' of your initials is a sufficient signature. Use a contrasting colour so it doesn't get lost in the paintwork.

Choose the best place and colour for your signature; it needs to be easily read without being too obtrusive.

Why varnish?

The traditional uses of varnish are to protect the paint film from knocks and scratches, pollutants and the fading effects of ultraviolet light. Modern acrylics are so tough and lightfast that these issues are hardly a problem: still, you'll find that a final coat of varnish pulls the whole piece together quite marvellously. The unevenness of gloss and matte patches caused by different makes and qualities of paint and mediums is unified in an even sheen, and suddenly your painting looks finished. (In fact, using quick-dry varnish, you can treat yourself to this effect at any stage of the painting – a great morale booster!)

Quick-dry varnish comes in handy-sized cans and has just the right viscosity for easy application. It looks milky when wet but dries clear.

Matte, satin, or gloss

Although gloss varnish is best for heightening colour, its reflectiveness causes problems with photography or gallery lighting. Satin is very attractive from the front but shows up any unintended lumpiness of surface. Matte gives an invisible but nonetheless quality finish. All three are fine to paint over, should you want to alter the picture later.

Matte varnish
Some paintings are meant to have a matte surface; for example, those done in the gouache mode. Here matte varnish is the best choice.

Satin varnish
Satin heightens the colours and gives a slight sheen without looking too obvious.

Gloss varnish
Gloss brings up the colours well but produces a reflective surface. Take care with lighting when photographing gloss-varnished work.

Secrets of successful framing

How you present your work is vitally important, so do it justice by dressing it to look its best. Framing is a skilled and subtle craft: the right or wrong frame can make or break a painting. Cheap, clashing, or badly made frames devalue the work; overdressing, on the other hand, looks pompous. There's a lot to think about, and expensive mistakes could be made. Here is the basic know-how that will help you make the right decisions when the time comes to frame your art.

TRY IT ▸

Selling unframed work

Many galleries and framer's shops have browser racks displaying unframed work. Presentation is all-important; and a mount (below right) will add more value than its cost. It's essential to reinforce and protect works on paper with sturdy cardboard backing sheets and a clear cellophane wrapper. Use punch pocket sleeves for small work (cut off the strip). For larger pieces buy a roll of florist's cellophane. Always include a label.

 284

No frame at all

Paintings on canvas are often left unframed, but to make this look good, you need to observe some rules:
• The stretcher must be at least 4 cm (1½ in.) deep. Thinner canvases look flimsy and cheap. They may also warp.
• No nails should show on the sides.
• The corners must be very neat.

• The sides should be immaculate, repainted in the ground colour to a crisp edge with the front, or the painting continued all around the sides. Decide which you'll do in advance; extending colour to the sides as an afterthought doesn't work. Use masking tape for pristine edges.

285

About glass

• Work on paper must always be framed behind glass.
• Don't use nonreflective glass. It seems like a good idea, but it is banned from many exhibitions.
• Glass is too heavy and unsafe for works over about 1 m (3 ft.) square. Use acrylic sheet and protect carefully from scratching in transit.
• Acrylics on canvas or plywood don't need glass. Eliminating the annoyance of reflections is another good reason to use these supports.

286

Framing flat work

Thin canvases, paintings on board, or marouflage will need conventional rebated frames. One vital function of the frame is to make an airspace between the work and the wall, to avoid damp. Deep frames give solidity and presence to a piece – an air of seriousness. Choose a moulding with some bulk, therefore, not less than 5 cm (2 in.) thick.

Frames can constrain a painting, but an unframed canvas gives the impression that the painting continues beyond the edges. Contemporary paintings need no dressing up; the image above will look great on a wall, just as it is.

287 How to choose a framer

Professional framing, besides saving you time, and the expense of buying and storing tools, is a worthwhile investment in so many ways. A good relationship with a skilful framer whose taste you trust is a real support. Shop around to find the best in your area.

Your framer should have a heat press that sticks works on thin paper onto a sturdy backing board to prevent wrinkling. Check the board is acid-free, otherwise your work may quickly decay.

A good framer offers:

1. Impartial advice after looking at the artwork and considering the options.
2. Precision tools. Check the standard of previous work. Corners should be invisible. A bad framer economizes on blades; request new ones!

3. A trade discount for quantity. You're in the art trade, too; you make the stuff!
4. Gallery space. Check that work is neatly displayed and any commission on sales is reasonable. Don't sign any contracts.
5. Contacts to the local art world.
6. A top-quality product: your work looks as good as it possibly can.

288

The mount

Paintings on paper need to be separated from the glass by an airspace. The mount provides this, and also enlarges the clear space round the artwork so it can be seen better. Here are some things to consider when choosing mounts:

• In general, small paintings need wide mounts, and large paintings narrower ones.
• The edges of the window must be perfect. You want a clean, bevelled edge.
• It's common practice to make the bottom edge 12 mm (½ in.) wider than the top and sides to correct an optical illusion that occurs when all are the same.

• The mount board must be acid-free.
• Thicker grades of board and double mounts give a distinguished look.
• Choose pale, neutral shades; ivory is classic. Avoid unusual colours that may overpower the painting.

Narrow mounts
A narrow mount can be very effective, but bear in mind that a little of the outer edges will be lost in the rebate of the frame.

Standard mounts
This is a fairly standard proportion of mount-to- painting, and the ivory picks up the lighter tones in the foreground and on the trees.

Wide mounts
A mount as wide as this is most suitable for small paintings – it adds presence and saves the painting from becoming lost on a wall.

289

Choosing mouldings

• Mouldings must be substantial enough to take screws for the hangers.
• Try not to be bewildered or seduced by the hundreds of fancy mouldings available.
• Simple is best, and the frame must never distract from or clash with the painting itself.

• Hardwoods like maple and oak give a quality look, classic yet neutral, acceptable anywhere.
• Avoid white, if your walls are white.
• Beware cheap mouldings in synthetic materials. These are often coloured paper stuck onto plastic, and fall apart easily.

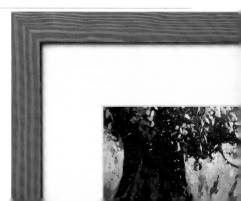

290

Make a simple frame

Attaching a simple bead of plain or painted wood around a canvas or wood panel serves the main purpose of a frame: creating an optical break between the edge of the work and the surroundings. This method also doesn't distract attention from the painting itself; it's tidy and modest, and a fancier moulding can be added later if desired.

Materials

Canvas or wood panel

Hardwood beading, wide enough for thickness of panel

Varnish, primer, paint, glue, filler

Brads

Adhesive paper tape

Hangers, string, label

Tools

Rasp, sandpaper, paintbrush

Mitre saw

Pencil

Drill

Hammer and punch

Screwdriver

1 Rasp and/or sand sharp edges from your hardwood beading pieces. Varnish, or prime and paint, and leave to dry.

2 Measure the hardwood beading against the length of your panel or canvas. Using a mitre saw, cut the wood to size.

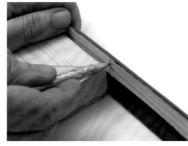

3 Measure the next cut against the corner of your panel/canvas. Cut again, and continue until you have four pieces cut. Check for fit.

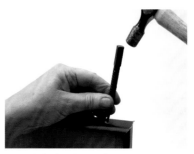

4 Drill very fine holes along the length of the hardwood, 7.5 or 10 cm (3 or 4 in.) apart. The number of holes will depend on the size of the frame you are making. Use your judgment.

5 Glue the beading to the panel/canvas.

6 Use brads to pin the beading into place.

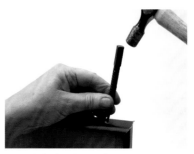

7 Knock the heads in with a punch.

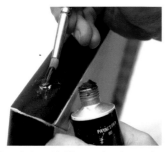

8 Fill any holes with filler, sand and retouch with paint or varnish where necessary.

9 Apply adhesive paper tape for a neat finish.

10 Add hangers, string and label, and your frame is ready to go.

291

Economy frames

Remember, the frame must fit the painting. If the proportions are wrong, it will look awful. So don't be tempted to squeeze your work into some recycled frame that 'almost' fits.

• Clip frames are inadmissible for most exhibitions, but a bargain way to buy glass and backing board; add your own mount, moulding and hangers.

• Cheap mass-produced frames can be useful if you want to produce a range of 'cheap and cheerful' paintings. (It's nice to have some work that anyone can afford.) Throw away the picture and insert your own, which you can paint to fit the frame!

• Secondhand frames often need new glass. Or, you can clean the original glass with white vinegar, polish it with newspaper and blow away any little black bits (nibs) with a hair dryer. Double check for nibs before sealing the back.

A tab gun is invaluable for reframing work. Nails or brads just won't do.

292

Hanging arrangements

For everyday purposes and lighter-weight work, D-rings (available from most art stores) and nylon string do a good strong job. Screw to the inside face of the frame if possible, to avoid projections on the back, about a quarter of the way down. Use double string, looped, and pull it tight. Pass the ends of the string through a flame to prevent fraying, and finish with a tidy knot or masking tape.

Mirror or glass plates are required for heavy work. There are two types: choose those with simple screw holes, not slots.

D-ring

Screw eye

Screw ring

Screwed to the frame and wall, mirror plates offer good support to heavier pieces.

On the frame

A screw eye or a screw ring (a screw eye with a keyring on it) is just as functional as a D-ring, but the pictures will hang at more of an angle from the wall because the screw rings/eyes protrude more. Screw eyes and rings are probably the cheapest option, but not as good as D-rings. A D-ring is a very strong hanging method and also does not stick out too much at the back of the frame.

Mirror or glass plates

Pictures can be screwed to the wall with glass plates that have been screwed to the frame. When hanging paintings in an exhibition, the plates should be set halfway down the sides of the painting, so that all hung paintings are centered along a level horizontal line.

Cord or wire?

You will need to attach picture cord or picture wire to the hangings. Both materials are very strong, although wire is not so widely used as cord.

Making the most of your images

So often your paintings are seen first as photographs – on cards, websites, or by selection panels. Good ones really matter, yet many artists ruin their chances with photographs that are distorted, out of focus, glaring, or shadowed – in other words, careless. Here is a guide to the techniques needed to photograph artwork properly, and further ideas on how you can use your images to the max.

294

'Open' exhibitions

Organized by national societies and advertised in art magazines, these juried shows are open submission with no guarantee of acceptance. You must send off in advance for entry forms, and pay a fee. It's wise to visit the show the year before you plan to enter, and assess your chances. Showing with the societies is the route to membership, which can be prestigious and worth some effort. Delivery/collection services are often available at fairly low cost. Museums and universities also host occasional exhibitions. Shows that make their first selection from photo CD or e-mail/JPEG submissions are often worth entering as there are no transport costs. But be sure your photos do your work justice!

293

How to photograph paintings

First, buy or borrow a good camera, preferably an SLR, with automatic white balance to give accurate colour. Then:
• Always use a tripod.
• Hang work vertically on a wall, not slanted on an easel.
• Level the top with a spirit level.
• Adjust the camera angles so sides don't slope in the viewfinder.
• Backgrounds should be neutral or cropped.
• Cover shiny varnish with matte to prevent glare spots.
• Check for shadows.
• Direct sun must be screened; use muslin or baking parchment over windows. North light (daylight on the north side of a building) can work well.
• Indirect lighting: Point several angled lamps with strong bulbs at sheets of white card (polystyrene, foamboard, etc.) held at an angle to the painting, so light bounces off them and is reflected evenly across the canvas.
• Take high- and low-resolution pictures.
• When in doubt, hire a professional. Classy images will pay for themselves in time.
• Never, never send out poor quality pictures. They will destroy your reputation.

295

Handing in

Before you take your work to the exhibition, reread the instruction sheet, and obey it to the letter! Is your painting within the size guidelines? Are the hanging fittings as specified? Paintings can be rejected for simply lacking mirror plates. Clip frames and nonreflective glass are generally banned, as are projections from the back, such as redundant hangers. Remove them. Is the work labelled? And you must turn up on the right day and time.

296

Reproduction: other methods

Specialist digital imaging bureaus have big scanners to copy large, flexible (it goes through rollers!) artwork directly onto CD; this method is expensive but best for a big poster or giclée edition. Many ordinary print shops have scanners, too. Some colour photocopiers give accurate results direct from an original, improved by using acid-free heavyweight paper. When scanning and printing your own work, be very quality conscious. Images must be a truthful copy of the art.

297
Carrying out commissions

Being asked to make a special piece means you must be getting something right; someone wants some of what you do. Commissions are a great opportunity to expand your practice, often into more functional or decorative realms of art, the stuff people really want. There are pitfalls; indeed there may be minefields ahead. Heed this advice:

• What people want may not be what you want to do. If you are uncomfortable, don't do it. Your integrity is worth more than a job.
• Informal private commissions are business, too. Have thorough discussions of expectations on both sides, make notes and sign agreements.
• Prepare costings carefully. Include everything, not just materials: equipment hire, heating, transportation, delivery, contingencies.
• Public commissions require a contract.
• Specify size, subject, medium, deadlines, delivery dates and maintenance arrangements. Keep fees and materials budgets separate. Insist on quality materials, and don't skimp. Try to charge the going rate for the type of work. Payments are customarily ⅓ on signing the contract, ⅓ halfway through, ⅓ on completion. Clarify copyright issues.

Some commissioners trust you to produce something they'll like; others want preliminary sketches so they can make changes. This adds to your workload, so charge extra. In extreme situations, remind people it's art they're buying, not a fridge! You can't show it to them until it's actually made.

298
How copyright works

Copyright is simple: as an artist/creator, you always own the copyright (including reproduction rights) on all your work, including commissioned work, automatically (until long after you're dead), unless you specifically assign it in writing to someone else. You don't have to do anything special, the copyright is yours.

Buyers of artworks own the object, not the image, and are not entitled to copy it. A warning note to this effect on your artist's label may be wise (see *The artist's label*, page 169). Copyright is a valuable commodity; think hard about parting with it and always charge a fee.

Alternatively, you can license a particular use of the image – as a greeting card, perhaps – for a fee, while retaining your copyright. Various artists' societies exist to handle these matters on your behalf, but they're often slow and inflexible. You can probably negotiate a fair fee yourself, having regard to the number of copies, wealth and purpose of the client, and publicity advantages to you. Always document the deal and insist on a byline with every use of your images, including a © symbol and web address.

Be aware also of other artists' copyrights: for instance, don't paint literal copies of photographs.

299
A note on titles

Every work needs a title for the catalogue. It's tricky, since paintings are nonverbal, ambiguous and contain a wealth of paradoxical meanings. Titles seem to limit that scope for interpretation. But avoid 'Untitled', which admits defeat. Think about this as you work, and settle for something that's short and descriptive, or gives the viewer a clue about how to approach it. Works that share a theme can have a single title, plus a number and phrase, such as 'Woodland Fungi 3: Amethyst Deceivers', 'Woodland Fungi 7: Dryad's Saddles' and so on.

300
Continue evolving

None of this advice will help you unless your art is alive and driven by a passion to make work that is beautiful and true. Work on it.

• Go to life-drawing classes to train your hand and eye.
• Look at masterworks in galleries and books to train your taste and your understanding. Visit the library, read the art magazines.
• Copy a painting you admire. You'll make a direct connection with that artist's mind and learn so much about form and colour selection – all the nonverbal, unteachable aspects of art.
• Find some work you dislike intensely and think hard about why. This helps greatly with shaping your own taste and style.
• Quality control! Ruthlessly destroy anything you don't like or that's been hanging around unfinished for too long.
• Volunteer on a community arts project or playgroup.
• Play with colour at every opportunity.
• Go on a painting vacation.

Glossary

Painters in general aren't too interested in words, and perhaps as a result of centuries of development across diverse cultures, many terms used in painting are ambiguous or contradictory. Often a word has several meanings that can only be deduced from the context. Here are some of the more obscure terms; others are explained within the text.

Acrylic 1. A polymer resin (type of plastic) derived from petrochemicals that takes many forms, including 'Perspex' sheets and 'woolly' jumpers. 2. A type of water-soluble paint where pigments are suspended in an acrylic polymer resin binder, which gives the paint workability and adhesion. It dries to a hard, durable, waterproof plastic film.

Alla prima A painting made all in one go, without underpainting.

ASTM American Society for Testing and Materials. The international quality standard; don't buy paint that doesn't carry the logo.

Canvas 1. A textile, which may be cotton, linen, hemp, sacking, calico or sailcloth, that is stretched over a frame to make a surface to paint on. 2. Any surface to which paint is applied: textile, wood, board. 3. The painting as a work in progress.

Chroma Chromatic colour, colourful, made of colour. Describes the intensity of a hue, and the saturation of pigment.

Complementaries Colours opposite each other on the colour wheel. Placed next to each other, each has maximum intensity; mixed together, they cancel each other out.

Composition The arrangement of all the structural elements within a painting, including positive and negative shapes, horizon lines and diagonals, highlights and shadows and colour patterns.

Contre jour (against the daylight) The light is behind the subject, 'backlit', creating a deeply shadowed foreground.

Cool colours The blue/green/violet side of the colour wheel. They recede towards the back of the picture plane.

Dyad, Triad, Tetrad Colour schemes built from two, three or four colours equally spaced around the wheel.

Glaze 1.Transparent colour thinly overlaid on another colour, modifying its hue or giving it more depth. 2. An acrylic mixing medium that adds transparency and spreading ability to paints; can be matt or gloss.

Granulation (or flocculation) Particles of pigment separating in over-diluted paint; a grainy effect.

Grisaille An underpainting in grey tones that establishes the structure and values of a painting.

Hot/warm colours The red/orange/yellow side of the colour wheel. They appear to advance towards the foreground.

Hue 1. A particular colour. 2. The name of a colour.

Imprimatura A first, dilute coat of paint over the primer to 'break the ice' of a too brilliant, unsympathetic white surface.

Key A high-key colour scheme is bright, hot, saturated; a low-key scheme is more neutral.

Knock back To mix tiny amounts of the complementary into a colour to quieten it.

Local colour The actual hues on the surface of an object.

Maquette Developed sketch used as a 'blueprint' for an artwork.

Medium (plural: mediums) 1. A binder or vehicle for pigment; a substance that modifies the handling properties of paint. 2. (plural: media) The broad type of drawing or painting material, such as oils or acrylic.

Negative space The spaces in a painting between, around or beyond the objects. These areas are part of the picture plane and also have to be painted, so make them shapely.

Opaque The opposite of transparent, fully opaque paint will obliterate what is underneath it.

Optical Effects that happen within the viewer's eye.

Palette 1. An artist's selection of colours. 2. The object on which the paints are laid out ready for work. 3. A surface on which paints are mixed together with a palette knife.

Pass Each time the canvas is completely covered. A layer of paint.

Payne's grey A 'black' specially formulated for mixing shades without dirtying the hue as (ivory) black does.

Pictorial colour The artist's choice of colours to interpret the actual colours of objects; not necessarily 'lifelike'.

Picture plane The two-dimensional surface that is the painting itself, regardless of pictorial illusions.

Pigment Dry, ground and powdered colour that is mixed into a medium such as acrylic polymer resin to make a chromatic paint. There are thousands of natural and synthetic pigments available, which all behave differently.

Plein air French term for painting outdoors; alfresco in Italian.

Primary colours Yellow, red and blue – the colours that can't be made by mixing others.

Retarder An acrylic mixing medium formulated to slow down drying times.

Saturation The purity and strength of a colour. Paint as it comes from the tube is at maximum saturation; once other hues are added, saturation decreases.

Secondary colours Green, orange and violet – made by mixing two primaries.

Shade 1. Darker value of a hue to which some 'black' has been added. 2. Any variation on a basic hue.

Staining power A pigment's ability to transfer colour.

Tertiary colours 1. The six colours between primaries and secondaries on the wheel, named thus: yellow-green, yellow-orange, etc. 2. 'Browns' (russet, citrine and olive) made by mixing all three primaries in different proportions.

Tint A light value of a colour, made by adding a little of the hue to white.

Tone See Value. May refer to the lighter half or the whole range of values.

Value How light or dark a colour is, relative to its surroundings.

Verdicchio A greenish grey shade used in underpainting.

Viscosity Relative fluidity or thickness of the paint. Low is runny, high is sticky.

Useful resources

COMPOSITION
• www.aboutscotland.co.uk/harmony

PIGMENTS AND COLOUR
• www.paintmaking.com

TECHNICAL ADVICE
• www.liquitex.com
• techsupport@goldenpaints.com
• www.winsornewton.com

ONLINE GALLERIES AND PAINTING WEBSITES
• www.painterskeys.com
• www.paintergallery.com

ACRYLIC & EXHIBITING SOCIETIES
• NAPA (National Acrylic Painters Association): www.napauk.org
• Federation of British Artists:
17 Carlton House Terrace
London SW1Y 5BD
www.mallgalleries.org.uk
• Society of Botanical Artists:
www.soc-botanical-artists.org
• Parker Harris Ltd, Esher Surrey: organizers of numerous art competitions, prizes and open exhibitions for societies and institutions. www.parkerharris.co.uk
• The Association of Illustrators:
www.theaoi.com
• AXIS: national database on visual artists. www.axisartists.org.uk
• Design and Artist's Copyright Society:
www.dacs.co.uk
• Society for All Artists (SAA):
www.saa.co.uk
• Artists newsletter (a-n) magazine:
www.a-n.co.uk. 12 issues p.a.
• Artists & Illustrators magazine:
 www.artistsandillustrators.co.uk.
12 issues p.a.
• Galleries magazine (distributed free):
www.artefact.co.uk. 12 issues p.a.

ART MATERIALS ONLINE
• www.Greatart.com

BOOKS ON COLOUR
• THE COLLINS ARTIST'S COLOUR MANUAL, Simon Jennings, (Collins, 2003), ISBN: 0-00714-703-1
• COLOUR, Betty Edwards, (Tarcher/ Penguin, 2004), ISBN: 1-58542-219-3
• THE ART OF COLOUR MIXING, Lidzey, Mirza, Harris & Galton, (A&C Black, 2002), ISBN: 0-7136-6181-X
• NOTES ON THE COMPOSITION AND PERMANENCE OF ARTIST'S COLOURS (Winsor & Newton, 1997)

BOOKS ON DRAWING
• THE NEW DRAWING ON THE RIGHT SIDE OF THE BRAIN, Betty Edwards, (HarperCollins, 2001), ISBN: 0-00711-645-4
• SECRET KNOWLEDGE: REDISCOVERING THE LOST TECHNIQUES OF THE OLD MASTERS, David Hockney, (Thames & Hudson, 2001), ISBN: 0-50023-785-9
• DRAW, Jeffery Camp, (Dorling Kindersley, 1994), ISBN: 1-56458-526-3

BOOKS: GENERAL
• CONCERNING THE SPIRITUAL IN ART, Wassily Kandinsky, (Museum of Fine Arts, Boston, 2006), ISBN: 0-87846-702-5
• THE ARTIST'S GUIDE TO SELLING WORK, Annabelle Ruston (A&C Black, 2005), ISBN: 0-71367-159-9

ONLINE DEMO VIDEOS
• uk.youtube.com/watch?v=bC_ IQkSneRo&feature=related

Index

Credits

Quarto would like to thank the following artists for kindly supplying images for inclusion in this book:

- Karen Mathison Schmidt p.2, 3t, 11t, 26bm, 95tl, 97bl, 142–147, 155t, 156–161
- Fiona Clucas p.10b, 11b, 97br, 99tl, 111l, 148t, 167
- Marcia Burtt p.10t, 110t, 155b
- Sara Hayward p.23b
- Belinda Eaton p.24b
- John Stoa p.26l, 97tr, 99mr, 136t
- Jennifer Bowman p.26br, 76, 94bl, 97tl, 98b, 111r, 164br
- Nick Andrew p.27tr, 32–37
- Don Saddington p.27m, 101b, 141t
- Barry Tate p.27b, 100tl
- Deborah Batt p.94b
- Brian Simons p.95b
- Dan Grant p.96tr
- Rita Banks p. 99tr, 128t
- Christine Derrick p.99bl
- Jane Strother p.99br
- Igor Avramenko p.100r, 101t
- Alan Oliver p.100bl
- James Harvey Taylor p.120t
- Stephen Rippington p.39, 76, 132–135
- Lexi Sundell p.57, 88–93
- Bob Brandt p.78–83
- Brian Gorst p.102–105, 122–125
- Sally Trace p.126t

With special thanks to the following for kindly supplying the paints:
- Daler Rowney
PO Box 10,
Bracknell,
RG12 8ST
England
Tel: 01344 461000
www.daler-rowney.com

- Winsor Newton
www.winsornewton.com

Special thanks also to Studio Arts, Crafts and Graphics (supplies for watercolour, acrylic, oil, gouache, brushes, pens, pencils or surfaces) for supplying the image of their store interior on page 19.
For mail order, contact: www.studioartshop.com
Tel: 01524 68014